NATURE PHOTOGRAPHY
PHOTO WORKSHOP

NATURE PHOTOGRAPHY
PHOTO WORKSHOP

Nat Coalson

Wiley Publishing, Inc.

Nature Photography Photo Workshop

Published by
Wiley Publishing, Inc.
10475 Crosspoint Boulevard
Indianapolis, IN 46256
www.wiley.com

Copyright © 2011 by Wiley Publishing, Inc., Indianapolis, Indiana

Published simultaneously in Canada

ISBN: 978-0-470-53491-5

Manufactured in the United States of America

10 9 8 7 6 5 4 3 2 1

For general information on our other products and services or to obtain technical support, please contact our Customer Care Department within the U.S. at (877) 762-2974, outside the U.S. at (317) 572-3993 or fax (317) 572-4002.

Wiley also publishes its books in a variety of electronic formats. Some content that appears in print may not be available in electronic books.

Library of Congress Control Number: 2011924141

About the Author

Nathaniel Coalson is a nature, travel, and fine-art photographer based in Colorado. Nat has worked professionally in photography, imaging, and printing since 1987. His work has been exhibited extensively, received numerous awards, and is held in private and corporate collections.

Nat is an Adobe Certified Expert in Lightroom and Photoshop and is a top-rated instructor who has taught digital photography and imaging to photographers at all levels. He is the author of two Lightroom books including *Lightroom 3: Streamlining Your Digital Photography Process*, published by Wiley in 2010.

For more information and to see Nat's work, visit www.NatCoalson.com.

Credits

Acquisitions Editor
Courtney Allen

Project Editor
Kristin Vorce

Technical Editor
Haje Jan Kamps

Senior Copy Editor
Kim Heusel

Editorial Director
Robyn Siesky

Business Manager
Amy Knies

Senior Marketing Manager
Sandy Smith

Vice President and Executive Group Publisher
Richard Swadley

Vice President and Executive Publisher
Barry Pruett

Project Coordinator
Patrick Redmond

Graphics and Production Specialists
Jennifer Henry
Andrea Hornberger

Quality Control Technicians
Lauren Mandelbaum
Robert Springer

Proofreading and Indexing
Leeann Harney
Sharon Shock

Acknowledgments

My sincere gratitude goes to the many people who helped make this book a reality. My good friend and trusted adviser Charles A. "CAZ" Zimmerman has provided his continued support and advice. Courtney Allen, Kristin Vorce, and the editorial team at Wiley gave me the opportunity to share my experience with other photographers and provided expert publishing guidance along the way. To my travel buddies and nature photographers Monte Trumbull, Jim Talaric, and Mark Ferguson: Our adventures and camaraderie have given me immeasurable inspiration and our many conversations have proved an invaluable sounding board for the development of my work. Thanks also to my friends and fellow nature photographers Jesse Speer, Rod Hanna, Adam Schallau, G. Brad Lewis, Erik Stensland, Guy Tal and Kalin Wilson. Your work is truly an inspiration.

Thanks also to my workshop partners Bret Edge and Grant Collier, with whom I've led many successful nature workshops over the years. Working with professionals of this caliber has helped me learn what it means to provide the best experiences for students. My thanks to Bruce Hucko at the Moab Photo Symposium for the opportunity to present at one of the best nature photo events in the United States; Jeff Johnson and Jill Bailey of the Professional Photographers of Colorado, Nancy Green of the Professional Photographers Association of Massachusetts, and the leaders of Denver-area photo clubs who invited me to present to their groups, especially Craig Lewis, John Jakobsen, Dick York, and Bruce Ryman; Bruce Borowsky, Zach Daudert, and Kira Woodmansee at Boulder Digital Arts, and Efrain Cruz at Illuminate Workshops who have provided me wonderful opportunities to teach a wide range of photography-related subjects.

On that note, I also offer my unending gratitude to my students. It's been said that to truly learn, one should teach, and I've certainly learned much from my interaction with students. Of note, my recent discussions with Gigi Embrechts and Terri Watson about photography, art, and life have been inspiring and helpful.

I want to extend my thanks to Kathy Waite, Tom Hogarty, and the team at Adobe Systems; thanks also to my sponsors and the equipment manufacturers who provided photos for this publication, in particular Dennis Halley at Digital2you.cc, Acratech, Hoodman, and Induro, and Jeff Payne at Hasselblad USA. Thanks to Dan Stainer, Monte Trumbull, and Grant Collier for providing photographs for illustrative figures.

I owe a great deal to the teachers and mentors who have taught me so much over the past 20 years, not only about making photographs but living a fulfilling life as a working artist. Many of the techniques and philosophical aspects of this book were inspired by the teachings of Freeman Patterson, Galen Rowell, John Paul Caponigro, Brenda Tharp, David duChemin, and Michael Freeman. My thanks also go to Tony Sweet for his generous inspiration and advice on the art and business of photography. Eddie Tapp took the time to give me a portfolio review that was very beneficial in helping me refine my vision for my work. I very much appreciate the advice.

To my parents Edward and Gail Coalson, my brother Sam, and my sisters Elizabeth and Maggie, my love and thanks to you all for supporting my efforts over these many years.

For Kelly

Contents

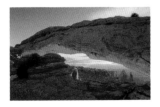

CHAPTER 3 Working with Natural Light **39**

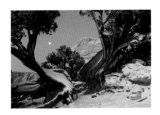

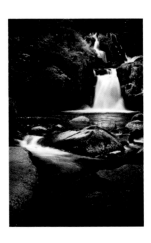

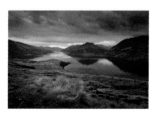

CHAPTER **7** The Intimate Landscape **165**

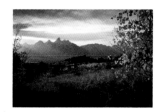

FOREWORD

The great wilderness photographer Galen Rowell taught that it is far more important to let your experiences validate your images then to let your images validate your experiences. Beyond Galen's deep technical mastery and artistic knowledge was an intense appreciation for the breathtaking natural world around him and profound respect for the fragile connection he shared with it. These, too, are the principles that Nat Coalson lives and photographs by.

I had the honor of photographing alongside Nat this past autumn while traveling through the Colorado Rockies on a personal workshop. On one particular early dawn morning when I was recovering from an altitude-induced migraine, Nat decided to visit a small lake near Crested Butte, Colorado, on his own. I'll never forget how Nat described the experience. It wasn't about getting the perfect shot. As a matter of fact, I don't think he would have cared one way or another. Rather, it was about immersing himself in the magic of the moment as the morning fog peacefully rose above the calm surface of the serene mountain lake.

For Nat, it was about contemplation and introspection; about creating an image that would not have existed without him; about revealing the invisibles and allowing the work to express itself of its own accord through him. Seeing his stunning photos later that morning, I was instantly transported to the lake; and I felt exactly how Nat felt — as if I was sitting on the shore watching the scene unfold before my eyes.

This is what nature photography is really all about. But how do you take the visual music and poetry you are feeling and translate it into emotionally compelling photographs that resonate among your viewers? How do you move beyond looking to seeing? No matter how lofty your vision and creative goals; no matter how strong your desire to communicate intention, you simply cannot ignore foundational concepts such as dynamic composition, good visual design, and technical execution. For without them, vision has no wings.

In his eloquently written book that is part artistic and technical, part philosophical and psychological, Nat shares his deep-seated knowledge and wisdom about nature photography, inspiring you along the way with concepts, such as how to use sound design principles to photograph the three-dimensional world using an inherently two-dimensional medium; how to find and recognize visual clues and blend them together into a harmonious whole; how human vision and perception work; and why previsualization and revisualization are important.

From an understanding of how to master natural light to step-by-step advice on how to create compelling grand scenics or intimate landscapes, Nat teaches you how to intuitively translate vision and intent into a language your camera can understand — seeing through the lens as it sees. Like a photographic sage, Nat can only pave the way for you — for this is a journey of self-discovery you must ultimately make on your own.

I encourage you to thoroughly absorb what he has to say, take advantage of all the outstanding exercises in this book, and practice relentlessly what you have learned. If you do that, I promise you'll be one step closer to mastering your understanding of nature photography.

The time I spent with Nat in Colorado was illuminating and rewarding in so many ways — and I'm still taking it all in. While nothing beats the insight you'd gain from mentoring with him in person as I did, reading this book is clearly the next best thing. I hope you enjoy it as much as I did.

Daniel Stainer, Fine Art Photographer (www.danielstainer.com)

Introduction

Greetings! Thanks for picking up this book. If you're interested in learning how to make captivating photographs in the great outdoors, you've come to the right place.

What is nature photography? In the context of this book, it's making photographs of natural subjects using natural light. Nature photography is wide ranging and can encompass anything from a panoramic image of a scenic vista to a close-up of a flower or rock pattern.

As a photographer, it's important to continually hone your craft. Making effective photographs is not easy, especially in nature, where you have little or no control over the elements that make up the picture. When learning about nature photography, some people learn a lot by reading about specific topics; others prefer hands-on exercises to fully understand the material. You find all this and more in this book.

When I first fell in love with photography in my early 20s it was all about nature. Like many other photographers, I was most inspired by the work of Ansel Adams. I wanted to do *that*. During the week of my 22nd birthday I went on a backpacking trip through Yosemite. I packed my Pentax K1000 SLR and six rolls of film; four of them Tri-X black and white. The next five days became a study in frustration and a test of my dedication to the craft of photography. I struggled enormously. Weeks later, when I got the film back from the lab, my disappointment confirmed what I had suspected all along while shooting in Yosemite: I had no clue what I was doing.

All around me I knew there were amazing photos to be made. After all, I stood in the same places as Mr. Adams, at about the same time of year that he made his iconic photographs. Why couldn't I get anywhere close to replicating the quality of vision the master appeared to so effortlessly demonstrate? Clearly I had a long way to go, and for the next ten years I dabbled in photography off and on, never really serious about learning or improving my work.

Then came digital cameras and with them a career change for me. Around 2002, my interest in photography was renewed just as I was transitioning out of a long career in digital media production. The timing was perfect, and this time I jumped in with both feet (or was it head first?). Either way, I was hooked. I became dedicated to learning the art and craft of photography as best I could. And once again, my first love of nature photography was rekindled.

For me, learning about photography has meant complete immersion. But that's just my way of doing things — all or nothing. You don't need to be a professional, an advanced amateur, or even a serious hobbyist to learn to make better nature photographs. With this book, you learn the essential methods for approaching nature photography at any level.

The first chapters introduce you to nature photography, including methods for learning to see the natural world in new ways, characteristics of natural light, and the fundamentals of composition. You then get an overview of the range of digital camera and computer equipment available to help you make your pictures. Next are chapters that provide an in-depth look at photographing nature, from grand scenic vistas down to intimate close-ups. You learn how to process and share your digital pictures, and the workshop wraps up with an examination of ways to continually improve your nature photography.

I'm here to inspire and guide you to make nature photography your own. Whatever you want it to be, it can be. Making choices can be the hardest part of photography — the options are infinite. With the right skills and the best available tools at your disposal you experience creative freedom, and your work will flourish.

My greatest hope for this book is that it will be the most fun you've ever had while learning more about your photography...and about yourself.

Nat Coalson

Conifer, Colorado

2011

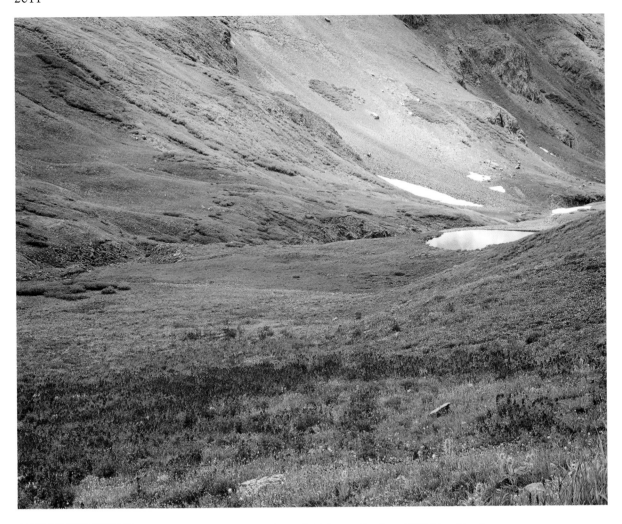

ABOUT THIS PHOTO *Image of Stony Pass, Colorado (ISO 100, f/22, 0.8 sec. with a Canon EF 17-40mm L lens).*

AWAKENING TO NATURE PHOTOGRAPHY

Whether you capture a trickling mountain stream, pounding waves on a shore, ripe fruit on tropical forest trees, a snowcapped peak, or high dunes of pure white gypsum sand, nature photography connects you to the land in remarkable ways. To see an incredible natural spectacle is one thing; to make a good photo of it is another thing entirely.

This chapter introduces you to a framework for thinking about nature and photography. The best advice I can give you for how to become a better photographer is to consciously think about what you're doing. Maybe surprisingly, great photographs don't usually happen through sheer luck. As you learn, getting out and shooting more frequently is certainly beneficial, but some of the most significant improvements you'll make in

your nature photography can come from performing activities other than shooting. Doing things like research, previsualization, writing, and even quiet contemplation will have profound effects on your photographs.

One of the most exciting aspects of nature photography is that it's never constant: The outdoor environment rarely remains the same for more than a few minutes. Often, a spectacular natural event lasts only seconds! If you see this coming ahead of time, you can be prepared to make beautiful photographs when the magic happens, such as the first light of sunrise at a beach on New Zealand's South Island (see 1-1). This quality of light lasted only a few minutes.

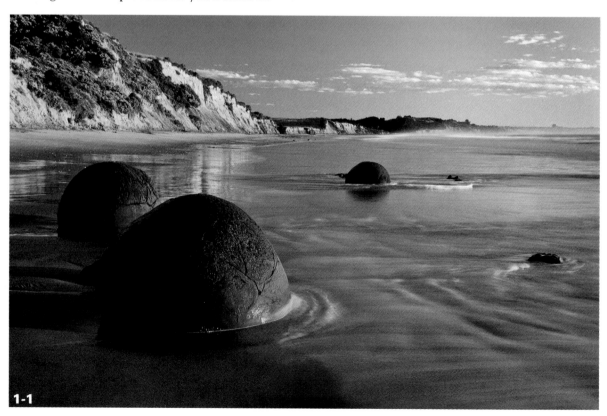

1-1

ABOUT THIS PHOTO *Image of Moeraki Beach, New Zealand (ISO 50, f/20, 2.5 sec. with a Canon EF 24-105mm f/4 L lens). This photo was taken shortly after sunrise on the first morning of a month-long trip to New Zealand. The boulders are concretions that over centuries have been naturally rounded by the waves.*

Whether you're entirely new to photography or just getting your feet wet in nature photography, if you commit yourself to working through the information and assignments in this book you will improve your visual perception, learn to work easily with natural light, and competently make photographs that fully express your creative visions that can also reveal deeply personal interpretations of nature.

EXPLORING YOUR RELATIONSHIP TO NATURE

Nature photographers are motivated by a love of nature. And nature photography can be an intensely personal journey. Simply spending time in nature inspires introspection and contemplation. You might be inclined to think about your place in the world and find amazement in the wonder of it all.

Personalizing your experience is absolutely essential to creating strong nature photographs. In particular, your photographs will benefit from consistently choosing subject matter that you find interesting. If you aren't genuinely intrigued by a subject, it will be evident in the photographs. Find what you love, and avoid pursuing clichés and icons if they don't truly inspire you.

IT ALL STARTED WITH VACATION PICTURES

Most photographers love shooting outdoor subjects in natural light. In fact, for many professional photographers working in all genres of photography, nature photography is something they do when they're not working.

For many people, an interest in photography starts on a family vacation. You know the feeling when you're standing in awe at Dead Horse Point State Park in Utah (see 1-2) or the Grand Teton in Wyoming and want nothing more than to be able to share this with people who couldn't make the trip? The desire to document your travel experience in a way that can be appreciated by others is nearly universal.

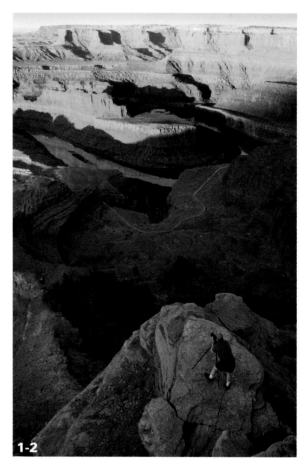

1-2

ABOUT THIS PHOTO *Image of Dead Horse Point State Park, Utah (ISO 800, f/8, 1/250 sec. with a Tamron XR Di II 18-200mm lens). This location overlooking the Green River is a popular spot with nature photographers from around the world. The best photos of Dead Horse Point are most often made in the early morning.*

Nature photographers create a particular photo because they are moved by what they're seeing. It's beautiful, pristine, and beyond human control. They want to capture and preserve something that triggers feelings deep inside them.

But it's hard for a photograph to have the same effect on people who weren't there at the time it was made. For a viewer to react to a photo, it must elicit some kind of emotion. How do you do this for someone who wasn't there? Memory often carries emotions with it; without a direct memory, how do you evoke emotion? One effective way is to capture and express the most basic essence of your subject matter.

THE ESSENCE OF THE SUBJECT MATTER

When you're in a beautiful place (or an ugly place, for that matter) the trick is to discover the essence of the subject matter you're photographing and portray it in the strongest way possible through the photograph. In nature this is no small feat. Nature is inherently chaotic and unpredictable. It is physically impossible to fully capture everything in a single photograph.

You need to distill your experience down to the simplest parts. This means choosing what matters the most and communicating what you want to say with the photo. In portraying the essence of the subject, you are also revealing your feeling about it and your reaction to it. This is illustrated by the well-known phenomenon that when you put ten photographers in one place at the same time, everyone will make different photos.

Find the essence of the natural environment and strive to discover what it means to you *personally*. My response to the smooth, sweeping dunes at White Sands in New Mexico is illustrated in 1-3. I wanted to show the delicate nature of this harsh landscape by emphasizing the shape of the dunes and the way they were illuminated by the late-afternoon sun.

MINDFULNESS AND INTENTION

Mindfulness is a state of paying attention, remaining acutely aware of the present moment in order to make more effective choices for your photographs. It might sound simple but it's difficult to maintain. If you're photographing nature and you think too much about the past or the future, your photos will suffer. It's imperative to stay in the present moment as much as you can. Of course, previsualizing what might happen next and how you can position the camera in the environment is also essential.

You should also think about your *intention* for a photograph. This means having a clear idea of what you're taking a picture of and what you want to say to the viewer about the subject. A good photograph effectively communicates your intentions to the viewer. For this to happen, of course, you must shoot with *purpose*. Seeing what's around you and then responding honestly to the environment helps you explore your truest interaction with nature. Effectively capturing that moment with your camera can result in a compelling photograph.

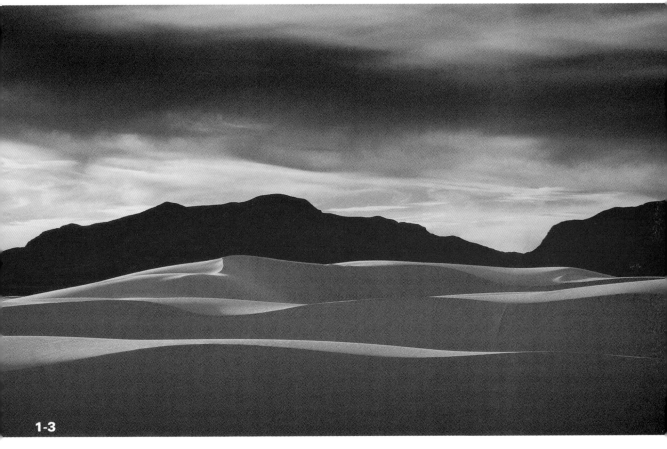

1-3

ABOUT THIS PHOTO *Image of White Sands, New Mexico (ISO 100, f/25, 1/25 sec. with a Canon EF 100-400mm L lens). The "stacking effect" and apparent lack of depth is the result of my using a long telephoto zoom lens.*

OWNING YOUR DECISIONS

Many people learning photography fear that they will make mistakes. Don't fear. You're supposed to make mistakes; you will learn much more from your mistakes than from your successes. I encourage you to approach your nature photography fearlessly. If you're too careful, too safe, you won't make much progress. And after all, what is there to lose? Think about what you're doing, make your decisions, and move forward. Then take time to look back at what happened and evaluate the results.

As you share your work with others, you'll find some people seem to love every one of your photos and other people seem to never like anything

you produce. Don't worry about this. Photography is a never-ending process and a personal journey with no destination. Shoot to please yourself first, and when soliciting critiques from others, listen carefully but remember that even the most expert critiques are often colored by personal opinion and perspective. In the end, if you are happy with your work, that must be enough. If you unashamedly pursue your own vision your work will improve and evolve, often quickly. But if you try to please other photographers, your work won't be as effective as it could be.

ETHICS AND ETIQUETTE

It's vitally important that nature photographers follow a few standards of good behavior. The actions of photographers in nature have resounding effects that are not always immediately felt directly. Being a good nature photographer also means being a good steward of nature and showing deference to other photographers who share similar ambitions. In 1-4 a group of photographers is working in close proximity to one another during a workshop in the Utah desert.

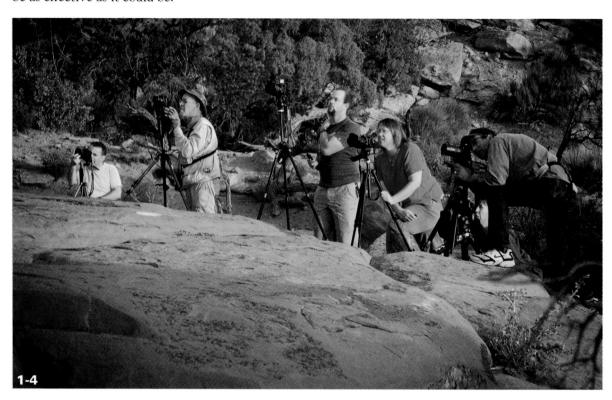

1-4

ABOUT THIS PHOTO *Image of workshop sunrise shoot in Utah (ISO 400, f/8, 1/40 sec. with a Canon EF 28-135mm IS lens).*

RESPECTING NATURE

It should go without saying, but the most important tenet of responsibility for the nature photographer is not to damage or destroy nature. Shockingly, not all photographers adhere to this. In recent years there have been cases of neglect or outright vandalism perpetrated by photographers in nature, some of them well-known and high-visibility cases. In one example, a photographer set fires under several natural arches in Utah national parks, attempting to make unique photographs. The damage was extensive. The photographer pleaded guilty to all counts, was fined nearly $11,000, and was banned from national parks for two years.

More commonly I've seen photographers tear up shrubs, break off tree branches, and trample wildflowers. Pulling up some grass that's in the way of the perfect composition may not always be a problem (unless it's a protected grass species!), but seriously, give some thought to the consequences of your actions. Do your best to keep the natural landscape the way you found it, or as the U.S. National Park Service slogan says, "Leave No Trace." Humans' impact on nature is already too significant; the responsible photographer never harms nature just to get a photo.

RESPECTING OTHER PEOPLE

I've seen photographers nearly come to blows in heated arguments in the field. Rather than taking a competitive or combative stance, showing respect and understanding for each other can make nature photography far more enjoyable.

Nature photographers are often isolationist types; being alone with a camera in nature is a sublime experience. But these days, many of the most spectacular places in nature are easy to access, which means lots more people. And with the advent of digital capture and the resulting huge rise in popularity of photography, many more photographers are in one place at the same time trying to make photos.

Mesa Arch in Canyonlands National Park (see 1-5) is one such place. If you've been there, you probably know what I mean. Most days of the year, you can find dozens of photographers lined up, tripod legs interlocked, shuffling for position as the sweet light passes. One time I saw a woman brought to tears by the actions of aggressive photographers. She had traveled thousands of miles over many days and only had this time to get her photograph of the iconic location. She felt bullied by rude photographers, and ran off, sobbing, to find a ranger. Also at Mesa Arch, I've seen photographers, who arrived before the hordes, camped out at a position just underneath the arch, in a place that ensured nobody else could get the singular photograph that most people go there for.

The point is many photographers want to get the trophy shot. When you're at an amazing location and amazing things are occurring, passion can quickly turn ugly. Stay cool. Put yourself in the other person's shoes and remember the Golden Rule. Be kind out there.

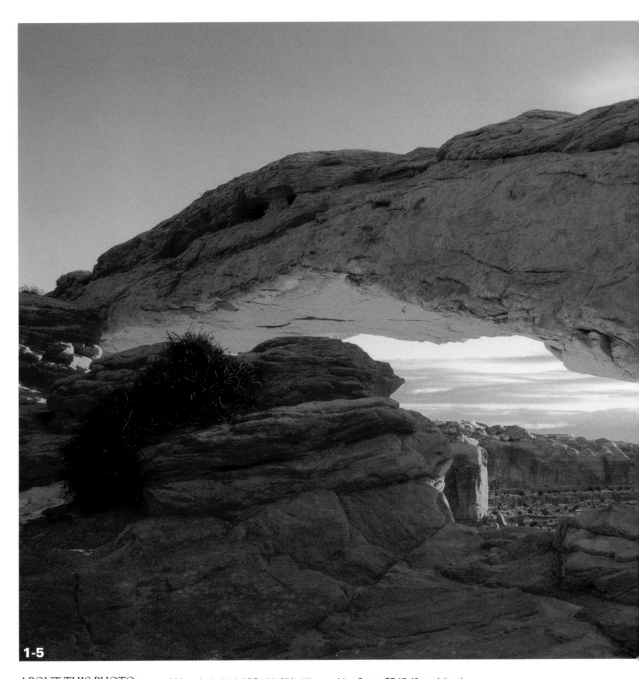

1-5

ABOUT THIS PHOTO *Image of Mesa Arch, Utah (ISO 100, f/22, 1/4 sec. with a Canon EF 17-40mm L lens).*

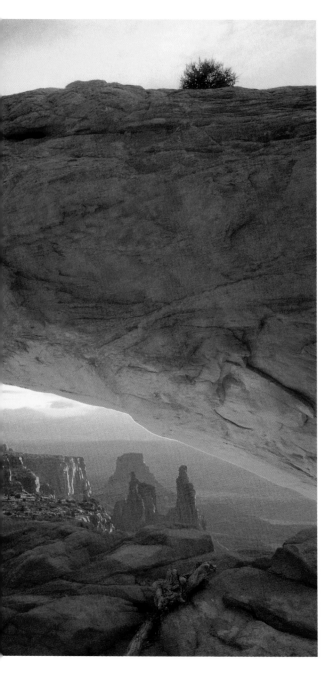

SAFETY

Carrying further the examples of buffoonery just mentioned are situations where a nature photographer assumes great risks of injury or death just to get a photo. In 2010, a photographer was killed when he stepped backward over a cliff at the Grand Canyon. Don't do this. Keep your wits about you while you're shooting; it's part of being mindful.

PROTECTING YOURSELF

Photographing nature often involves some type of risk. As many safety training classes teach, you need to be able to assess the risk factors and minimize them. The more risk factors present at one time, the more likely it is that an accident (or "incident") will occur.

An accident in nature could range from getting a bad sunburn, to slipping down a hill and scratching yourself with a tree branch, to being struck by lightning. Anything's possible out there. The smart nature photographer doesn't take unnecessary risks to get the shot. The dumb nature photographer might get the shot but be killed doing so. Assess your priorities, evaluate the situation, and make clear decisions about your safety.

Following are a few tips for taking care of yourself in nature:

- **Bring a light.** Nature photographers often hike over uneven terrain in the predawn hours or after sunset. A flashlight is an essential piece of gear for the nature photographer; a headlamp allows you to keep your hands free.

- **Put on sunscreen.** It's easy to lose track of time when you're out shooting; a couple of hours in the sun (even under cloud cover) and you can get cooked.

- **Seek shelter in bad weather.** Lightning and flash floods are common in the wilderness, especially in desert and alpine environments.

- **Watch your step.** It's easy to become fixated on a part of the scene you're interested in photographing and charge forward without looking where you're walking. This is a recipe for a twisted ankle or worse.

- **Don't climb up what you can't climb down, and vice versa.** This rule especially applies when you're carrying a heavy backpack.

- **Keep your distance from wildlife, especially large mammals.**

- **Tell someone where you're going.** When possible, hike with a buddy or in a group, but when you want to get out into the wild yourself, someone needs to know where you're going and when you'll be back.

- **Carry a locator beacon.** In recent years many new systems have come into the market that help people find you should you need to be rescued.

- **Wear appropriate clothing for the weather.**

- **Bring water.** You need to stay hydrated.

PROTECTING YOUR GEAR

I know from experience that nothing gives you that sinking feeling in the pit of your stomach like seeing your brand-new, expensive camera dunked (seemingly in super slow motion) under the water of an otherwise beautiful mountain stream. Short of a disaster like this, there are all kinds of other threats to your equipment when doing nature photography. Here are a few things to watch out for:

- **Rain and snow showers.** Shooting in the rain can yield amazing pictures of nature, but most cameras don't do well if they are subjected to even a slight rain shower. Top-end, professional dSLRs often can handle a deluge, but in general, you need to keep your camera gear dry. You can invest in a fancy rain cover for your camera and lens, or just use a plastic grocery bag. The image shown in 1-6 was taken in a light drizzle just after a heavy rain.

- **Theft.** The second worst thing to ruining your own gear is having some schmuck run off with it. Don't leave your stuff lying around unattended. Maybe I'm paranoid, but to me, when folks walk half a mile from their camera backpack lying open on the ground with other photographers lurking about while they chase a shot down the road, it seems like asking for trouble. Keep an eye on your stuff, even when you're out in the middle of nowhere.

> **tip** Get a good insurance policy for your camera equipment. You may be able to insure your gear under your homeowner's or renter's policy; there are also insurance companies that offer specialized policies for photographers.

ABOUT THIS PHOTO *Image of Washington Gulch, Utah (ISO 200, f/11, 1/8 sec. with a Canon EF 16-35mm lens).*

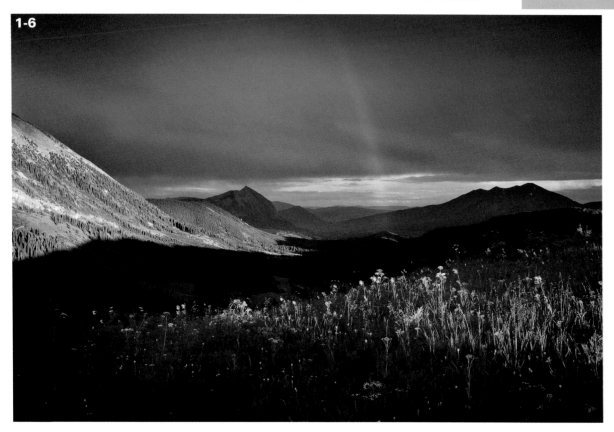

1-6

LOCATION SCOUTING

The best nature photographs almost always involve some preparation. Basic research like knowing where to go, what the sun and weather will do, potential hazards, and other environmental considerations goes a long way toward giving you the ideal set of circumstances in which to photograph.

The more you know about a place, the better. Location scouting involves visiting a place, looking around, and considering the photographic possibilities — at a time when you're not intent on getting a shot.

Many of the best nature photographs in history resulted after the photographer revisited a place many times. Even the familiar city park down the street can use some scouting from time to time. You never know when you'll discover something new.

ONLINE RESEARCH

The Internet is the nature photographer's best friend. Start by doing basic searches using the names of locations (or specific subject matter) that you're interested in photographing. Seeing photos that other people made of a location can

really spark your enthusiasm and get your creative juices flowing. The photo sharing site Flickr is great for this.

Google Maps and Google Earth are excellent, free resources for getting the lay of the land. In the United States, the National Park Service and Bureau of Land Management (BLM) also provide very good maps in a variety of formats. Make a list or mark spots on the map that you want to consider as shooting locations. You'll start to get an idea of the time and logistics required to get from place to place. This is the first step in putting together a travel itinerary.

Once you have a general idea of the photographic potential of a place, start digging deeper. Learn about the flora and fauna (plants and animals) found in the area, such as the redwood trees and rhododendron flowers in 1-7. Research climate history and weather patterns. Look up sunrise and sunset times, and moon phases. Ask friends and colleagues for advice. Participate in nature photography forums and blogs (some of the best of which are listed in the Appendix).

Remember, a great photograph doesn't happen by accident. In nature photography, the more you know about a place the better chance you have of getting the images you want.

If you have a GPS and can get coordinates from other people, your job scouting a location becomes much easier, especially at places where you've never been or that are hard to find even when it's not your first time there (see 1-8).

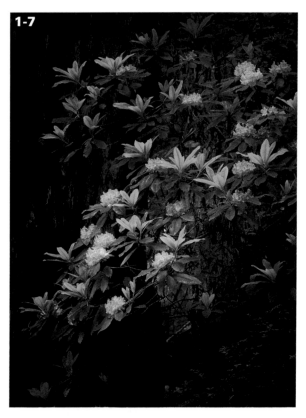

1-7

ON LOCATION

After doing your online research, it's time to get out to the location to find out what's really happening. During my photo trips throughout each year, at least 50 percent of my time in the field is spent scouting. There is no substitute for seeing a place for yourself, walking (or driving) around, and getting your thoughts together. If you can, visit potential locations at different times of day to get an idea of the scene under various lighting conditions.

ABOUT THIS PHOTO *Taking this image of Whahariki Beach in New Zealand required a two-mile hike in the pre-dawn darkness. This location might have been impossible to find without GPS (ISO 250, f/20, 0.6 sec. with a Canon EF 24-105mm lens).*

1-8

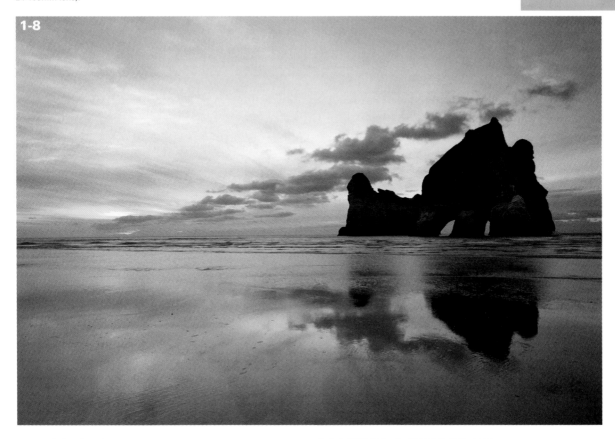

MAKING A TRIP PLAN

Create a nature photography trip plan. This doesn't have to be your trip of a lifetime to a distant, exotic place; a trip to the local botanic gardens will do just fine. Either way, choose a location that inspires you enough to do some real research and planning, and ultimately, shooting. Following are a few suggestions to get you started:

- Do some research online.

- Ask other people about the location you're considering.

- Jot down some notes.

- Previsualize and list the kinds of photos you want to make.

(P) *x-ref* Location scouting is an integral component of the previsualization and revisualization techniques covered in Chapter 2.

KEEPING NOTES

While doing your online research and scouting, keep good notes. Print out Web pages, keep a notebook with you, or use the audio recording app on a smartphone. Whatever it takes, keep yourself armed with good information.

While you're out shooting, it's a good idea to carry a notebook or index cards to keep notes as you go.

Assignment

Nature in Your Neighborhood

Nature is all around you. Find a spot in your backyard or in a local park to start thinking about nature photography and what it means to you. What subjects do you find most interesting? What kinds of pictures inspire you the most? Do you have a preference for color or black and white? Wide-angle or close-up? This is your chance to personalize your nature photography and understand what really motivates you. Your photos will immediately improve.

With a simple agenda in hand, spend a few hours making nature photographs in an easy-to-reach, nearby location. Where can you easily find sources of bountiful subject matter, with minimal effort? Parks, zoos, botanic gardens, and aquariums are great places to start practicing nature photography with minimal travel effort.

For this assignment, I went into the pine forest that surrounds my home in the Colorado mountains and captured this image of wildflowers, kinnikinnick, and grasses backlit by the late-afternoon sun. I used ISO 400, f/9.5, and 1/180 sec. with a Canon EF 70-300mm lens. During my first years studying photography, I photographed around my home extensively. You may find this less than inspiring at times, but you can practice composition, lighting, exposure, and many other photographic skills right where you are. Later in the book you learn techniques for seeing with new eyes even in the most familiar places.

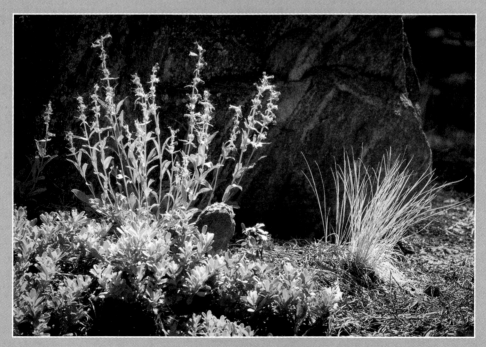

Remember to visit www.pwassignments.com after you complete the assignment and share your favorite photo! It's a community of enthusiastic photographers and a great place to view what other readers have created. You can also post comments, read encouraging suggestions, and get feedback.

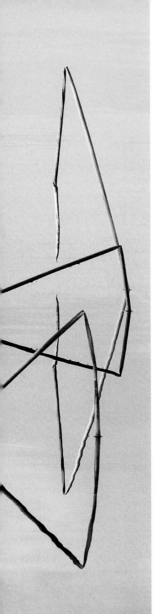

Nature photography is first and foremost about seeing. Your challenge is to learn to see more effectively with your own eyes and also learn to see like the camera does. As you work on your nature photography, remind yourself that developing your visual skills is the most important part of making pictures that convey your intentions. Fortunately, there are proven methods for developing your visual abilities.

In this chapter you learn about how human vision differs from the camera's view. You also learn some techniques for improving your ability to see the natural world and for developing "fresh eyes" to see familiar places in entirely new ways. With these new skills you'll find that in nature great pictures can be made anytime, anywhere.

ABOUT THIS PHOTO *Image of Tuscany, Italy, shows the approximate shape of normal human vision (ISO 100, f/18, 1/6 sec. with a Canon EF 28-135mm IS lens). To the human eye the central part of the scene is in sharp focus and the outer edges become indistinct; I simulated this effect in Photoshop by creating a rounded box and blurring the outer edges.*

2-1

HUMAN VISION AND PERCEPTION

The first thing to consider is how human vision and perception work. Most people have two eyes situated side by side; this simple physiological fact establishes the initial conditions for how your vision operates. Using two eyes allows you to perceive depth and dimension between objects near and far.

The placement of your eyes also results in a naturally horizontal orientation for your field of vision. In fact, the normal human field of vision is essentially a horizontal ellipse, with the outside edges and corners (*peripheral vision*) not being as clearly defined as the center, as shown in 2-1. This fact helps explain why the most comfortable orientation for a landscape photograph is horizontal — it's consistent with how you see the world.

Taking the signals from your eyes, your brain completes the picture in your mind, forming your total comprehension of what you're seeing. Most people generally see the world in the same way and vision is something you usually take for granted. However, there are many possible variations.

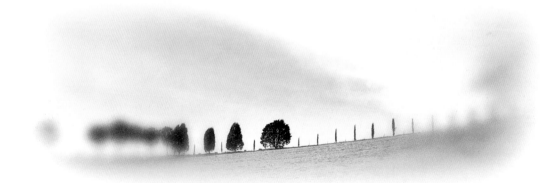

Conditions like color blindness and near- or far-sightedness affect many people. Some people lack the brain function that conveys depth — these people see shadows as solid objects. (Imagine walking on a sidewalk and needing to step around shadows because they appear to be solid objects impeding your path.)

Your individual life experiences, preconceptions, and personal preferences also affect the way you see things. Over time, people become conditioned to expect certain things and to ignore others. This response is highly subjective and along with physical variations can have a significant effect on how a viewer perceives your photo. Some people immediately notice certain things that other people do not.

THE SEQUENCE OF SEEING

Whether looking at the real world or a photograph, you will notice the brightest (or "lightest") objects first, followed by darker ones. (The reverse is photos that are mostly light, with a dark center of interest, in which case the condition is opposite.) Photo 2-2 clearly shows this — surrounded by darker, orange rock, the bright, elliptical window attracts immediate attention.

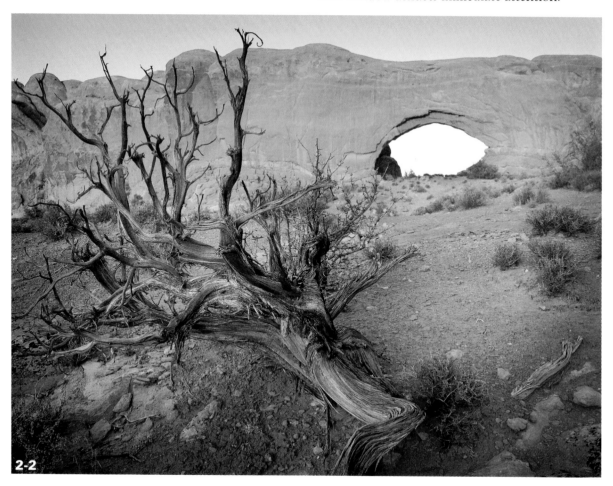

2-2

ABOUT THIS PHOTO *Image of North Window, Arches National Park, Utah (ISO 400, f/7.1, 1/30 sec. with a Canon EF 28-135mm IS lens).*

This *tonal* response has developed in human physiology over millennia — you can derive a lot of visual information from brightly lit areas because you can see detail and variation between objects. To your human eyes, darker areas simply don't contain as much information.

After the initial response to lights and darks you will notice any *patterns* present in an image. Patterns are created by repeating instances of similar objects (see 2-3). A pattern communicates order and structure and has a significant impact in a photograph.

Next, you see sharp, clearly detailed objects. This again illustrates that your brain is seeking information from your visual input. Sharply focused elements in a photograph attract the viewer's attention more than those that are blurry and nondescript. In 2-4, the grass in the foreground is clearly defined from the background, even though both share the same tones and colors. Your eye naturally goes to the crisp edges on the sharply focused grass.

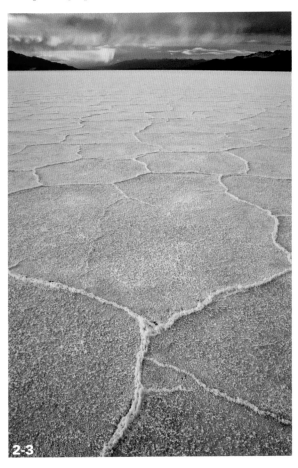

ABOUT THIS PHOTO *Image of Badwater, Death Valley, California (ISO 250, f/22, 1/5 sec. with a Tamron 18-200mm XR Di lens).*

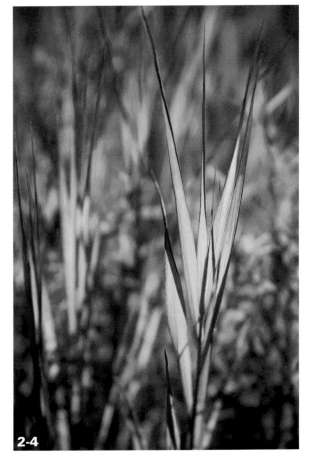

ABOUT THIS PHOTO *Image of autumn grasses (ISO 200, f/5.6, 1/200 sec. with a Canon EF 28-135mm IS lens).*

When you combine these factors, you can understand how the physical aspect of visual perception affects the experience of viewing a photograph. The goal of the picture is to engage the viewer. Your job as a photographer is to make creative decisions that will guide the viewer's eye throughout the image using the fundamentals of human vision. Developing your photography means learning to see *more* and to see *better*.

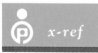

x-ref
Tones, patterns, and sharp/blurry relationships are discussed in detail in Chapter 4.

SEEING LIKE THE CAMERA SEES

As you've learned, one of the major challenges in producing good nature photography is that a camera does not see like you do. You can learn to see like the camera without looking through the viewfinder and even when you don't have a camera with you.

The biggest factor is that a typical camera has just one lens, focused on one area of capture. With one lens, the camera can't possibly provide the same depth perception as you see with two eyes.

Thus, a conventional photograph is inherently two-dimensional. Whether viewing a photo as a print or on a computer display, a photograph only has width and height — and no physical depth. You need to apply some photographic trickery to convey depth and dimension. You learn how to do this in Chapter 4, but for now, you can begin this process by understanding how the camera sees.

The easiest way to begin seeing like the camera is to simply cover or close one eye. (You may find that one eye is easier to close than the other.) Try this, and notice how you immediately lose depth

perception. I use this technique frequently when evaluating subject matter and possible compositions when preparing to make a picture.

After closing one eye, the second trick you can use is squinting the remaining open eye until it's almost shut. This decreases tonal perception, reduces detail, and leaves only the strongest elements visible.

Finally, with some practice using your eye muscles, you can defocus your open eye to blur the scene in front of you and reduce detail further. This trick is especially helpful to see potential compositions and the interaction of elements within the frame.

With one eye closed and the other squinted and defocused, what remain are only the most basic, essential visual clues. This is the closest you can get to physically seeing like the camera.

x-ref
On a full-frame dSLR, a *normal focal length* lens is 50mm. This focal length is called "normal" because it's roughly equivalent to the human field of vision. Lenses and focal lengths are discussed in Chapter 5.

tip
Most people have a *dominant eye*; that is, one eye whose signals register most strongly with the brain. If you're interested in finding out which of your eyes is dominant, you can find more information online. Generally speaking, if you close one eye you'll naturally leave your dominant eye open; this is an easy test to determine your dominant eye. You may also find that you more naturally prefer your dominant eye when looking through the viewfinder. However, some people (including me) will find there is no obvious distinction between the dominant and weak eyes. I have to remind myself to look with my other eye; sometimes I see things more clearly or easily when I switch between eyes. This is similar to the differentiation between left-brain/right-brain activity.

LEARNING TO SEE

You may have been told that you have a "good eye." Though it may be true, you might be surprised at how much better you can learn to see. Starting out, you won't see things as well as you will with some years of practice — an experienced photographer sees more things and sees those things more clearly.

This doesn't necessarily mean seeing more clearly in terms of sharpness and focus, but in acknowledgment and comprehension. Learning to see is training your brain, not your eyes. And even photographers with decades of experience can still discover new ways of seeing. Learning to see is an ongoing, never-ending process.

Of course, some improvement in seeing can occur naturally as you work on your photography. But with conscious effort, the process of developing your visual skills can be controlled and accelerated to provide better results in less time.

One of the biggest challenges for all nature photographers is seeing what's really there. When you observe a scene, your brain fills in the gaps automatically, using your past experiences. So you might see things that aren't there, or not see something that is there. You should practice seeing without applying your own personal bias and without assuming anything. Start seeing your environment in terms of light and shadow, lines and shapes, color and texture.

You need to be able to look at the big picture and recognize the creative potential it holds and then find the individual elements within the scene that will provide the strongest building blocks for a composition.

SCANNING THE ENVIRONMENT

When you're on location preparing to make pictures, begin by looking all around you. Let your eyes roam freely around the environment without making judgments or being influenced by preconceived notions. Remember, you're just taking it all in. The time for decisions will come soon.

As you scan the environment, begin to observe the direction of light and the presence of shadows. This is an example of contrast: light versus dark. As is covered in later chapters, the effective use of light and shadow is essential to making compelling nature photographs.

Also look for contrasts of other kinds: big versus small, smooth versus textured, or bright colors versus dull colors. As you scan, be sure to pay attention to anything that seems to tug at your eye.

FOCUSING YOUR ATTENTION

The process of scanning for contrasts and areas of visual interest naturally leads you to things that beg for a closer look. This is where photography gets exciting: Something profound and unexplainable happens in the mind of a photographer immersed in the joy of discovery.

When you find something that looks interesting, notice how your eyes immediately attain focus on that object and how the rest of the scene fades into the blurriness of peripheral vision (see 2-5). Also notice how your eyes and brain are working together. You may actually feel your eye muscles flexing. Being aware of these physical processes is very helpful in developing your visual skills.

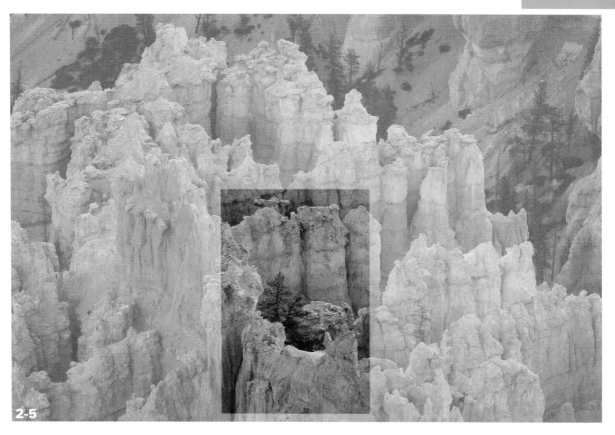

2-5

ABOUT THIS PHOTO *This image of Bryce Canyon, Utah illustrates how the photographer's eyes focus on a particular part of the scene and the rest of it fades into the blurriness of peripheral vision.*

SUPERIMPOSING THE FRAME

As you scan a scene and continually narrow and widen your focus, imagine a frame placed around different areas within the scene. You've undoubtedly seen photographers and filmmakers use the old trick of putting their two hands in front of them with their index fingers and thumbs forming a rectangle to establish a framed area.

You can use the two-hand method or just extend your arm with your index finger outstretched and "draw" the imaginary frame edges around where you are visualizing a potential picture. This act helps you begin to visualize the edges of the frame in your mind.

You can also learn to do this without using your fingers. All it requires is for you to draw the frame edges using your mind's eye.

Horizontal? Vertical? Square? Where should the frame edges be placed for the best composition?

The idea is to learn to see the many pictures possible without needing to look through the camera, as shown in 2-6. After practicing superimposing an invisible frame on the world for just a short time you'll be able to see compositions all around you much more easily.

These simple but powerful techniques can go a long way to helping you previsualize what parts of a scene could look like when photographed, even when you don't have a camera with you. Practice frequently and your visual skills will begin to be honed.

LOOKING ALL AROUND YOU

A common problem among nature photographers is allowing the act of focusing to completely take over, turning into tunnel vision. When you see something interesting, you naturally want to fix your gaze and study it, allowing everything else to recede into the periphery. Learn to break the spell. The most obvious thing that catches your attention will not necessarily make the most unique, compelling photograph.

In particular, I've seen many photographers on location become so entranced by the most obvious part of the scene that they don't notice as something even more amazing is happening behind them.

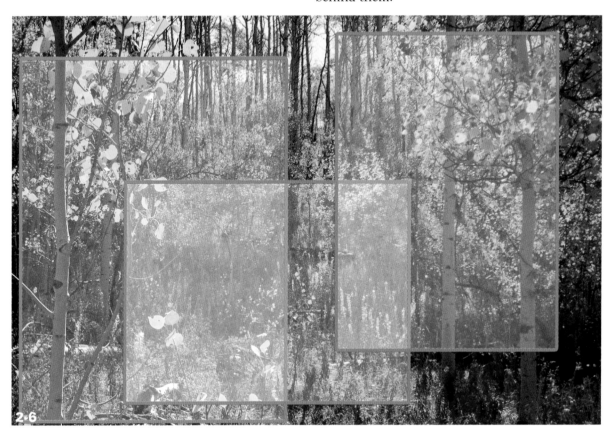

ABOUT THIS PHOTO *On this image of fall colors in Jackson Hole, Wyoming, I drew the frame edges you might consider as you visualize a potential picture.*

Periodically remind yourself to stop and look around. The best picture could be behind you, at your feet, or even directly above you. Photos 2-7 and 2-8 demonstrate this concept. I was photographing the sunset on the South Island in New Zealand, with most of my attention focused on the interplay of the ocean waves, rocks, and glowing light, as shown in 2-7. I periodically looked all around me, and at one point was rewarded with the double rainbow shown in 2-8, which only lasted for a few moments.

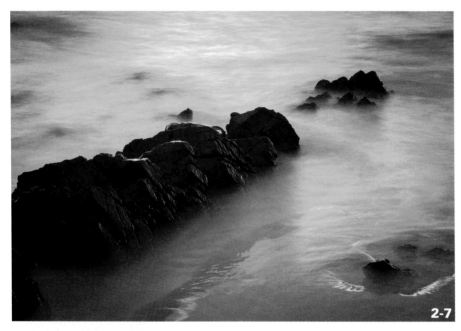

2-7

ABOUT THESE PHOTOS
Images of Kaka Beach, New Zealand (2-7 taken at ISO 50, f/20, 10 seconds; 2-8 taken at ISO 100, f/16, 1.3 seconds; both with a Canon EF 24-105mm f/4 L lens).

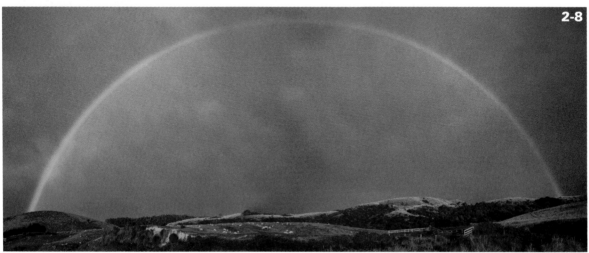

2-8

PREVISUALIZATION OFF LOCATION

Most of the work of a photographer happens long before the moment the shutter is pressed. *Previsualization* is when you imagine ahead of time what something will look like without actually being there, or visualize how it might look under different conditions. If you can previsualize the photographs you want to make, you can also figure out ahead of time how to do it. Some of the most successful pictures of nature have been made after the photographer previsualized the images and then produced them by being in the right place at the right time or by affecting the conditions to influence the outcome (see 2-9).

Though you must be able to respond quickly and naturally to photographic opportunities and allow the subject matter to "speak to you," practicing previsualization helps you better see what's actually there. It hones your perception by strengthening your brain's ability to generate and process visual information.

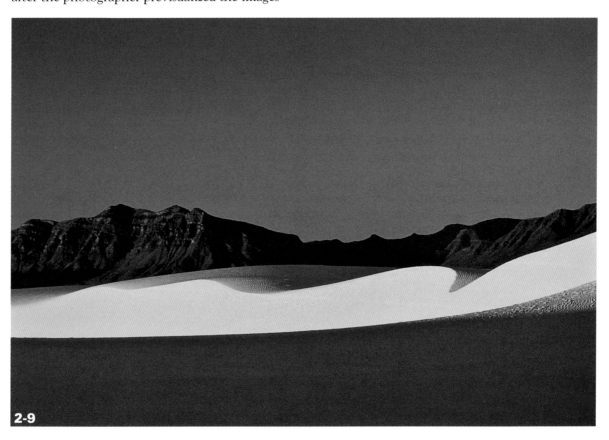

2-9

ABOUT THIS PHOTO *Image of White Sands, New Mexico (ISO 100, f/8, 1/30 sec. with a Canon EF 28-135mm IS lens). I previsualized this photograph months before I arrived at the location. I knew I wanted a gently curving dune face brightly lit by the first light of sunrise, set against distant mountains. On location, I scouted the afternoon before, and also on the morning of the shoot prior to sunrise, to find the best possible position to make the photograph I had envisioned much earlier.*

Most importantly, in nature photography — with so many variables out of your control — if you don't plan your shots in advance you may become frustrated working on location.

You can practice previsualization at any time. Ask questions that inspire your imagination. How is the view from the top of that mountain? What if you went around to the other side? What if you lay down on the ground? What if that cloud covers the sun? What would this place look like covered in snow, or at night?

note

Previsualization is often controversial — some photographic masters swear by it while others insist there really is no such thing. Many highly respected photographers have stated that they don't find pictures, the pictures find them. These photographers try not to influence the creative process before they're ready to make the photographs.

The extent to which you can preconceive something is directly related to your personal experience. Of course, some people will be more predisposed to this ability than others. But like seeing, you can develop this skill. With practice, you can start imagining the photographs you want to make and then bring them into reality.

If you find it's a struggle to imagine something other than what you're looking at, for now, I encourage you to be willing to pretend. Stretch your imagination. Even if you've never seen something before, just imagine it as you wish. You don't need to stay rooted in rigid, logical thinking. Nature photography is a creative act and your mind has infinite bounds — push them!

In particular, other photographers' images can have a profound effect on your previsualizing process. Seeing what someone else did can give

you ideas about how you would do it. Here's a simple exercise to help you begin to previsualize photographs:

1. **Think of a location in nature that you find intriguing.** It can be anywhere.

2. **Go online and search Flickr.com for photos of that place.**

3. **Spend 15-20 minutes looking at photos of your location.**

4. **With each photo you examine, think of how the photographer set up the shot.** Visualize where the camera must have been placed. Get a general sense of what it must have been like to be there at that moment. Try to be as specific as you can.

5. **Still imagining being on location, picture yourself moving the camera to make different shots.** What kinds of compositions could you come up with? What's happening with the light? What do you imagine you would see if you looked behind you?

caution

Reproducing other photographers' shots can be a good way to learn the craft of photography, but don't get stuck in the rut of always trying to exactly re-create someone else's work.

PREVISUALIZATION ON LOCATION

After you imagine the photographs you want to make and arrive at the shooting location, it's time to rein in your mind back to reality. The fact is that you can't change nature; what's there is there. The light, the weather, and the conditions of the flora and fauna are beyond your control.

So the next key skill to learn is to *revisualize* your photographs on location. After you see in your mind's eye what you think it will look like and

what pictures you want to make, when you're at the scene and ready to set up for photographing, you need to revisualize what's actually possible. This really is just another round of previsualizing; however, this is previsualizing with some actual "on-the-ground" information.

Be receptive to what's provided to you. Don't get caught up in wishing something would have been this way or that. What matters is the reality of the situation and your response to it. Remember that good pictures can be made under any and all circumstances.

Previsualizing and revisualizing are constant, never-ending processes. You imagine what might be, you see what is, then you decide how to make a photograph.

I previsualized image 2-10 earlier in the day and then revisualized when I arrived on location. I initially approached this cluster of rhododendrons from the other side, which was mostly in shade with the flowers blocked from my view. I envisioned the flowers, the moss, and the curve of the branch in the composition I wanted to make. It took approximately 15 minutes for me to work my way through the thick brush to the ideal location for the picture I was looking for. (On foggy and overcast days the light doesn't change quickly, so you can take your time to work the shots.)

ANTICIPATION

In nature, conditions can change rapidly. Though it's essential to remain aware and present in the moment, anticipating what's likely to happen next can improve your photography immensely. Keeping an eye on the clouds, watching the light change, and observing the behavior of wild animals helps you decide how to respond quickly so you can capture the magic shot.

ABOUT THIS PHOTO *Image of Ladybird Johnson Grove, California (ISO 320, f/18, 1/4 sec. with a Canon EF 28-135mm IS lens).*

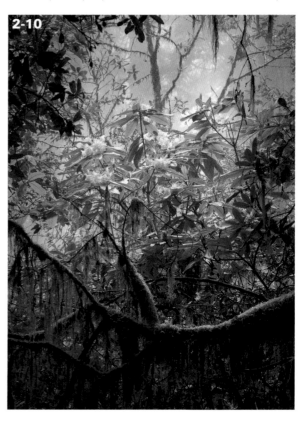

2-10

To photograph the images shown in 2-11 and 2-12, I previsualized and revisualized my ideal shot many times both before arriving and on location. From my Internet research I knew that the full moon would be rising just as the sun was setting. I wanted to make a picture with the full moon rising large behind a yucca plant.

As the afternoon waned, I was searching to find a spot to make my composition. When I found the right yucca plants, I set up my tripod and made many photographs before and during the moonrise. For each exposure I adjusted the composition slightly, working little by little toward my ideal setup as the moon continued to rise.

2-11 shows one of the early shots just after moonrise, and 2-12 is the final image from the sequence. There were 13 frames between these two images.

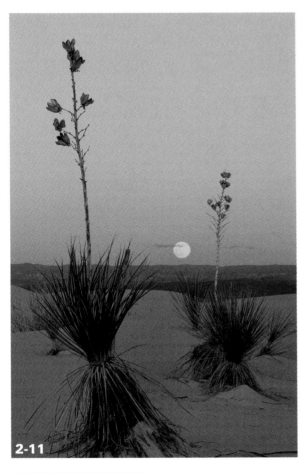

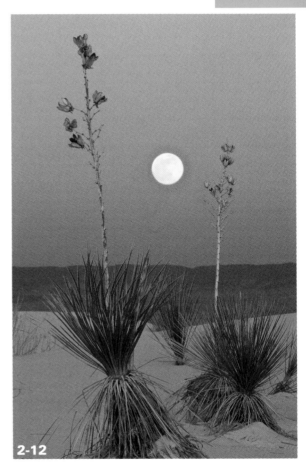

ABOUT THESE PHOTOS *Images of White Sands, New Mexico (2-11 at ISO 200, f/32, 1/5 sec.; 2-12 at ISO 125, f/32, 1 sec., both images with a Canon EF 100-400mm L lens).*

REGAINING FRESH EYES

There will be times when you can no longer accurately see what's in front of you. This occurs from your own overexposure to the same scene or subject matter. The longer you look at something, the less effectively you see it. This is based on physiology: The neurons in your brain become "numb" and deadened to further stimulus when they are exposed to the same information for lengthy periods of time. This actually applies to all your senses, but in nature photography you have to deal with numbing of your visual sense.

There is an easy remedy. The following exercise is adapted from one taught by the great photographic artist John Paul Caponigro. You can do this any time you suspect your photographic vision has become impaired from overexposure to a place:

1. **Choose a place outdoors that you see on a frequent basis — someplace you find boring.**

2. **Determine a time when you can sit by yourself undisturbed in this place for 10-15 minutes.**

31

3. **Have a pen and paper with you.** A timed alarm is helpful, too.

4. **Sit or lie down and get comfortable.** Your body should be in at least partial contact with the ground and other things around you, such as a large rock or tree, so you can use your sense of touch to engage the environment without sight.

5. **After getting comfortable, take a deep breath and close your eyes.**

6. **Sit with your eyes closed for at least 5 minutes.**

7. **During this time with your eyes closed, focus all your attention on your other senses.** Hear the sound of the leaves rustling in the trees. Feel the blades of grass between your fingers. Smell the fresh aromas of spring. Keep your eyes closed!

8. **After the allotted time has passed, open your eyes.** Take a moment to soak in the experience, and then jot down some notes about the things you noticed when you first opened your eyes. These might make great photographs.

tip If you don't have time to sit and wait for an extended period of time, simply face the direction of the key area of interest in the scene and close your eyes for just a few moments. When you open them, pay close attention to the first place your eyes go. These objects can often create the strongest compositional elements for your photographs.

WHAT MAKES A COMPELLING NATURE PHOTOGRAPH?

A good nature photograph is both visually appealing and intellectually stimulating. You must engage the viewer. One way to do this is by including variety within the frame (you learn more about this in Chapter 4). Of course, nature offers infinite variety, and often the challenge is to make sense of the visual chaos.

You will encounter many situations where you sense there's a good photo "somewhere in there" but can't quite make it out. Take the time to find it; don't just grab a couple of half-hearted shots and walk away, and don't assume that the most obvious picture is the best one. Your most successful photos will come from spending quality time at a location and continuing to delve deeper into the subject matter.

So how do you know if a subject or scene is even worth the trouble of delving deeper? Surely, there are times when the situation may not be worth the effort. These criteria can help:

- Strong match between the subject and your intention for the picture

- Appropriate light for the subject and subject matter

- Many possible compositions

- Equipment available to make the shots you've previsualized

- Anticipation of what might happen next that would affect the appearance of the scene

If these criteria aren't met to your satisfaction, it might be best to move on to another location.

As you observe (and photograph) a scene, look for triggers to tip you off. If you find part of the scene has especially nice light, concentrate on that for a while. If a pattern of lichen on a rock appears particularly interesting, focus on that. See how you can combine and juxtapose interesting elements.

> **tip** Don't try to force a picture to be made. Instead, *allow* it to happen through your natural interchange with the environment.

Nature photography is highly personal and subjective — what resonates with one person may not with another. Make the photos that resonate with your own personality.

How will you know when you have "the shot"? Primarily, this comes from seeing your response to the scene effectively expressed in the picture. Composition also is key. You will encounter many situations where you spend hours at a location making dozens of very similar photos, each a little more refined than the one before. In these cases, the last one you make will typically be the "champion" shot, and you'll know when you have it.

> **x-ref** Chapter 4 explains how to translate what you see into a strong composition using the principles of effective image design.

SUBJECT AND SUBJECT MATTER

"What's this a picture of?" is an essential question you must answer in order to make a good photograph. However, this question can be broken down into two distinct parts.

The *subject* of a photo is the theme, story, or message. What's it trying to say? This might be a noun, like "peace," "transition," or "energy," a verb like "moving," "waiting," or "standing," or an adjective like "quiet," "welcoming," or "red."

The *subject matter* is simply what you choose to include in the frame, such as a tree, a stream, or a bird.

One of the keys to making a strong image is to match the subject matter to the subject. For example, if the subject is peace and tranquility, you should avoid including lightning and storm clouds, crashing waves, or other potentially destructive phenomena. These imply something other than peace and tranquility — the subject and subject matter are incompatible.

Composition and camera settings also have an effect on the pairing of subject and subject matter. Imagine a stream flowing into a waterfall. Conveying peace and tranquility requires some careful decisions about the appearance of the water, and camera settings will make all the difference: with a fast shutter speed you could create an image that showed the rushing fury of tons of moving water tumbling over a cliff; with a slow shutter speed you can make the water appear soft and gentle, communicating peace and tranquility, as shown in 2-13.

You learn more about how to make these decisions in later chapters. For now, just remember that the subject and subject matter must be in harmony.

> **tip** It sometimes helps to think less about what you want to say and more about what the subject matter itself is saying. Change your perspective to that of the subject matter. Come up with descriptive adjectives to describe it. "Tall," "ancient," and "proud" might be used to describe a redwood tree. These descriptions will help you match subject with subject matter.

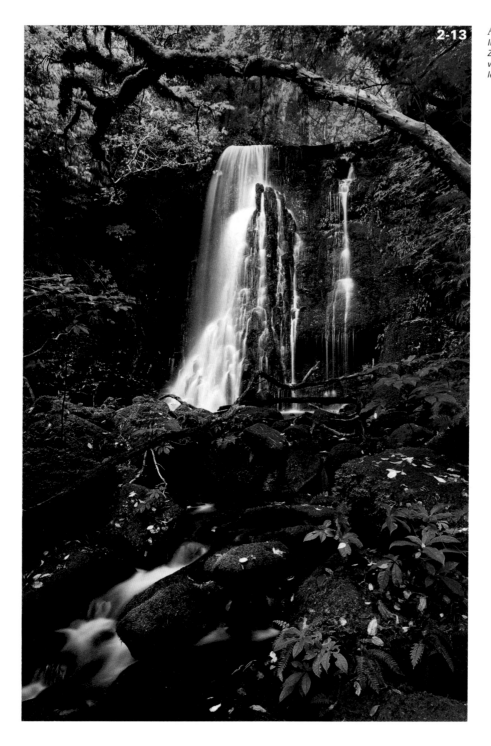

ABOUT THIS PHOTO
Image of Matai Falls, New Zealand (ISO 160, f/16, 6 sec. with a Canon EF 24-105mm f/4 L lens).

WHAT WILL YOU DO WITH THE PHOTOGRAPH? There are many possible outcomes and potential uses for a nature photograph. Fine-art prints, postcards, calendars, licensing as stock photography — the list goes on and on. The intended use of a photograph defines the criteria that it must meet and the ultimate value of any image is entirely based on the context in which it is viewed.

For example, if you want to sell large-format, fine-art prints of your work, you need to take into account different factors than if you're shooting stock. Large-format, fine-art prints require immediate impact and expert technical execution. With stock photography (work licensed for various commercial applications) the range of usable imagery is much wider. A photo that may not sell as fine art can be very successful as stock.

Being clear about the parameters in which your photo will be viewed (or used) helps you make the appropriate creative choices.

PEOPLE IN NATURE PICTURES

Many nature photographers prefer not to include human elements or evidence of human presence in their photos. A photograph of pure, unspoiled nature conveys themes that feel timeless, eternal, or untouched by man. This is the purest representation of nature in a photo and ensures that nature itself is the subject and the subject matter.

Certainly, some photos are made even stronger by the inclusion of a person, such as a hiker, kayaker, climber, or meditator (see 2-14); or a man-made thing, like a tractor, bridge, or wagon (see 2-15). In most cases, though, these photographs become something other than pure nature photography. Terms for photographic genres such as *adventure photography*, *travel photography*, or *agricultural photography* may be more appropriate.

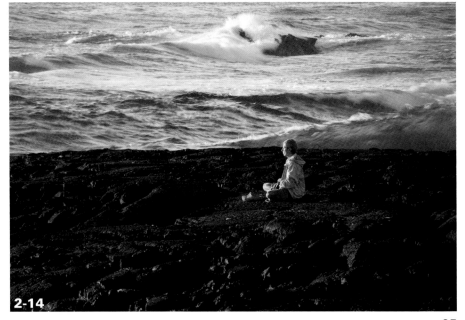

ABOUT THIS PHOTO
Image of woman at Punalu'u, Big Island, Hawaii (ISO 100, f/16, 1/15 sec. with a Tamron 18-200mm XR Di lens).

2-14

Most importantly, when you include other subject matter in a nature photograph, the emphasis nearly always shifts away from nature and onto the other subject matter. This is because your mind immediately creates a story in which the other element is interacting with nature. The person or manmade object becomes the focal point of the photograph.

Of course, there are exceptions to this principle, but for the purposes of working through this book, concentrate on photographs that do not include human or manmade elements or props.

2-15

ABOUT THIS PHOTO *Image of old wagon in a pasture taken at ISO 100, f/9.5, 1/125 sec. with a Canon EF 28-80mm lens.*

Assignment

See Nature with Your Camera Lens

Find a place where you can spend 45 minutes to one hour working in peace. This location should have interesting subject matter for you to work with. Make 20 distinctly different pictures of the same subject matter. If you're surrounded by forest, for example, don't shoot in all directions. Identify and isolate one very specific part of the scene, or one very specific object, and make all your exposures only of that. Pick one tree, one rock outcrop, or one bunch of wildflowers.

As you make your compositions, pay close attention to how you first see it with your eyes. Don't keep your eye in the viewfinder or on the LCD all the time. Notice the changes in how you see it with your eyes versus how the camera sees it. In particular, notice the *sequence of seeing* items discussed at the beginning of this chapter: bright objects first, then patterns, and then sharpness.

You should begin to understand that any scene or subject matter contains an infinite number of possible compositions. Remember, each of your photos should be distinctly different from one another. Post your first and last photos from the assignment on the Web site.

In my example for this assignment, I made 26 different compositions of pebbles in a small puddle on top of a large rock. This type of subject matter is great for practicing different ways of seeing because it stays in place while you work and offers strong, graphical elements for myriad compositions.

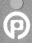 Remember to visit www.pwassignments.com after you complete the assignment and share your favorite photo! It's a community of enthusiastic photographers and a great place to view what other readers have created. You can also post comments, read encouraging suggestions, and get feedback.

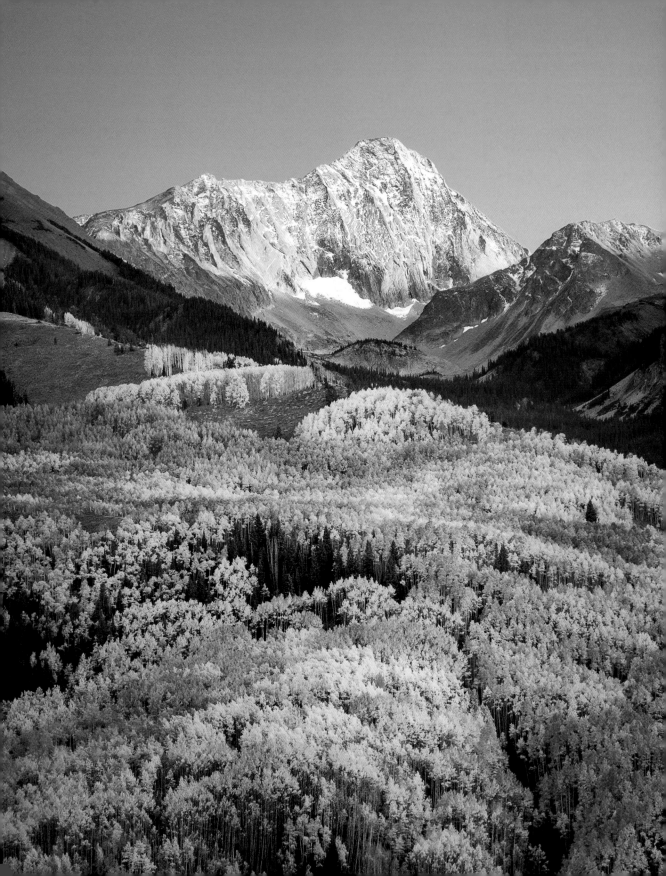

WORKING WITH NATURAL LIGHT

Light is fundamental to photography. In fact, the word *photography* is made of two Greek words essentially meaning "writing with light." To make good nature photographs, you should know about the properties of light, learn to read the light on a scene, and anticipate what the light might do next. Most importantly, you need to know when the current lighting conditions are not ideal for the subject matter. This chapter introduces the characteristics of light and explains how you can use this knowledge to your advantage when you're out shooting.

PROPERTIES OF LIGHT

Like other forms of physical matter, light has properties that have been discovered and subsequently better understood over centuries. Though you don't need to know all about physics to be a nature photographer, to make the best possible photographs you should learn as much as you can about how light works in the natural world and how it affects the way objects appear and pictures are captured by the camera. The continuing study of light is one of the most important aspects of nature photography.

You first need to know the basic properties of light. Following are descriptions of the most important lighting characteristics for the nature photographer.

DIRECTION

The direction of light on the landscape is the main consideration in photographing nature because it determines the appearance of highlights and shadows and influences how the shapes and forms of objects are rendered in the photo. The direction of the available light is the first thing to evaluate when setting up your shot.

The three basic directions are *front* light, *sidelight*, and *backlight*. These terms all refer to the direction of light as it appears *relative to the camera position*. Based on these three primary directions, you find conditions in nature photography that offer a combination of lighting directions, or relative degrees of variation among the three.

- **Front light.** An object or scene appears front lit when the light is striking the front of the object from your perspective. In other words, the light is coming from behind the camera, as shown in 3-1. Front light makes objects appear flat, because there is little or no shadow visible from your perspective — you're looking directly at the brightest highlights of the object. In most nature photography situations, this is the least appealing type of lighting, however, there are certainly situations where front light represents your subject matter in the most appealing way.

- **Sidelight.** With sidelight (see 3-2), the form, shape and dimension of an object become much more evident because there is a clear distinction between the lit side and the shaded side. Sidelight gives depth and dimension to a photograph, so generally speaking, it's the most workable and pleasing direction of light for nature photography.

- **Backlight.** When the light comes from behind the subject, the side that faces you is in shadow. This can produce what's known as *rim* light, where only the edges of the subject appear illuminated. Backlighting in nature photography often can produce very dramatic, otherworldly kinds of photographs, including silhouettes (see 3-3).

ABOUT THESE PHOTOS *Image 3-1 of autumn mountainside near Crested Butte, Colorado, shows front light (ISO 100, f/13, 1/30 sec. with a Canon EF 28-80mm lens). Image 3-2 of the Three Kings in Goblin Valley, Utah, shows sidelighting (ISO 200, f/10, 1/8 sec. with a Canon EF 28-135mm IS lens). Image 3-3 of Cholla Cactus Garden in Joshua Tree National Park, California, shows backlighting (ISO 400, f/10, 1/100 sec. with a Tamron 18-200mm XR Di lens).*

3-2

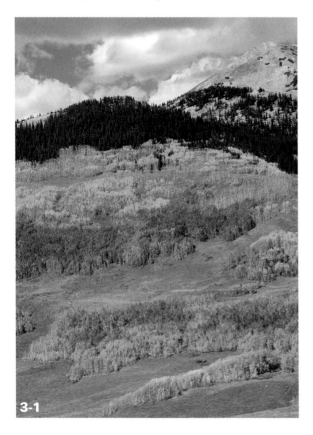

3-1

3-3

In some cases you will encounter light coming from what seems to be directly above the scene. If you evaluate the direction of shadows you can determine if it's actually front light or backlight.

On a cloudy day, the light often does not appear to be coming from a single direction; this type of *omnidirectional* light produces soft shadows or no shadows at all.

When shooting against backlight, you need to watch out for lens flare. Flare can occur when the source of light is in the frame, and the light comes directly through the front of the lens. The light rays refract and reflect inside the lens, as shown in 3-4. Use your lens hood and/or shift your position to reduce flare. (Dirty lens filters can also exaggerate flare.)

3-4

3-5

SIZE

The size of the light source determines the strength and edge definition of shadows: a small light source produces strong, hard-edged shadows; a large light source produces weak shadows with soft, feathered edges or no shadows at all.

The apparent size of the light source is entirely relative to its distance from the object. For example, the sun is a very small light source. Though the sun is physically very large, its distance from the Earth results in a very small size relative to how you see it.

To better understand this, consider the size in relation to the entire sky — it's tiny. On a clear day the sunlight produces very strong shadows. This is *specular* light; photographers often refer to it as *harsh* light because the shadows and highlights are so intense. For most natural subjects, direct, overhead sunlight is the least interesting and visually appealing type of light, as shown in 3-5. However, there are times when great photos can be made even under specular light.

3-6

ABOUT THIS PHOTO *This image of a waterfall and fall colors at Marcellina Mountain, Kebler Pass, Colorado, shows soft light (ISO 200, f/25, 1/4 sec. with a Canon EF 70-200mm f/4 L lens).*

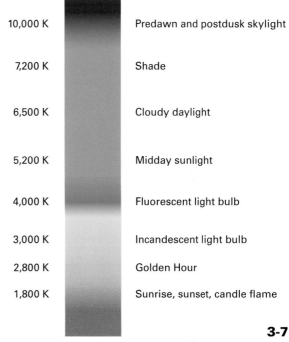

10,000 K	Predawn and postdusk skylight
7,200 K	Shade
6,500 K	Cloudy daylight
5,200 K	Midday sunlight
4,000 K	Fluorescent light bulb
3,000 K	Incandescent light bulb
2,800 K	Golden Hour
1,800 K	Sunrise, sunset, candle flame

3-7

ABOUT THIS FIGURE *The Kelvin scale illustrates the color and numeric temperatures of light in the visible spectrum. Numeric values are approximate and vary based on location and environmental conditions.*

On an overcast day, or even when the sun is just behind a small cloud, the light becomes very soft and *diffused*. With diffused light, shadows appear very light and soft or may not be visible at all. As a result, objects don't reveal a great deal of three-dimensional form. (Any light in which you can't see strong shadows or highlights is often referred to as *flat* light.) However, colors appear more vivid and saturated in soft light (see 3-6).

The term *quality* of light is often used to refer to the combined effects of direction, intensity, diffusion, color, and tonal value. The quality of light has a significant effect on the portrayal of subject matter and the mood of a photo.

> **tip** An overcast day is usually the best time to photograph flowers and waterfalls; these subjects typically don't depend on strong three-dimensional form to present their best photographic representations. Photographing waterfalls is discussed further in Chapter 7.

COLOR

The color of light illuminating an object determines how you see its colors and can significantly change its appearance. Light color is measured in *degrees Kelvin*. It may seem counterintuitive, but on the Kelvin scale, lower color temperatures are yellow-orange and are referred to as *warm* light and higher color temperatures are more blue and called *cool* light. The Kelvin scale is shown in 3-7.

One example is the early-morning or late-afternoon sunlight striking rocks on a cliff wall or high mountain peak — the rock takes on an orange glow, as shown in 3-8. Snow in predawn light or daytime shade is notably blue (as shown in 3-9) because it reflects the open sky. During the middle of the day, direct sunlight appears neutral, but is actually somewhat cool on the numeric scale (see 3-10).

Your eyes and brain work together to assess colors based on your past experience. For example, when you see snow in shade, you naturally perceive it as white because you "know" snow is white. However, to the camera it's really blue. A digital camera reads the color of light in a scene very literally and has controls for changing how the color of light is depicted in the digital capture. This is called *white balance* and is explained later in this chapter.

You can train yourself to see the colors of light and objects in a scene as your camera sees them; in many scenes you can identify both warm and cool light.

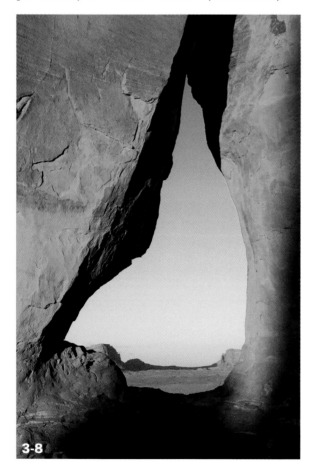

ABOUT THESE PHOTOS *Image 3-8 of Teardrop Arch, Monument Valley Tribal Park, Arizona (ISO 400, f/10, 1/80 sec. with a Canon EF 28-135mm IS lens). Image 3-9 of a mountainside near Cottonwood Pass, Colorado (ISO 250, f/5.6, 1/640 sec. with a Canon EF 75-300mm lens).*

3-10

ABOUT THIS PHOTO *The sunlight in this image of Joshua Tree National Park, California, appears neutral (ISO 320, f/13, 1/400 sec. with a Tamron 18-200mm XR Di lens).*

NATURAL LIGHT PHOTOGRAPHY

Natural subjects have more visual appeal when they are photographed in certain kinds of light. You need to know what is good light or not-so-good-light given a specific set of circumstances and you must match the subject matter with the right light. For example, a grand scenic photograph (covered in Chapter 6) might look absolutely spectacular in the early morning, but at any other time of day, the same landscape could appear dull and drab, lifeless and totally uninspiring — all depending on the light.

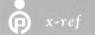

x-ref

As covered in Chapter 2, the most important part of previsualization is seeing the light and anticipating what will happen next, based on lighting conditions.

THE SUN AND CLOUDS

As a nature photographer you almost always deal with *natural* light. Nearly all natural light comes from the sun or a modified variation of sunlight. Even a cloudy day is lit by the sun. A landscape bathed in moonlight is indirectly lit by the sun. In rare cases, such as deep in a cave or under the

sea where animals glow with phosphorescence, you might encounter other forms of natural light. But in most cases, you'll be concerned with the effects of sunlight and its derivatives.

So by far, the biggest factor all nature photographers must contend with is the sun. Where is it in the sky? Is its light being affected by objects in the sky or on the ground? That great orb in the sky can be your greatest ally or your worst enemy depending on what you're trying to do. Learn the ways of the sun and your photographs will improve.

The sun is a pinpoint, spot light source resulting in hard shadows and very bright highlights. Clouds are a whole other story. Under cloud cover, the light is soft, diffused, and much weaker than in direct sun. When you're shooting under clouds, you're shooting under a diffused shadow; the cloud cover becomes a very large, soft light source.

There is a visible difference between shooting under open cloudy conditions than in the shade of some other large object. Under cloud cover, the "shade" is provided by water droplets in the clouds; there is a distinct quality to this light. It's diffused, but not necessarily colored by the fact that it's shade. It's soft but fairly neutral in color.

Yet in the shade of a tree or a mountain, the light is distinctly blue. Why? Because the light you see in "open shade" is coming directly from the clear blue sky. This is incredibly important! As you learn to see light and shadow and read the color temperatures of the light, you will begin to make critical decisions about your photographs based on the combined, overall qualities of light, which vary widely.

idea Most people don't perceive light; they see "things." Photographers see both light and its effect on things.

HOW LIGHT AFFECTS SUBJECT MATTER Light striking any material *absorbs, reflects,* or *transmits.* When light is absorbed, what you see is the color of the reflected light. If all colors are absorbed, you see black. If no colors are absorbed, you see white. In a reflection, you see a reproduction of the original light. A perfect reflection is extremely rare in nature; reflections are almost always influenced by some other factor. For example, a reflection of a sunny mountainside on the water of a calm lake is always somewhat darker than the actual scene. In nature, light is often transmitted through the material it encounters. *Refraction* bends the light waves so that what you see is distorted; the distortion you see at the bottom of a rippling lake is an example of this. *Diffraction* is a form of refraction where the light frequencies are visibly split into individual colors, resulting in rainbows.

In nature, these interactions between light and solid objects are almost never absolute. Every situation presents a combination of these properties. Even a seemingly simple subject like a calm mountain lake might present multiple light behaviors. The degree to which you (and the camera) perceive the light depends on where you're standing relative to the subject and the light source.

In practicing nature photography, you benefit greatly by learning to keenly observe how the light interacts with the material framed within the picture. You will undoubtedly find many situations in which you can see the various effects of light based on the material it illuminates.

CHANGES THROUGHOUT THE DAY

On a clear day before sunrise, the sky becomes widely illuminated. The light cast on the landscape is soft, blue, and not very bright. This is one of my favorite times to make photographs. In this predawn light, the surrounding landscape seems to glow. The light waves are literally bouncing around you in all directions (see 3-11).

THE EARTH'S SHADOW

When the sun is just below the horizon, turn around and look the opposite direction. Many times you will see the Earth's shadow visible in the sky opposite the rising sun. The shadow is literally cast on the atmosphere by the curvature of the earth blocking the sun. You will recognize the Earth's shadow as a distinct blue band.

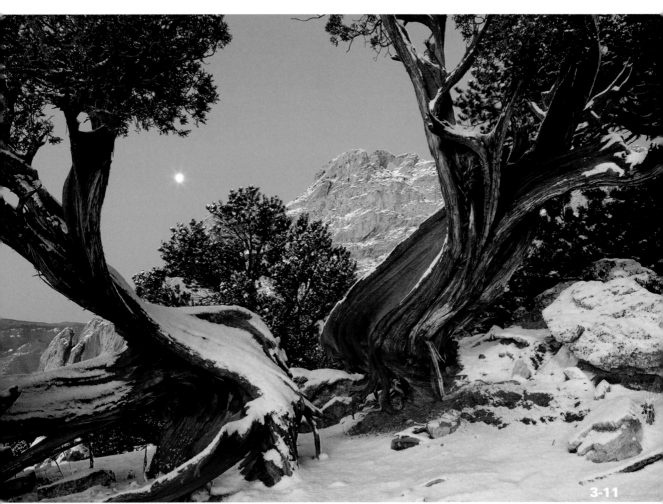

3-11

ABOUT THIS PHOTO *Image of Kissing Camels, juniper tree and full moon at Garden of the Gods, Colorado (ISO 200, f/16, 8 sec. with a Canon EF 24-105mm L lens).*

Above this blue band, the sky is often pink or a peachy-orange color. As the sun rises, the shadow dips lower toward the far horizon, and at the moment of daybreak the shadow is no longer visible. Photographs featuring the Earth's shadow can be extremely beautiful, as depicted in 3-12.

As soon as the sun peeks over the horizon, things change dramatically. Sometimes, you might feel like the show is over because the soft, beautiful light is gone. Other times, the best light is only beginning. This difference is based on the presence of clouds and the interaction of the sunlight with the surrounding environment.

If the sun rises unobstructed, be prepared for very warm light. During this *golden hour* or *magic hour* (which can actually be shorter or much longer than one hour) the entire landscape seems bathed in gold, as shown in 3-13. Nearly all surfaces take on the warm hue of these early rays. Rock formations, especially granite and sandstone, take on a distinctly red or orange hue. Of course, the light does not discriminate. A blue rock becomes green. The green needles of a pine tree become khaki. A yellow flower displays a super-saturated hue that becomes difficult to reproduce in print. Yet even during the golden hour, if you look in the shade you'll see light or shiny surfaces reflecting the bright blue light of the open sky.

Just a little while after sunrise, depending where you are on Earth, things again change significantly. You can literally watch as the light becomes cooler and highlights and shadows become stronger. As you shoot in the time after the golden hour, you recognize the moment when you notice the light's become harsh.

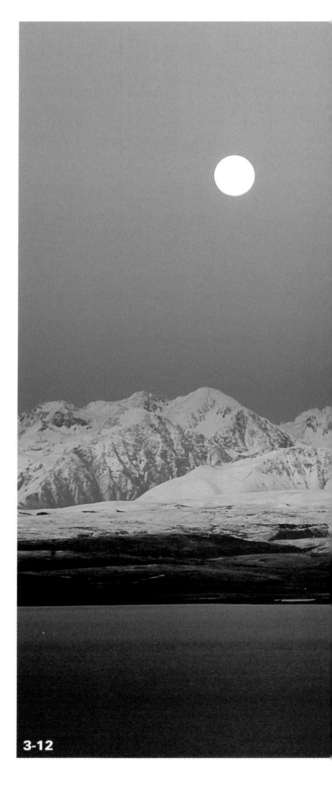

3-12

ABOUT THIS PHOTO *Image of Lake Tekapo, South Island, New Zealand, shows the Earth's shadow with the sunlight sky above (ISO 100, f/8, 1/13 sec. with a Canon EF 24-105mm L lens).*

ABOUT THIS PHOTO *Image of Bosque del Apache National Wildlife Refuge, New Mexico (ISO 200, f/11, 1/8 sec. with a Canon EF 28-135mm IS lens).*

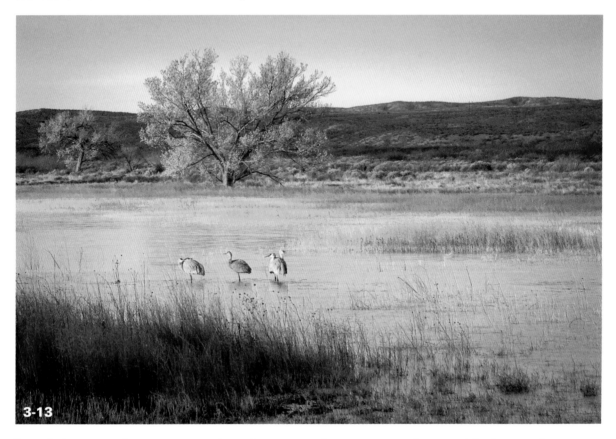

3-13

Basic lighting conditions continue throughout the day, notwithstanding weather conditions. After the sun rises above approximately 6-10 degrees over the horizon (based on your location), the light looks essentially the same throughout the day but the direction of shadows changes as the sun traverses the sky.

At this point, many photographers pack it in, at least until late afternoon, thinking that the golden hour is the only good time to make pictures. But remember, there's no such thing as bad light, only light that's more appropriate for certain subject matter. If you're clever and creative and you have the time and determination to keep shooting, you will find ample photographic opportunities throughout the day. Most significantly, you need to be concerned with

the presence or absence of shadows in the scene. On a sunny day, often the key to making nice images is finding some shade where you can work.

At the end of the day the light show is reversed: As the late afternoon turns to early evening, you have another chance to shoot the golden hour. After sunset, the cool, soft blue light returns. I often shoot long after sunset, until it's too dark to make any pictures. The main difference between the golden hours of sunrise and sunset is often the presence or absence of atmospheric haze. Depending on your environment, you may have fog or haze early, late, or not at all. Scouting locations to know how they look in the morning and evening helps you decide the best time for the photographs you want to make.

THE IMPORTANCE OF SHADOWS

During the middle part of a sunny day, your photographs will exhibit extremely strong shadows that may render as completely black in a photo. Depending on your creative intention, this isn't necessarily a bad thing, but for most photographers, hard, solid shadows create a significant challenge to producing an appealing image.

Because they can be so dark and hard-edged, shadows play a dominant role in a composition. Shadows attract lots of attention in any photo and you need to learn to identify their presence and deal with them according to your intentions. (This is discussed further in later chapters.) Photo 3-14 shows how shadows can create strong graphic shapes within the frame.

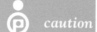

caution Solid black shadows can also create "black holes" that risk sucking the viewer in and can make it difficult for the eye to traverse the photograph.

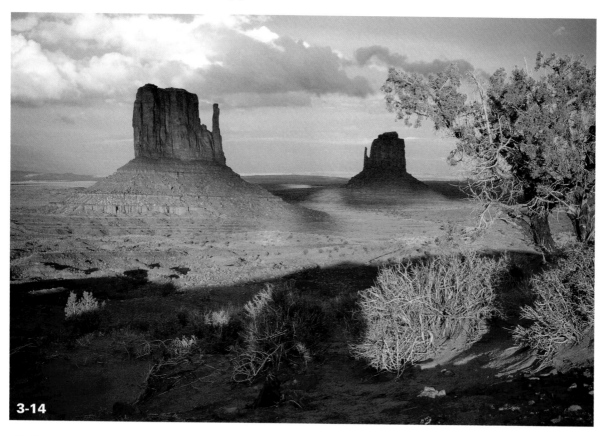

3-14

ABOUT THIS PHOTO *Image of Monument Valley Tribal Park, Arizona (ISO 250, f/22, 1/50 sec. with a Canon EF 17-40mm lens).*

SILHOUETTES

A *silhouette* is produced when the light source is behind the object, leaving the shape of the object visible and its interior solid black. Photos featuring silhouettes can be very dramatic and powerful.

3-15 and 3-16 show examples of silhouettes in nature.

In order for a silhouette to be produced, the subject matter must be backlit, with little or no light falling on the front of the object and

ABOUT THESE PHOTOS
Image 3-15 of cabbage tree at Lake Te Anau, South Island, New Zealand (ISO 250, f/22, 1 sec. with a Canon EF 24-105mm lens). Image 3-16 of Saguaro National Park, Arizona (ISO 250, f/36, 1/8 sec. with a Canon EF 100-400mm L lens).

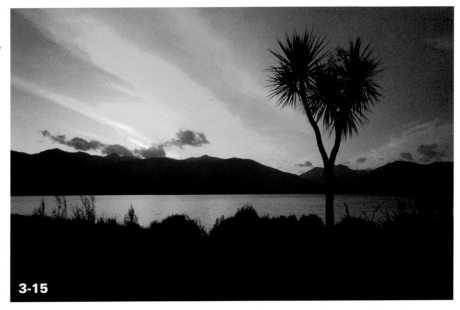

3-15

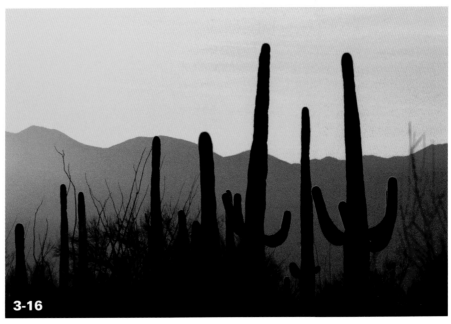

3-16

your exposure needs to be set so that the objects are rendered black or near-black. (This may not always be the case; the camera may try to lighten the scene to render more detail in dark areas.)

The most effective silhouette photographs feature an identifiable object set against the sky or other simple background with no distracting elements overlapping or interfering. Look for subject matter that has an interesting geometric shape that provides enough visual interest as a silhouette. For example, a craggy rock spire might make an interesting silhouette; a whole mountain likely would not.

READING THE LIGHT

Similar to the way you learned in Chapter 2 to see things as the camera sees them and for what they really look like, you can learn to *read the light*. Reading the light is how you perceive and evaluate what the light is doing to the subject matter. Take a look at 3-17 and try to answer the following questions:

- What is the main source of light? Are there multiple sources of light?

- Where in the sky is the sun? Where will it be in 15 minutes or one hour?

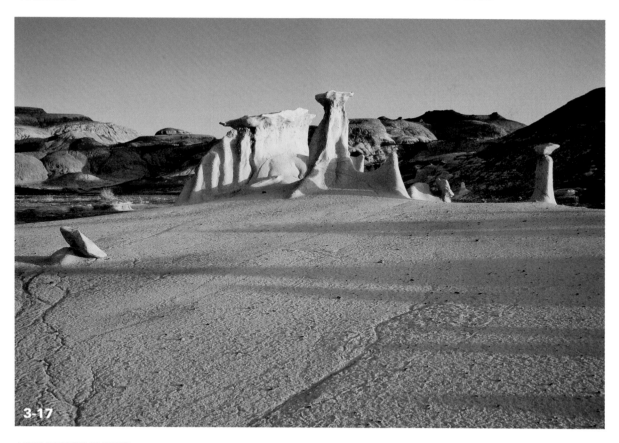

3-17

ABOUT THIS PHOTO *Image of Bisti Wilderness, New Mexico (ISO 100, f/20, 1/2 sec. with a Tamron 18-200mm XR Di lens). The light is specular (not diffused at all), coming from the right with a warm color. The strong sidelight is emphasizing the texture of the rock and sand. Over the next few minutes I'd anticipate the shadows to continue to get longer until the sun sets, at which point the light will turn soft and blue. With the sky clear, I wouldn't expect weather or clouds to affect the light.*

- What direction is the main light coming from?

- How strong and bright are the highlights? How strong and dark are the shadows?

- How is the light affecting color?

- How is the light affecting textures or patterns?

- What environmental conditions might affect the appearance of the light on the scene as time passes, such as changes in clouds or the direction of shadows?

MANIPULATING THE LIGHT

Although nature photography is nearly all about working with natural light, there are some situations in which manipulating available light or creating additional light can produce better photos. The following equipment can help you manipulate light:

- **Reflectors.** The use of small, portable reflectors is common to all kinds of outdoor photography. A reflector allows you to illuminate parts of a scene by bouncing the available light into areas that are shaded (see 3-18). Reflectors come in a wide range of sizes and colors.

- **Flash.** Sometimes adding a slight burst of light from a flash can provide the optimal exposure for a photo (see 3-19). This is particularly true for close-up photography, where you may need additional light just to get a sharp image.

- **Flashlights.** Light painting is a technique used at night or in very low light, where you "paint" objects with a flashlight to illuminate them during a long exposure.

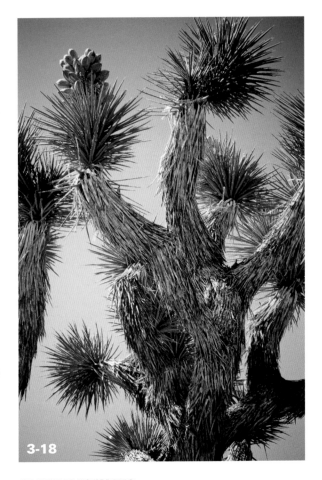

3-18

ABOUT THIS PHOTO *To make this image of a Joshua tree in California, I held a gold reflector underneath the tree to bounce sunlight up into the shadowed areas (ISO 320, f/13, 1/50 sec. with a Tamron 18-200mm XR Di lens).*

The most important part of using reflectors or flash in nature photography is making it look natural. Light modifiers and artificial sources are discussed in more detail in Chapters 5 and 7.

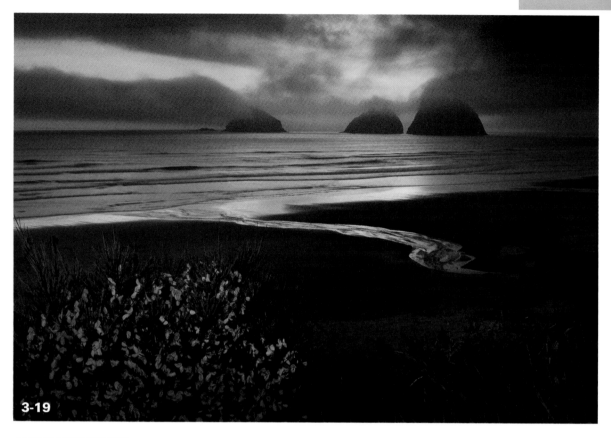

3-19

ABOUT THIS PHOTO *I used fill flash to light the flowers in the foreground of this image of the Oregon coast (ISO 200, f/20, 1.3 sec. with a Canon EF 24-105mm L lens). The flash was held off-camera using manual settings. I used a flash diffuser to soften the light. My intention was to use as much ambient (available) light as possible, and only slightly illuminate the flowers with the flash.*

DIGITAL EXPOSURE

When you press the shutter button to take a picture, a lot of things happen in the camera before the image is stored on the card. For a digital camera to make a picture, photons from incoming light waves are captured on the sensor and converted to electrical signals. More light results in a stronger electrical signal.

The signals are then processed by the camera's internal computer and recorded onto a storage device, typically CompactFlash (CF), Secure Digital (SD), or Memory Stick cards. These storage media are discussed in Chapter 5.

tip You should always try to get the capture as perfect in the camera as you can. Even if you plan to process the photos using the computer later, starting with the best possible capture makes the rest of the workflow much easier and produces the highest quality results.

EXPOSURE

The term *exposure* refers to the combined effect of the camera settings that produce the rendered image. Many camera settings have an effect on exposure. Depending on your creative intentions, a captured photo can be perfectly exposed, *overexposed* (brighter than the actual scene), or *underexposed* (darker than the actual scene), as shown in 3-20 through 3-22.

Like other aspects of photography, what is considered a perfect exposure (or an "ideal" exposure) is subjective and open to personal interpretation. After all, it's your art. If someone looks at your photo and thinks it's underexposed, it's possible he or she may be missing your creative intention. However, there are some long-established criteria for what would be considered a proper exposure of a good nature photograph, and these usually are based on a close representation of what the human eye would see in real life.

What's important in your photography is to deliberately manage your exposures so you can produce pictures you're happy with.

There are several factors involved in producing a controllable exposure; most of these can be calculated automatically by your camera. Your camera uses preprogrammed methods for determining exposure, and some cameras are better at this than others. And depending on the circumstances, in automatic mode your camera might make pictures that are overexposed, underexposed, or just right.

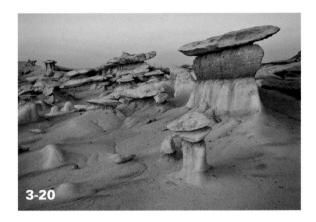

3-20

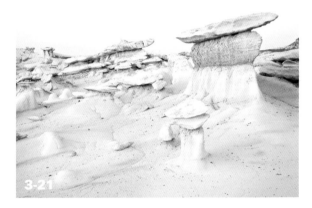

3-21

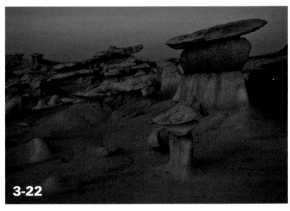

3-22

> **note** You can "bracket" your photos to capture a range of exposures; this is discussed in more detail in later chapters.

ABOUT THESE PHOTOS *Images of Bisti Wilderness, New Mexico, taken at ISO 100, f/18, 1/5 sec. (correct exposure), 1.3 sec. (overexposed), and 1/10 sec. (underexposed) with a Tamron 18-200mm XR Di lens.*

STOPS

All digital cameras provide controls that determine how much light is recorded by the imaging sensor. Your manipulation of the light is measured in *stops*.

A change of 1 stop equals either double the light or half the light, depending on which direction you're going. Twice as much light increases the exposure by 1 stop; half the light decreases it by 1 stop.

All cameras also allow the incoming light to be controlled by partial stops, such as 1/3 or 1/2 stop.

Stops of exposure can be changed in three ways: aperture, shutter speed, and ISO. Using different combinations of these settings, it's possible to produce the same exposure using different values for each setting. These are called *equivalent exposures* or just *equivalents*. An example is shown in Table 3-1; the settings in each row produce the same exposure. Later chapters demonstrate exposure in different situations and explain in detail the relationships between aperture, shutter, and ISO.

Table 3-1

Equivalent Exposures

ISO	Aperture	Shutter speed
100	f/8	1/125 sec.
100	f/11	1/60 sec.
200	f/8	1/250 sec.
200	f/11	1/125 sec.

note The term *stop* comes from photographic history, when the equipment actually had physical notches that would stop at specific increments as they were adjusted. With modern cameras, changes of full stops (or 1/2 stops, 1/3 stops, and so on) are calculated electronically.

DYNAMIC RANGE

Dynamic range refers to the amount of light in the scene — from the brightest highlights to the darkest shadows — and the camera's ability to capture it. The human eye can perceive a much wider dynamic range than can any camera. The typical dynamic range of most dSLRs is around 9 stops, and camera models vary in their ability to capture dynamic range — understanding this is one of the keys to learning to think like your camera does. For beginning photographers this is one of the least understood aspects of why their photos don't turn out as expected — for example, to your eye the sky was blue but in the captured photo it's blown out to white. This is due entirely to the amount of light striking the sensor and the way the camera metered the scene.

For the nature photographer, dynamic range has several important consequences. First, understand that there are times when what you see cannot be photographed in a single exposure. A typical example is when photographing a scene that has brightly lit sky and a foreground in shade. You can use filters (such as graduated neutral density, covered in later chapters) or change the composition

to account for this, or you can make multiple exposures and combine them later in order to more faithfully render what you saw. The latter technique is referred to as *High Dynamic Range* (HDR) imaging and is covered thoroughly in another book in the Photo Workshop series.

When reading the light in a scene, you need to always take into account the dynamic range present and calculate your exposures accordingly. See 3-23 for a scene with a dynamic range that can't be captured with just one exposure.

CAMERA METERING AND AUTO-EXPOSURE

There is a light meter inside all dSLR cameras. The meter measures the amount of light coming in through the lens and suggests settings to produce a "correct" exposure. What is defined as a correct exposure varies slightly from one camera to another and, due to differences in technology some cameras meter a scene differently than others. But in general, all cameras are designed to

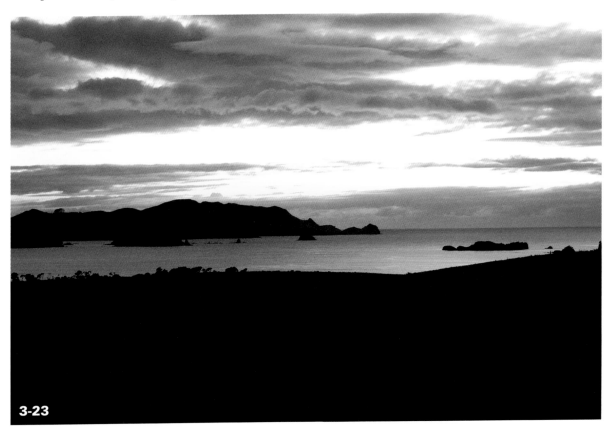

3-23

ABOUT THIS PHOTO *Scene at Bay of Islands, New Zealand (ISO 200, f/11, 1 sec. with a Canon EF 24-105mm L lens). In this single capture, the highlights in the sky are blown out to white and lacking detail, and the shadows in the foreground are close to blocking up to solid black. To faithfully render this scene would have required at least two separate exposures.*

calculate exposure settings the same way, and all cameras provide several choices of metering settings which can measure a scene differently.

When you press the shutter button halfway, the camera takes a meter reading and calculates the settings for a correct exposure. You then have two options: (1) use the camera's suggested settings, or (2) override them using manual settings.

Auto-exposure is designed to eliminate much of the work for you. In many cases, you will find that the camera has calculated the exposure settings optimally to produce a good exposure. In other cases, the camera will not automatically do what you want it to. In these cases you need to take more manual control over the process; this is covered in detail later.

CAMERA HISTOGRAMS

A *histogram* is a bar graph showing the range of brightness values in a photo. The dark tones are at the left and the bright tones are at the right. The "humps" represent the number of pixels at the corresponding brightness level. You can find histograms in your computer software (discussed further in Chapter 9) and all dSLRs have histograms, but they vary in their display.

When you're shooting, you can use the histogram to help evaluate the captured images. To display a histogram, your camera reads the captured photo and analyzes the levels of brightness using its internal programming — so a histogram of the same photo might look different on other camera models. Every photo has its own unique histogram and there really is no such thing as a correct histogram.

Also, because the histogram is entirely based on the camera's internal processing, you should use it only as a guide. You will find that when you look at your photos on the computer the histograms will be different.

One of the things nature photographers look for when viewing a histogram is the appearance of *clipping*. In a digital image, clipping refers to pixels that are either pure white or solid black. Both situations result in a loss of detail, so in general, it's best to avoid clipping whenever possible — but there are exceptions. For example, if you capture a properly exposed photograph that includes the midday sun, you can expect the sun to be totally clipped to pure white. Or, in some photographs you would expect to see deep shadows that are fully black.

See 3-24 for a photo with its corresponding histogram.

ISO

The ISO setting on your camera controls the level of sensitivity for the sensor. Higher ISO settings produce greater sensitivity. With more sensitivity, the electrical signals are amplified so that the captured photons produce more data.

ISO is important because it affects shutter speed. Because the signals are being amplified, you don't need as much light to produce a faster shutter speed. For example, if your camera meter reading produces a shutter speed of 1/125 second at ISO 100, increasing the ISO to 200 cuts the shutter speed value to 1/250 second. (Remember, in full stop changes, everything is either double or half.)

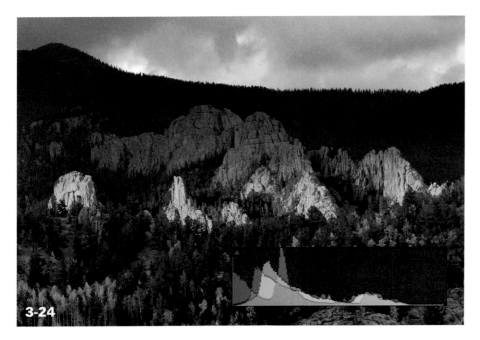

3-24

If you're shooting handheld and the shutter speeds are too slow to prevent blur, you can increase ISO for faster shutter speeds. This is especially true in low-light situations. Even when shooting on a tripod, increasing ISO can help you manage your shutter speeds for optimum results.

The downside to higher ISO is that it increases *noise*, shown in 3-25. In digital capture, noise is undesirable grainy speckles and colored blobs in your photo that detract from its appearance. Higher ISO increases noise because of the amplification. (Some cameras offer high ISO noise reduction, which can help.)

tip Always use the lowest ISO possible that produces the shutter speed you want, but in some cases it may be better to accept a little noise in order to get a sharp shot.

3-25

ABOUT THIS PHOTO *This close-up crop of trees and sky shows heavy digital noise. In many cases this can be corrected with noise reduction controls like those provided in Adobe Lightroom and specialized software such as Noise Ninja.*

WHITE BALANCE

As you learned earlier in this chapter, light always has a color. And, in general, this color can very often be characterized as warm or cool unless it's perfectly neutral (which is rare in nature).

A camera's *white balance* setting is designed to compensate for the color of light, so that colors appear neutral. It does this by shifting the colors in the image so that any apparent *colorcast* is minimized. A colorcast is an overall tint to the image, as shown in 3-26 through 3-28.

Most modern cameras offer an automatic white balance setting. In many situations, this produces acceptable results. However, the camera's auto white balance setting can sometimes be fooled and shifts the color incorrectly. Furthermore, there are times when you want the color to look a certain way, not necessarily the way the camera figures it. In these cases, you can use the white balance presets on your camera or can specify a custom white balance. (See your camera manual for more on this.)

If you capture in RAW format, you don't need to worry much about getting the perfect white balance, because you can adjust it later. When capturing JPEG or TIFF, the white balance setting is very important. (Capture formats are covered in Chapter 5.)

3-26

3-27

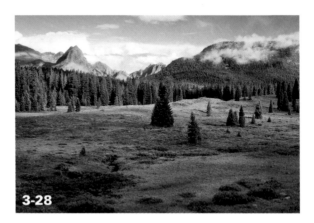

3-28

ABOUT THESE PHOTOS *Images of the San Juan Mountains in Colorado (ISO 100, f/18, 1/8 sec. with a Canon EF 17-40mm L lens). 3-26 shows a cool colorcast, 3-27 shows a warm colorcast, and 3-28 has no colorcast (is neutral).*

Assignment

Photograph a Scene Throughout the Day

This assignment teaches you to see the effects of varying light conditions on a single scene and the dramatic changes it has on the appearance of the objects in the scene.

Scout a location where you can shoot at various times throughout an entire day (or at different times on multiple days.) Find a pleasing composition of part of the scene that receives direct light for at least part of the day. Photograph the same part of the scene early in the morning (ideally before sunrise), just after sunrise, and then again later in the morning, at noon, midafternoon, late afternoon, just before sunset, and after sunset. Your compositions should be as close to identical as possible. Ideally, you'll set up your camera on a tripod and position it the same for all the photos, but capturing handheld will work, too.

My example photo shows Paradise Divide near Crested Butte, Colorado, during the middle of a summer day. I shoot there every chance I get and I've photographed that location under all kinds of conditions. This image was taken at ISO 250, f/22, 1/6 sec. Chapter 6 includes another photo of Paradise Divide at dawn that illustrates how the variation in lighting conditions produces entirely different photographs.

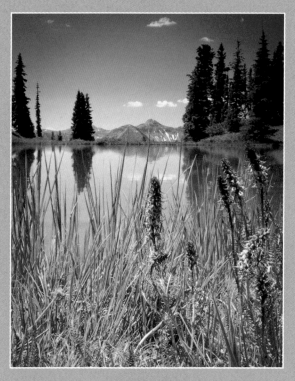

 Remember to visit www.pwassignments.com after you complete the assignment and share your favorite photo! It's a community of enthusiastic photographers and a great place to view what other readers have created. You can also post comments, read encouraging suggestions, and get feedback.

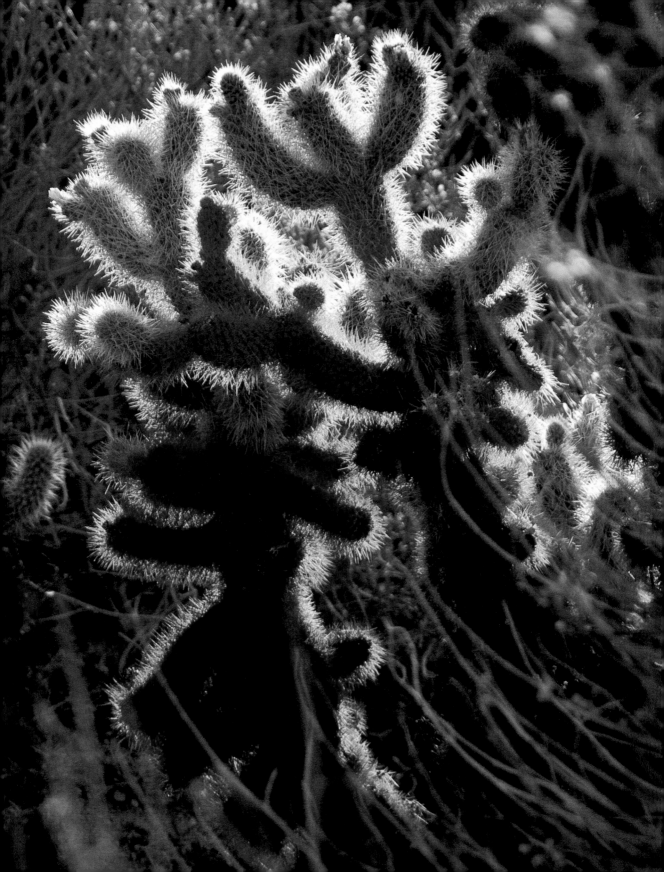

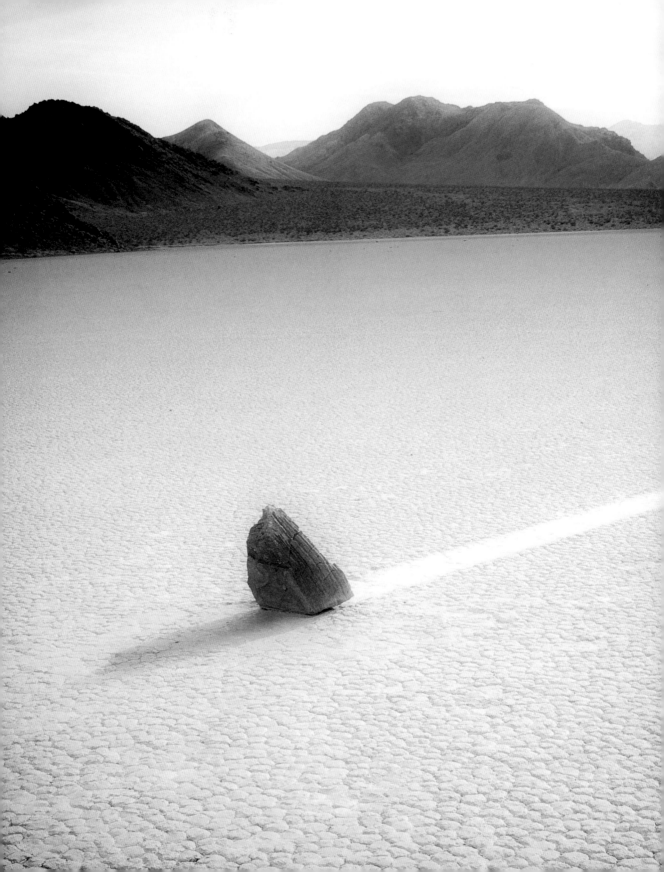

COMPOSING NATURE PHOTOGRAPHS

A good nature photograph doesn't happen by accident. Your best images will be made with clear intention and deliberate design. Photographic design is mostly about composition — how the elements are arranged within the frame. But composition itself can be broken down into many distinct parts, and when making a photograph you need to be aware and in control of everything that ends up in the frame. And beyond the initial choices of what to leave in and what to leave out comes the creative use of the camera to fulfill your vision.

This chapter introduces the essential principles behind good photographic design and teaches you how to use the building blocks of composition to put together the strongest images possible in any situation. Later chapters explain how to apply these fundamentals of design while working in the field.

PRINCIPLES OF PHOTOGRAPHIC DESIGN

Good nature photography is a process of elimination. In all nature photography, you start with visual chaos. Infinite possibilities are available when making a picture; your main objective is to choose what you want to show in the photograph and eliminate everything else. When you're framing a shot, find what doesn't fit and get rid of everything that doesn't directly contribute to your vision for the picture. Identify the main subject and remove all distractions to distill the image down to only the essential elements.

tip

A great way to learn composition is to study painting. Although, unlike painting, with photography you're somewhat constrained by the reality of a scene, the fundamental principles of building a strong picture apply equally to painting and photography. Some of the best books on composition are aimed at painters.

THE PROCESS OF ELIMINATION

New photographers often are inclined to try to get everything possible into a picture. You're standing there, surrounded by magnificent beauty, and you want to capture it for everyone else to feel it exactly as you did. This is impossible. Always remember that a photograph cannot ever completely communicate the experience of being there. The limitations imposed by the frame and the two-dimensional viewing experience dictate this. Your job is to find the essence of the scene that most effectively communicates your feelings and response to the environment and place your frame edges around it accordingly.

Once you decide on a picture, you should work slowly, carefully, and methodically to refine and perfect the composition. You can accomplish this with slight changes in the camera position, zooming in and out, and changing where the lens is focused. In time you'll be able to work quickly to react and adapt to rapidly changing conditions, but for now, the most important thing is to *slow down*.

See in 4-1 and 4-2 how the process of elimination works to create a better design. Much of the time, elimination simply requires getting in closer. Other times you might need to change your position or use a different lens.

ABOUT THESE PHOTOS
Images of Seal Rock State Park, Oregon. 4-1 taken at ISO 50, f/25, 1/10 sec. with a Canon EF 28-135mm IS lens. 4-2 taken at ISO 320, f/5.6, 1/400 sec. with a Canon EF 28-135mm IS lens.

VIEWER PARTICIPATION

When others view your photographs, they fill in the details themselves. Because looking at a picture can't precisely reproduce the feelings of actually being there, the viewer's mind makes up the parts of the story that the photo leaves out. This is critical to remember: *you don't need to show everything to tell the story*. Often, quite the opposite is true — less is more. If you provide the key visual elements that capture the essence of the subject matter, the viewer's mind does the rest.

In fact, this is ideal, because it involves the viewer in a participatory process. When people respond strongly to your photograph, it's because they get your message. It captures their attention, inspires their imagination, and takes their mind on a journey.

For you to do this effectively as the photographer who made the picture, you need to choose carefully what goes in the picture and how the elements are arranged. This is the core of photographic design: tell the story with as few elements as possible. Look at 4-3 and identify the parts of the story your mind infers from the simple elements provided. Where was this photo taken? What time of year was it? What time of day? What would it feel like, sound like, smell like to be there?

idea

Less is more in nature photography. Use the fewest possible elements to tell the story.

4-3

ESSENTIAL TECHNIQUES

When you design a photograph, whether by pre-visualizing or composing a picture on location, there are a few key points to remember. If you simply run through a mental checklist of these points you'll immediately start making better pictures. You need to deliberately use the frame, work effectively in two dimensions, and direct the eye through your creative choices.

USING THE FRAME

The most important aspect of the composition is the *frame*, a term that refers to the edges of the picture. Because you're using the four sides of the frame to isolate what you want to show and eliminate everything else, the frame is the first thing to pay attention to. By remaining aware of your selection process, you will learn to use the frame with great control.

Once a picture is made, the sides are rigid and inflexible. But the frame can be used with enormous power. Superimposing a rectangle on a tiny part of the world gives the contents of the frame importance. Depending on what's in the frame, the four straight sides of a picture can impose a strong effect on the composition or can be minimized so they don't draw attention.

> **tip**
>
> When composing a picture on location (or cropping later on the computer), make sure to look all around the edges for distracting elements.

When arranging elements within the frame, you have two simple possibilities to consider: you can move the camera, or some subjects can move themselves. Simple enough? (In cases where you can't move and the subject can't move, forget creative control — take the snapshot.)

When you're perfecting a composition, you might find that removing one element has an undesirable effect on another element that you want to keep. In cases where the composition is perfect except for one offending object, if it can be removed in post-processing you should usually keep it in the frame. For example, if you have a perfectly composed grand scenic, but there's a telephone pole visible in the distance, it wouldn't make sense to recompose the entire picture just to work around the telephone pole. Remove it in digital processing. Of course, some offending elements are too large or cumbersome to get rid of later. In these cases, your only choice is to find another composition.

See in 4-4 and 4-5 how the effects of the frame can be minimized or enhanced by the positioning of elements in relation to the frame edges. In 4-4, the proximity of the trees close and parallel to the edges emphasizes the sides of the frame, especially the left side. In 4-5, the effect of the frame is minimized because the viewer's eye remains farther inside the picture.

WORKING IN TWO DIMENSIONS

Never forget that a picture is two-dimensional (use the eye tricks in Chapter 2 to remind yourself of how the camera sees). You need to use photographic techniques to convey depth and dimension; later in this chapter you learn techniques for doing this. For now, remind yourself that when you compose a picture you need to decide whether you want to show a lot of depth and dimension. (Of course, you can make the creative decision to "flatten" the elements of the picture and remove the appearance of depth, which I often do.)

ABOUT THESE PHOTOS *Images of Damnation Trail, Redwoods National Park, California. 4-4 taken at ISO 320, f/16, 1.3 sec. with a Canon TS-E 24mm L lens. 4-5 taken at ISO 320, f/11 at .6 sec. with a Canon TS-E 24mm L lens.*

4-6 gives the illusion of depth using techniques explained later in this chapter, such as shading and perspective. 4-7 shows no depth because all the visual clues for depth have been eliminated.

DIRECTING THE EYE

You can arrange the elements in the frame to deliberately direct the viewer's eye around the picture. In Chapter 2, you learned the basics of human vision and what attracts the eye; later in this chapter you learn how to do this purposely.

In your preshot checklist, remember that you need to be aware of how the eye traverses the picture. The most important purpose of directing the eye is to keep the viewer's attention within the frame. In most cases, if the viewer's eye is pulled out of the frame, the composition is flawed. Very bright or dark objects surrounded by areas of contrasting tone attract the eye, especially when they're at the edge of the frame. Also, elements that are divided by the frame edge and left partially in and partially out of the frame can also be distracting.

ABOUT THESE PHOTOS *Image 4-6 of Zebra Canyon, Utah (ISO 200, f/20, .8 sec. with a Canon EF 17-40mm L lens). Image 4-7 of autumn aspen leaves (ISO 160, f/8, 1/50 sec. with a Tamron 18-200mm XR Di II lens).*

4-6

4-7

Look at 4-8 and pay careful attention to how your eye moves around the frame. Where does it start? Where does it go next? Where does your eye

resolve, or end up, in the picture? You will find your eye travels through the frame in a sequence of steps from start to finish and then starts over again. This is a good thing — again, you want to keep the viewer's eye in the frame. You can imagine (or draw on a print) lines separating parts of the picture from one another or arrows indicating the direction of eye travel.

Be sure to identify and eliminate all distracting elements. Everywhere the viewer's eye goes, you should have sent them there on purpose. Make sure the main subject or theme of the photo is strongly evident and use supporting elements to add interest and direct attention to the main subject.

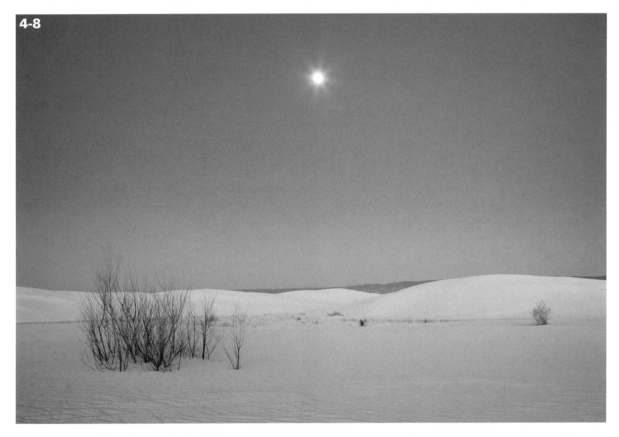

4-8

ELEMENTS OF DESIGN

Good nature photography requires conscious design. Some people are inclined to think that because nature "is what it is" and you can just point your camera at it and take a picture that the photographic process can be approached randomly. Sure, some photographers shoot without ever looking through the viewfinder — hold the camera in one hand away from the body, press and hold the shutter, and wave the camera around. You might get an interesting picture.

But that's certainly not photographing with intention or purpose. When you're ready to take creative control over your photographs, you need to assume full responsibility for everything that ends up in the final image. Remember that a

great photograph is no accident — by simply deciding to direct the process you've made a big step forward. The rest is mastering the skills to visually express your ideas. Photographic design is about how you actively choose the inclusion and arrangement of the elements within the frame.

Following are descriptions of the essential graphic elements that you can use to build strong compositions.

POINT

A point is the basic building block in any picture. A point can be visible or invisible. An invisible point can be created by small objects within the frame or at the intersection of lines and shapes (see 4-9 through 4-12). Points establish corners and edges.

As a viewer looks at your photograph, points are the places where the eye changes direction and/or comes to rest.

LINE

A line is made of at least two points. In photography, lines connect important points in the picture. The most important function of lines is that

4-9

4-10

ABOUT THESE PHOTOS
The points in the 4-9 image of leaves on the surface of a pond are circled in 4-10 (ISO 320, f/11, 1/125 sec. with a Canon EF 70-200mm f/4 IS L lens).

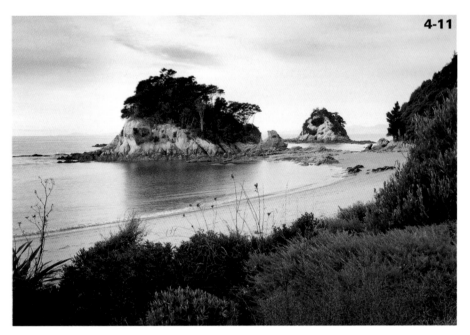

4-11

ABOUT THESE PHOTOS
The points in the 4-11 image of Kaiteriteri, South Island, New Zealand are circled in 4-12 (ISO 200, f/22, .6 sec. with a Canon EF 24-105mm L lens).

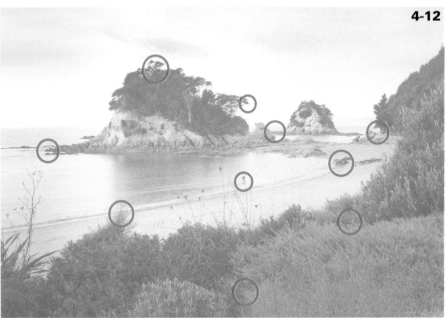

4-12

they are largely responsible for guiding the eye around the frame. A photograph containing many lines causes the eye to travel around the frame a lot, resulting in a very active viewing experience. Fewer lines means less eye travel, which feels calm, peaceful, and serene. In every composition, make sure to identify the lines and the directions they give to eye movement. This is one of the keys to understanding how other people will view your photo.

Lines generate psychological responses in the viewer. Smooth, curving lines feel slow, meandering, and gentle (see 4-13). Thick lines imply strength; thin lines seem fragile. Jagged, short lines feel harsh and unnerving. Much of your response to lines is based on gravity; a horizontal line feels more solid and grounded than a vertical line. Angled or diagonal lines (see 4-14) impart energy to a composition because they can appear to be moving or falling down.

4-13

4-14

ABOUT THESE PHOTOS
4-13 of the East River, Crested Butte, Colorado shows a meandering, curved line that conveys a gentle or lazy feeling (ISO 200, f/6.3, 1/640 sec. with a Canon EF 70-200mm IS L lens). 4-14 of trees at Redwood National Park, California contains a combination of angled and straight lines that energetically move the eye around the frame (ISO 400, f/18, 1 sec. with a Canon EF 24-105mm L lens).

SHAPE

Shapes are made of lines and are two-dimensional — they are essentially flat, without shading. You know some shapes by their grade-school geometry names: rectangle, triangle, and circle. All regular shapes are derived from these. A square is a form of rectangle, an oval is a form of circle, and so on. Irregular shapes, often referred to as polygons, can take any random form but still can be easily identified in a composition. Some simple shapes are shown in 4-15 and 4-16.

Like lines, shapes convey emotion. A square feels solid, grounded, even heavy. A triangle sitting on a wide base also feels solid and sturdy, but a triangle balanced on a point feels unstable and wobbly. A circle feels complete and whole.

Learning to quickly see shapes, identify their interplay, and understand their emotional connotations is key to assembling a composition that conveys your intentions.

4-16

ABOUT THESE PHOTOS *Image 4-15 of aspen trees along Kebler Pass, Colorado, shows a dominant triangle shape at top right, as well as numerous converging lines (ISO 100, f/22, 1/10 sec. with a Canon EF-S 10-22mm lens). Image 4-16 of a sand dune at White Sands, New Mexico, shows how lines and the frame edges can combine to form shapes (ISO 200, f/32, 1/8 sec. with a Canon EF 100-400mm IS L lens).*

FORM

Forms are based on shapes, but also have *shading* that's seen as highlights and shadows (see 4-17). Whereas shapes are two-dimensional, forms are three-dimensional. Showing depth in a photo is largely about conveying the form of objects, as any natural object will appear as a flat shape if there's no shading.

PATTERN

Patterns are repeating, uniform, geometric shapes. Patterns can be very strong design elements, but a photo showing *only* a pattern lacks a main center of interest and can be boring. The most effective way to use patterns in a composition is to break the pattern in some way, as shown in 4-18.

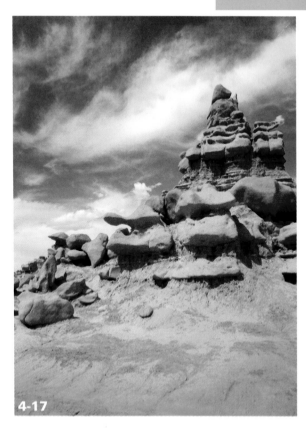

ABOUT THIS PHOTO *Image of Goblin Valley, Utah shows an example of three-dimensional forms (ISO 100, f/22, 1/20 sec. with a Canon EF 17-40mm L lens). This photo was made using a polarizing filter, which darkened the sky and removed glare from the rocks.*

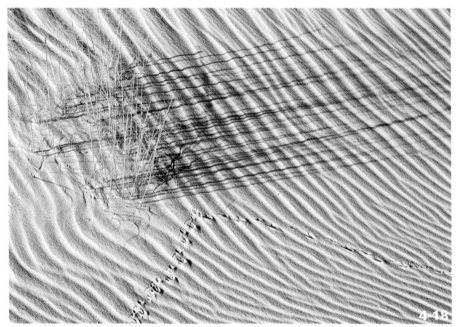

ABOUT THIS PHOTO *Image of the pattern of sand ripples at White Sands, New Mexico (ISO 100, f/9, 1/320 sec. with a Canon EF 28-135mm IS lens). The pattern of the sand is broken up by the grass and the bird tracks.*

TEXTURE

Textures are random, organic surfaces in a photo. A key characteristic of texture is that is conveys a tactile sensation; that is, when you see a texture in a photograph you can sense what it would feel like to the touch. Textures can be rough or smooth, subtle or dramatic. You can emphasize textured elements by contrasting them with smooth, solid shapes (see 4-19).

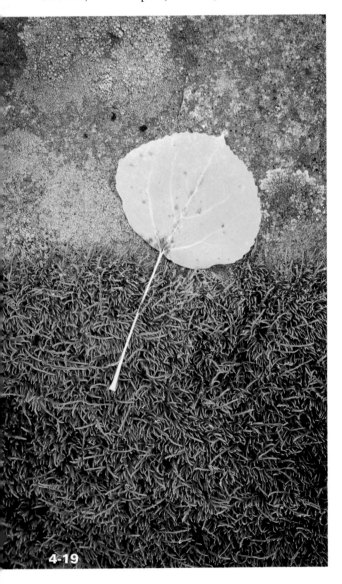

4-19

TONE AND COLOR

Every photo has a range of tones and many also have color components. Beyond the graphic elements you can identify in your photos, tone and color complete the picture for the viewer. You should learn to evaluate tone and color separately.

TONE

Tone refers to the levels of brightness in the photograph, from solid black to pure white. Shadows are dark tones; highlights are bright tones. The majority of nature photographs display a wide range of tones, from black or near black to white or near white.

A photograph with mostly dark tones is called *low key* and feels heavy and dramatic. A photo with mostly light tones is called *high key* and feels bright and airy.

Evaluating and controlling the tones in your composition is a key skill in designing effective photographs. A range of tones is shown in 4-20, 4-21, and 4-22.

ABOUT THIS PHOTO *Image of rock, lichen, moss, and leaf taken at ISO 320, f/8, 1/40 sec. with a Canon EF 28-135mm IS lens). It's easy to imagine what the textures of the rock and moss would feel like to touch.*

ABOUT THIS PHOTO *Image of White Sands, New Mexico, shows just three distinct tones — light, medium, and dark (ISO 100, f/32, 1/8 sec. with a Canon EF 100-400mm IS L lens).*

4-20

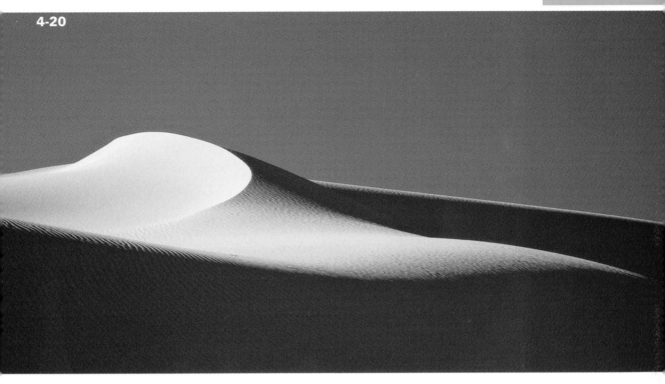

4-21

ABOUT THIS PHOTO *Close-up of snow and flowers demonstrates a high-key image (ISO 100, f/11, 1/350 sec. with a Canon EF 70-300mm lens).*

CONTRAST

The term contrast is most often used to describe variation between tones. In this context, *high contrast* means there's a big difference in the brightness levels between highlights and shadows. (High-contrast images typically don't show a lot of variation in the midtones.) A high-contrast image has a lot of "pop." By comparison, *low-contrast* photos appear flat and comparatively dull. 4-23 is a high-contrast image; by comparison 4-24 is relatively low contrast in terms of tonality (although it does have significant color contrast, which is discussed in the next sections).

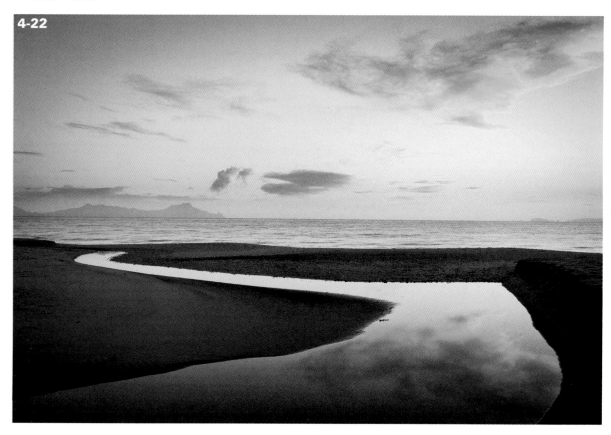

4-22

You also need to be aware of other kinds of contrasts because you can use them as compositional elements. Sharp versus blurry is a kind of contrast. Smooth versus textured is another. Bright color versus dull color, and even small versus large are contrasts. These kinds of contrasts set off elements against one another, creating more interesting pictures.

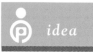

idea

> Keep an eye out for different types of contrasts and try to include several of them in each of your photos.

COLOR (OR BLACK AND WHITE?)

The presence (or absence) of color in a photograph is one of the strongest factors influencing viewer perception. You should use color purposefully and with an understanding of how it affects the composition.

The choice of whether the final photo will be in color or black and white is fundamental. Some pictures just seem to work better in black and white, and many of the most famous nature photographs throughout history have been black and white.

ABOUT THESE PHOTOS *Image 4-23 of White Sands, New Mexico (ISO 200, f/8, 1/250 sec. with a Canon EF 28-135mm IS lens). Image 4-24 taken near the Forgotten World Highway on New Zealand's North Island (ISO 250, f/22, 1.3 sec. with a Canon EF 24-105 IS L lens).*

4-23

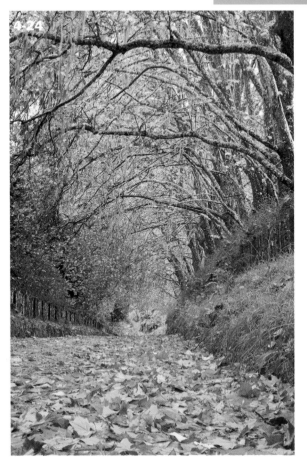

4-24

> **note** Warm colors appear to advance or come forward, cool colors appear to recede. For example, if you have a picture that is mostly blue with a bright red spot, that red spot will appear to come forward in the composition.

If you do use color in a photograph, you need to pay close attention to the relationships of color in the photo and how they affect the composition and overall mood of the image.

You also need to evaluate how color relates to tone in the picture. In addition to a color component, or hue, elements in a photograph also have a light or dark tone.

All colors have three components:

- **Hue.** The named color, such as red, green, purple, yellow, blue, and so on.

- **Saturation.** The purity of color as opposed to neutral gray. A color that appears vivid and bright is *highly saturated*.

- **Brightness.** The tone of the color — is it light, dark, or somewhere in between?

COLOR RELATIONSHIPS AND HARMONY

Colors have relationships, based on the frequencies of their wavelengths of light, that can be naturally pleasing to the human eye. In the visual arts these relationships can be used for an infinite range of effects. In your nature photographs, you present relationships between the colors in the composition that communicate your intention and guide the viewer's response. The relationships of colors have been arranged into a *color wheel* (see 4-25). Colors opposite each other are *complementary* and provide the most contrast between one another. Colors near each other provide less contrast and are referred to as *analogous*. Both can create pleasing combinations of color.

Harmony refers to how well the colors go together. Colors are harmonious and pleasing to the eye when they share components of hue, saturation, and/or brightness. Color harmony can create a mood or affect the emotional state of the viewer. Often, colors will appear to clash, and unless your intention for the photograph is discord, this should be avoided. Look for examples of color harmony in nature; these relationships can create photos with a lot of visual appeal.

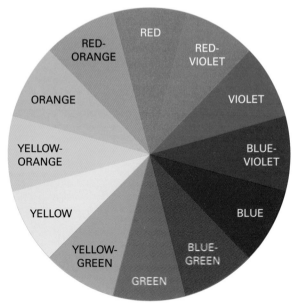

4-25

ABOUT THIS FIGURE *The color wheel shows relationships of colors. You can create the most impact with color by placing objects with complementary colors against each other in the composition. Relationships between red and green, orange and blue, and so on, generate lots of power in a photo.*

PSYCHOLOGY OF COLOR

Color carries very strong psychological and emotional implications. Some of your response to color is influenced by cultural standards; for example, in most societies, greens and blues carry common meanings: life, water, renewal, growth, and so on. In western countries, black is often associated with death, but in many eastern civilizations red is the color most associated with death.

In either case, there's no doubt that black and red are very strong colors that carry meaning and have strong effects within any photograph.

Choosing to include or emphasize certain colors in your photographs greatly influences how the viewer perceives the image. See 4-26, 4-27, and 4-28 for examples of how color (or lack of it) can be used to convey meaning and intention within your photographs.

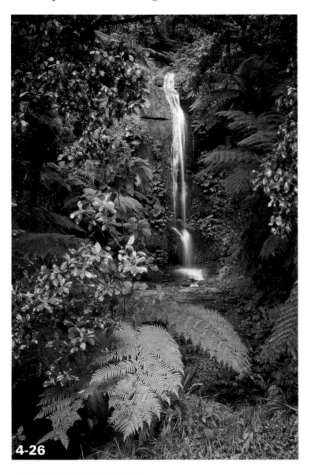

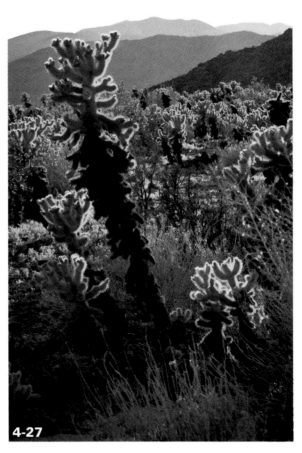

ABOUT THESE PHOTOS *Image 4-26 of a waterfall near the Forgotten World Highway, New Zealand, is full of lush, green colors that reinforce the theme of abundant water and rich, thriving plant life (ISO 200, f/8, 1/250 sec. with a Canon EF 28-135mm IS lens). In image 4-27, taken at Joshua Tree National Park in California, the various shades of brown and an overall lack of bright color emphasize the dusty, dry nature of the desert (ISO 250, f/6.3, 1/400 sec. with a Tamron 18-200mm XR Di II lens).*

ABOUT THIS PHOTO. *The tones and forms in this image don't need any color to strongly represent the subject matter, and the black and white treatment emphasizes the stark, lifeless appearance of the tree roots and rock (ISO 125, f/8, 1.5 sec. with a Canon EF 24-105mm L lens).*

CREATING A DYNAMIC PHOTOGRAPH

After you master the identification and arrangement of basic graphic elements, take your work to the next level by making your photographs more exciting and dynamic. When making creative choices for your compositions, you can use proven techniques to design photographs that are both visually engaging and technically sound.

FOCAL POINT AND CENTER OF INTEREST

The *focal point* of a photograph is the part that most attracts the viewer's eye. As the eye travels around the frame looking at all the elements in the picture, the focal point is often where the eye repeatedly comes to rest. The focal point can also be the first place the viewer looks. In either case, the focal point is the main thing a viewer looks at in the picture.

The *center of interest* in many cases is also the focal point, but doesn't necessarily need to be so. The center of interest is the part of the picture the viewer finds most interesting and intellectually stimulating. In 4-29, the horse is certainly the focal point, but it could be argued that the mountain peaks are the center of interest.

> **note** In camera terminology, the focal point is the point at which the image is focused on the recording plane inside the camera.

FOREGROUND/BACKGROUND

Most nature pictures contain a foreground and background. The foreground is what's nearest the camera and appears in front of objects behind it. The background is comprised of the elements farthest from the camera and appears behind and might be blocked or obscured by objects in front of it. Some images also have a midground or various elements at different distances.

ABOUT THIS PHOTO *Image of Grand Teton National Park, Wyoming (ISO 200, f/11, 1/125 sec. with a Canon EF 28-135mm IS lens).*

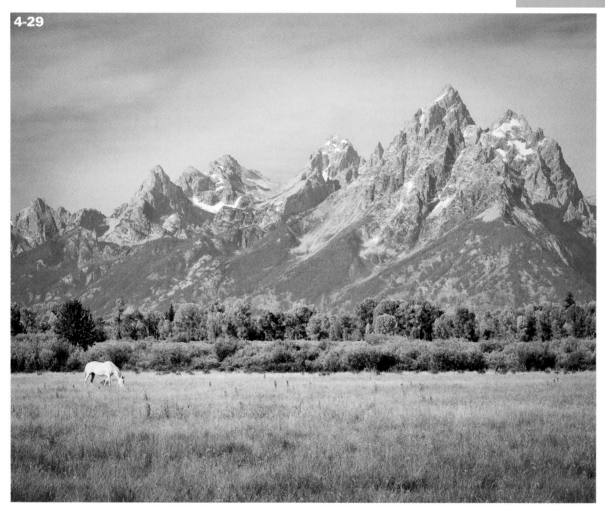

4-29

The relationships between foreground and background are critical. One of the main problems with unsuccessful photographs is that the photographer didn't pay enough attention to the background.

When a picture contains a very strong center of interest it's easy to overlook critical flaws in the background. Evaluate every part of the composition and make decisions to control how the elements work together. Learn to look at all parts of the composition, from foreground to background and everything in between.

4-30 shows a clear relationship between foreground and background. You can also identify objects in the midground.

ABOUT THIS PHOTO *Image of Arches National Park, Utah (ISO 100, f/22, 3 sec. with a Canon EF 17-40mm L lens). The foreground leads the viewer's eye into the frame and the position and contrast of the rock feature in the distance draws the eye up through the picture.*

4-30

PERSPECTIVE AND DEPTH

Because a photo only has two dimensions, if you want to show a three-dimensional appearance you need to use some photographic techniques.

The first is called *perspective effect*. It's based on your understanding that if there are two identical objects and one is farther away it will appear smaller. You may have seen the old illustration that depicts this: a line drawing of a railroad track with telegraph poles alongside it, both stretching into the distance. The illusion is created by *converging lines* and the fact that the objects are drawn smaller as they go upward in the frame. Keep this principle in mind as you create your compositions (see 4-31).

> **tip**
>
> When you're shooting on location, there's an easy way to better see what's really going on in the frame: Manually defocus the lens as you compose the shot. When you look at a sharply focused image, your eyes and brain want to concentrate on the details. With the image blurred, you easily see light and dark shapes and their relationship to each other. Compose the shot with the lens out of focus, and when you have the basic design you want, refocus before taking the shot.

ABOUT THIS PHOTO *This image of tulip fields in Burlington, Washington uses converging lines to create perspective (ISO 200, f/16, 1/80 sec. with Tamron 18-200mm XR Di II lens).*

4-31

Shading is another technique used to create a three-dimensional appearance. As discussed earlier in this chapter, the presence of highlights and shadows conveys depth in a photograph. 4-32 shows a photo that uses shading and variation in light levels to convey depth.

SCALE, PROPORTION, AND DOMINANCE

Quite simply, *scale* refers to size — how big or small something is within the composition. Scale can affect the appearance of depth; as discussed in the preceding section, an object that is farther away appears smaller, and a closer object appears bigger. In this way, you can use scale to show distance.

Scale also determines how much attention is drawn to a particular object in the frame. Depending on the visual relationships involved, a large element can attract more attention than a small one, or vice versa.

Proportion refers to how much space an element takes up in the frame relative to other objects. You need to carefully evaluate the proportions between elements to be sure they accurately convey your intentions.

Dominance refers to how strongly an element attracts attention and influences the composition. The correct application of dominance within the photo is essential: If the picture is of a distant tree but the foreground is dominated by a huge boulder, the viewer may miss the message.

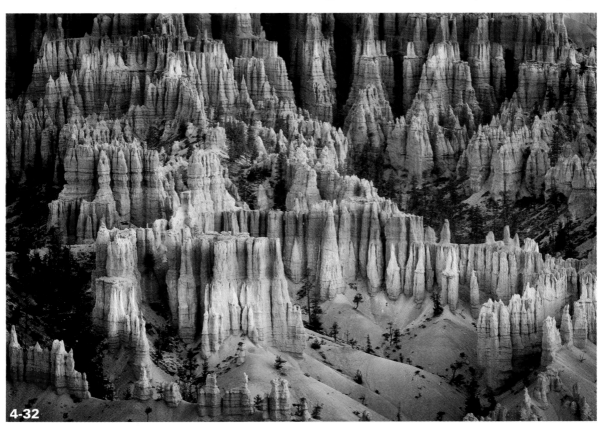

4-32

ABOUT THIS PHOTO *Image of Bryce Canyon, Utah (ISO 125, f/6.3, 1/20 sec. with a Canon EF 70-200mm IS L lens).*

In most nature photographs you should have one clearly dominant object in the composition. A dominant object can also be the focal point and/or center of interest, or not; if a dominant element is *not* the main object in the scene you need to be careful that it doesn't distract from the center of interest.

In 4-33, the largest tree near the left side of the frame attracts the most attention because it's the biggest, brightest tree. The large tree is the dominant object in the frame. However, the sky and the ground both take up more space in the frame, so in this case the dominant object isn't the largest element. Also note how the complementary color relationship between the yellow leaves and the blue sky creates color contrast and impact.

TENSION AND BALANCE

Tension is created mainly by lines and proportion. When the visual energy of different elements is not identical, tension is generated. Elements in the composition that appear to influence each other and pull the viewer's eye back and forth between them result in tension. Tension can hold the parts of the composition together; this cohesion is a hallmark of a strong image.

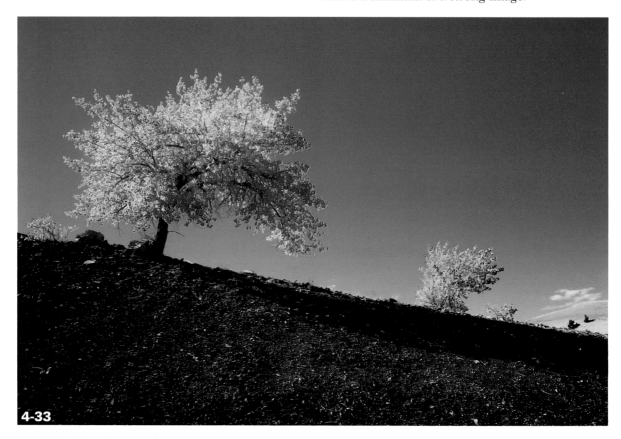

4-33

ABOUT THIS PHOTO *This image of autumn trees along a roadside in Wyoming has a clearly dominant object (ISO 200, f/16, 1/60 sec. with a Canon EF 17-40mm L lens).*

Similar to tension, you can achieve *balance* in your composition by varying the relationships of graphics, tones, color, and scale. Look back at 4-29 and consider how the horse attracts attention even though it's very tiny in the frame. And though it's much larger, the huge mass of mountains visually counteracts the impact of the horse, so tension and balance are created.

This is important to remember: *Balance is created by the juxtaposition of how strongly the elements attract the eye, not necessarily by their size or shape alone.*

4-34 demonstrates significant tension and balance created by the arcing horizontal lines and the interplay between shapes containing bright, warm tones against those with dark, cool tones.

VISUAL WEIGHT

Visual weight gives a composition a sense of "heaviness" in a certain area. Most nature photographs tend to feel right when they are weighted at the bottom, or in some cases, on either side, but for creative effect you can compose a photo with visual weight anywhere you like. A photo with weight at the top would appear to be teetering, ready to fall, or invoke a feeling of looming overhead of the viewer.

You can create visual weight by placing large, dark elements in key positions within the frame. In 4-35, the weight is placed solidly at the bottom of the frame and slightly to the right. 4-36 has visual weight at the top of the frame. The dark rocks and distant sea are interacting with the extreme upward motion of the triangular waveform, creating dynamic energy in the composition.

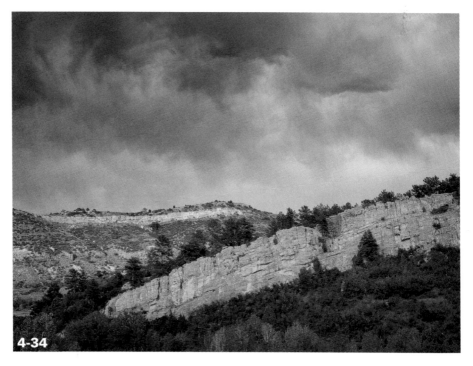

ABOUT THIS PHOTO
This image of the Hogback, Front Range, Colorado demonstrates tension and balance (ISO 100, f/8, 1/30 sec. with a Canon EF 17-40mm L lens).

4-34

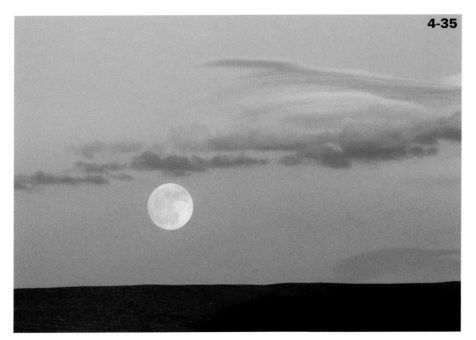

4-35

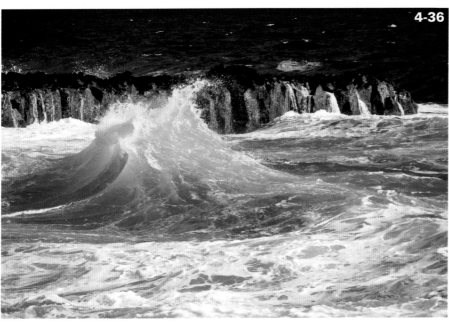

4-36

POSITIVE AND NEGATIVE SPACES

In all graphic arts, including photography, compositions often contain what are referred to as *positive and negative spaces*. An easy way to visualize this is using the letter "O". The dark, outer ring of the letter is the positive space; the interior is the negative space. However, a negative space doesn't necessarily need to be fully enclosed; consider the letter U. The interior is still the negative space.

Of course, in a photograph, positive and negative spaces are typically much more complex than this. Also, a positive space is not always dark and the negative space light. It all depends on the relationships of the shapes and their tones.

The important thing to understand about positive and negative spaces is how they influence the perception of the viewer. Often, a negative space is seen as a "hole" and emphasizes the strength and solidity, and depth or dimension of a corresponding positive space. This can create a layering effect in the composition that goes beyond simple foreground/background relationship.

See 4-37 for a simple example of a photo with strong positive and negative spaces. In 4-38, the relationship is reversed; the yucca is positive space and it's surrounded by negative space. The dune face in the background contains both positive and negative spaces.

ABOUT THIS PHOTO
This image of a sandstone wall and window in Garden of the Gods, Colorado demonstrates positive and negative spaces (ISO 200, f/8, 1/750 sec. with a Canon EF 70-300mm lens).

4-37

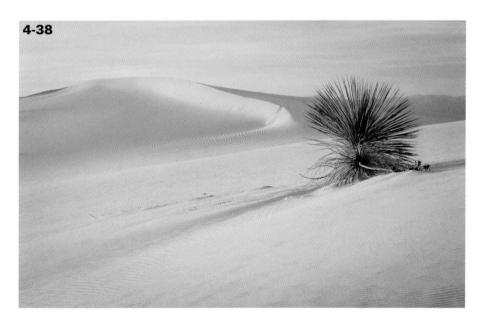

4-38

MERGERS AND INTERSECTIONS

You must always be aware of any *mergers* or *inter-sections* within the frame. A merger is created when separate objects of similar tone or color appear to blend into one shape within the composition. This is very common due to the two-dimensional nature of a photograph. Remember, even though you might be able to see distinct, separate objects with your eyes, in the camera they might appear as a single element in the picture.

Mergers are almost always something to be avoided because they significantly weaken the impact of the photograph by making things appear indistinct from one another. Unless you're doing this for creative effect, you must always work to eliminate mergers and maintain separation between elements in the composition by varying position, tone, or color. This is especially true in cases where you have sharply defined shapes merging with one another. A classic example is the pole sticking out of someone's

head; many similar situations will arise in your nature photographs. You should also be aware of mergers when photographing silhouettes.

An intersection is a point created where lines cross. It can happen with visible or invisible lines or along the edges of shapes. Intersections (see 4-39) are not always a bad thing but you need to know when they are present because the points created by intersections naturally draw the viewer's eye.

RHYTHM

When a composition contains a series of repeating objects (but not necessarily a pattern), *rhythm* is created. Rhythm in the visual arts is similar to rhythm in music — it's a series of evenly spaced, identical elements. Think of the regular beat of your favorite song and you get the idea. Like a song, in a photograph you can create a fast or slow pace (or *tempo*) for the rhythm, based on how closely spaced the elements appear in the frame. An example of rhythm is shown in 4-40.

ABOUT THIS PHOTO
Image of intersections on a cliff wall (ISO 640, f/5.6, 1/60 sec. with a Tamron 18-200mm XR Di II lens).

ABOUT THIS PHOTO *This image of trees in northern Washington State illustrates rhythm (ISO 400, f/6.3, 1/1000 sec. with a Tamron 18-200mm XR Di II lens).*

GESTURE

In a photograph, *gesture* refers to a sense of flair, a "swoosh" or sweeping effect that implies a sense of motion. A gesture leads the viewer's eye in one direction, culminating in a crescendo. Imagine a painter flamboyantly sweeping her brush widely across a canvas, or someone talking dramatically with his hands, and you have gesture. The branches of the tree in 4-41 show gesture.

DIRECTIONAL PERCEPTIONS

Many pictures of nature contain a strong sense of direction; that is, as the viewer's eye travels the frame there is an overriding flow to the motion of

the image: left-to-right, top-to-bottom, and so on. You must always be aware of these directional perceptions because they have important implications for the ideal placement of elements in the frame.

For example, if your photo includes an animal's head or eyes, there is an implied direction to the image. A viewer naturally looks in the direction that the animal's head or eyes are pointing. This is an example of the invisible lines created in a composition. Also, if you capture subject matter that appears to be traveling in a specific direction, such as birds in flight or a stream flowing, you need to account for this by balancing the composition to keep the viewer's eye in the picture.

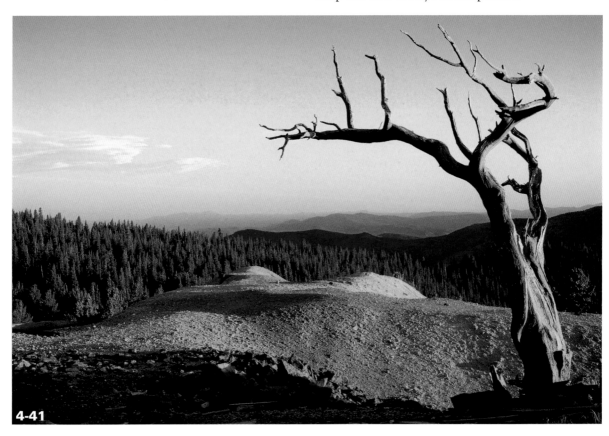

4-41

ABOUT THIS PHOTO *This image of dead tree near Bonanza, Colorado demonstrates gesture (ISO 320, f/8, 1/25 sec. with a Canon EF 28-135mm IS lens).*

In these cases, the most important thing is to leave enough room in front of the direction of movement so the viewer's eye doesn't go out of the frame. If you put a flying bird close to the edge, the viewer's eye naturally follows the direction of the bird right off the edge of the frame.

4-42 and 4-43 show examples of this. Leave some room in front of the bird, and the eye remains within the picture. (These images were made by cropping a single photo in different ways; see Chapter 9 for more about cropping.)

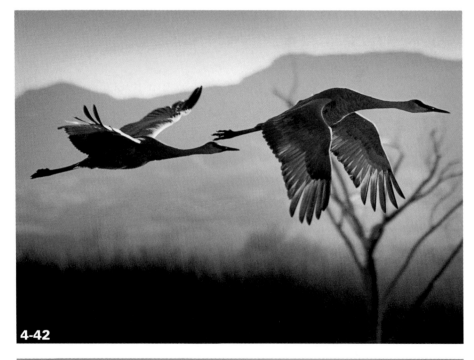

4-42

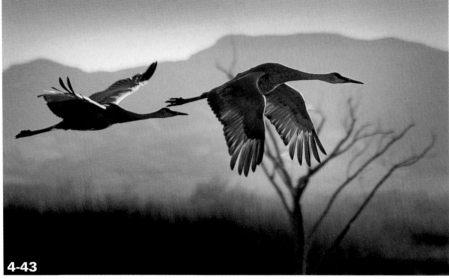

4-43

ABOUT THESE PHOTOS
Image of sandhill cranes at Bosque del Apache National Wildlife Refuge, New Mexico (ISO 200, f/5.6, 1/500 sec. with a Canon EF 75-300mm lens).

Graphics in the photo also influence directional perception. In 4-44, the shapes of the trees create well-defined triangular shapes, creating "arrows" that point downward. This guides your eye to the patch of bright red wildflowers in the foreground.

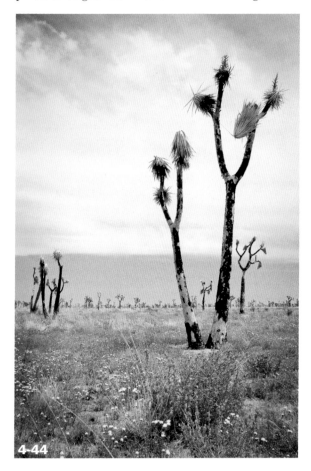

4-44

ABOUT THIS PHOTO *This image of Joshua Tree National Park, California uses graphics to influence directional perception (ISO 320, f/20, 1/100 sec. with a Tamron 18-200mm XR Di II lens).*

GUIDELINES FOR COMPOSING BETTER NATURE PHOTOS

On a case-by-case basis, you can use all the aforementioned graphic elements and techniques to deliberately design better photos. I encourage you to take a somewhat technical approach to designing your photographs — the aesthetic aspects of nature photography can be learned. Develop your visual vocabulary and apply your creativity with purpose and intention.

With so many tools at your disposal, knowing a few rules and guidelines will give you more creative freedom and successful results:

■ **Don't center the subject.** Most compositions are most interesting when the dominant element isn't centered in the frame. Centering the main subject creates a bull's-eye effect, making it difficult for the viewer's eye to move around the frame. Interestingly, a photo often looks more balanced when things *aren't* centered.

■ **Don't center the horizon.** Similar to the concept outlined in the previous bullet point, centering the horizon usually creates a boring, static composition with little room for eye movement. If the horizon (or any horizontal line) extends across the frame, try placing it above or below the middle of the frame; a 60/40 ratio often works well. The exception to both rules is any photo in which you want to emphasize symmetry by centering mirrored elements.

■ **Watch for crooked horizons.** If you have a horizon or any line resembling a horizon in the frame, it often should be straight to "feel right." Use a bubble level (discussed in Chapter 5) to make sure everything's straight. Of course, you can always angle your photos for creative effect, but if your intention is to have everything straight, pay close attention to this.

■ **Use the Rule of Thirds.** One of the most well-known, useful guidelines for composition simply divides the frame into nine equal boxes and places the main focal point at one intersection of the lines (see 4-45). Following the Rule of Thirds is the easiest way to start improving your photos right away. Of course, there are many compositions that are stronger

when you don't follow the Rule of Thirds — the constant objective is achieving balance with dynamic tension in the composition.

■ **Be careful cutting off elements at the edges of the frame.** Look for objects in the scene that extend out of the frame edges. By no means do you need to always keep everything cleanly within the frame, but watch out for elements that attract attention to the edges of the photo. A tree branch intruding from the edge of the frame is a common example. If you're going to cut something off at the edge of the frame, do it deliberately and make sure it doesn't draw unwanted attention.

■ **Match orientation to subject.** If the main subject matter has a vertical orientation, use a vertical ("portrait") composition. If the main subject is wider than it is tall, use a horizontal ("landscape") framing.

■ **Fill the frame.** Don't leave empty space around the edges of the frame unless it contributes to the composition. In general, your pictures will be more engaging if you fill the frame with the subject matter. Especially in close-ups, when you allow the subject matter to extend beyond the edges of the frame you draw the viewer in and add more presence to the photo.

■ **Use supporting elements.** Once you establish your main focal point and apply the rules of dominance and proportion, try to find secondary elements to support the main subject matter. For example, in a photo that features the full moon, including a few small, circular stones in the photo mimics the shape of the moon and makes it appear stronger in the composition.

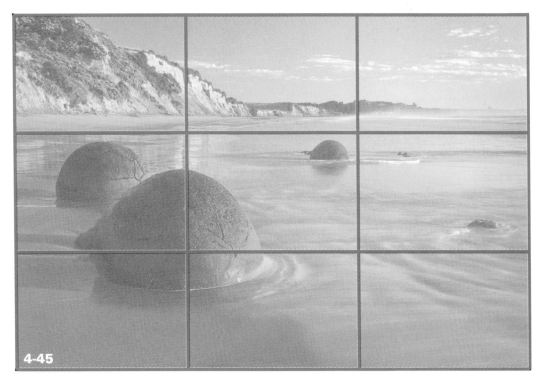

ABOUT
THIS PHOTO
*Image shows the
frame divisions
created by the
Rule of Thirds.*

4-45

Assignment

Compose and Evaluate a Photograph

An easy way to break down composition into its basic elements is to draw lines on the picture to identify the lines, shapes, and directions present in the photo. First, make a nature photograph using what you've learned in this chapter to carefully arrange the elements in the frame to create a good composition.

After downloading the picture to your computer, either print it on a letter-size sheet of paper or open it in Photoshop. If you made a print, use a marker (ideally a red one) to draw outlines around the most obvious elements in the composition. Simply trace over the picture to outline the shapes and lines. If you can perceive directional clues or motion in the frame, draw arrows to indicate that. In Photoshop, use a paintbrush with a bright color and paint over the picture. When you finish, you should have a photo that looks like the example below.

My example picture was taken in rural Maine. This image has very strong lines and strong contrast in both tone and color. It was shot at ISO 125, f/8, 1/50 sec. with a Tamron 18-200 XR Di II lens. My outlined version shows how I broke up the composition into its basic parts.

Remember to visit www.pwassignments.com after you complete the assignment and share your favorite photo! It's a community of enthusiastic photographers and a great place to view what other readers have created. You can also post comments, read encouraging suggestions, and get feedback.

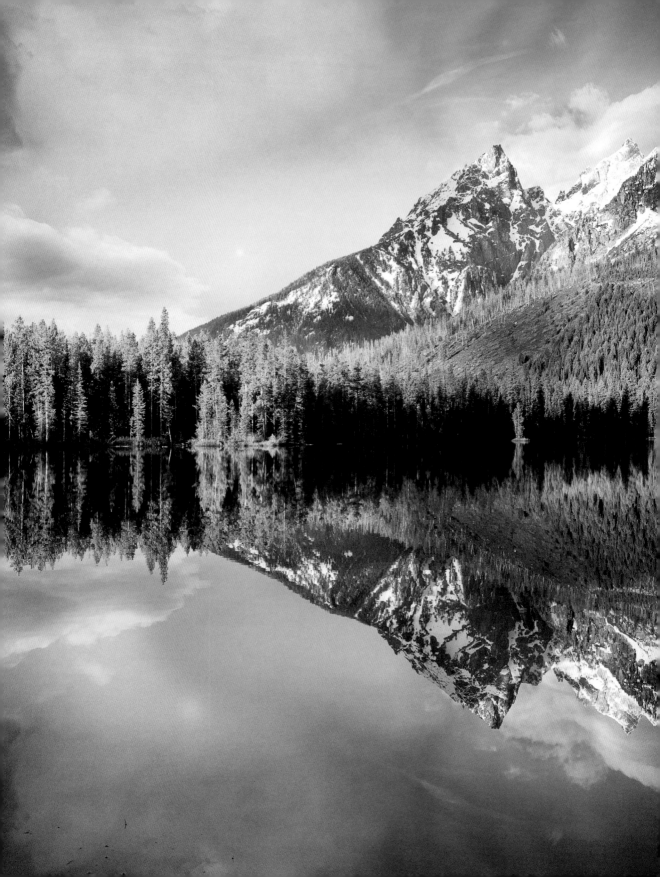

There's a lot of hype surrounding camera gear and much debate over brand X versus brand Y. And unfortunately, many people think that it's the equipment that matters most. I've overheard people looking at a print say, "I wish I had a better camera." But it's important to remember that cameras don't make pictures; people do. Cameras, lenses, and all the trappings can give you various levels of flexibility, performance, and quality for shooting in a wide range of situations, but in the end it's the photographer who creates the picture, and the camera simply captures it.

You need to use good-quality equipment, but try not to get hung up believing you need to always have the newest, most expensive equipment to make the pictures you want. In fact, many of the capabilities of today's gear exceed the ability of the photographers using it.

A skilled nature photographer can make excellent, pro-quality shots with today's midrange, consumer-grade cameras — in fact, many fantastic photographs have been made with less than professional-quality camera equipment, as is demonstrated in 5-1. Conversely, in the hands of an inexperienced photographer, a high-end pro camera won't magically produce exceptional results.

5-1

ABOUT THIS PHOTO *Image of Zebra Canyon, Grand Staircase-Escalante National Monument, Utah (ISO 125, f/18, 1/20 sec. with a Canon EF 28-135mm IS lens). This image was captured with a "prosumer"-grade camera with a sensor resolution of only 8.2 MP. Maybe more importantly, the lens used to make this photo is also a nonpro-grade lens. I've printed this photo at 40×60 inches with excellent results.*

That said, there is a reason some photo gear is very expensive and popular: It's simply the best available. And there's certainly no doubt that it can be a real struggle to learn your craft using inferior equipment. Features such as resolution, image stabilization, ISO capabilities, and live previews are key functions to consider when shopping for gear. The trick is finding the ideal balance between price and performance and acquiring equipment that has the controls *you* need at a price you can afford. The kind of shooting you plan to do makes a difference in equipment choices: for example, if you enjoy low-light or night photography you need a camera with exceptional performance at high ISOs.

It's easy to go overboard and carry too much gear, but for nature photography it's important to only carry what you really need and will actually use.

Whatever camera gear you have, you need to learn to use it properly. At minimum, you should be intimately familiar with the functions that you'll use most of the time. To know what's important and what's not, spend some time really getting to know the controls on your camera and lenses. In the end, you'll find a few key settings that you'll use most frequently for each kind of picture. (On all my cameras there are many functions I never use.)

Most important is that you know how to change ISO, focus, exposure mode, aperture, shutter speed, exposure compensation, and white balance.

Ultimately, you need to know your equipment well enough to set up your shots quickly and without too much thought so you can concentrate on designing the photograph. You must learn to use the correct settings for the picture you want to make, not simply know what a

certain setting does in the camera. In this chapter, you learn about the basic characteristics and recommendations for the equipment; in later chapters, you learn the essential settings for specific techniques on certain kinds of nature photos.

> **tip**
>
> When you read a camera manual, try not to get overwhelmed by all the available options — you very likely don't need to know about all of them. Learn your camera settings a little at a time as you make certain kinds of pictures. This allows you to use the correct settings for each set of circumstances.

DIGITAL CAMERA TYPES

There are several main types of digital cameras available today. The basic design of cameras has not changed much throughout the past few decades. Newer models add more automated features and controls to make aspects of photography easier, but the principles used to produce a captured photograph have remained essentially the same.

The camera *body* is the housing that encloses the recording medium and holds the knobs, dials, buttons, and switches that affect the making of pictures. The *lens* is made of glass elements that allow light into the body and onto the recording medium. Some bodies have lenses permanently attached while others allow switching between lenses for different conditions.

The quality and size of your digital image files depend on the camera and lens you use. The three common types of digital camera designs are

- **Compact point-and-shoot.** These cameras are generally the least expensive. Most have very small lenses, poor to moderate image quality, and few manual options. You can make some

decent nature photographs with a point-and-shoot, but as your skills improve you'll want to consider other types of cameras.

- **Advanced compact.** Sometimes called *bridge cameras*, *superzooms*, or *mirrorless systems*, these are a step up from point-and-shoot and provide manual controls and good image quality. Many newer models offer interchangeable lenses. The key characteristic of these cameras is that they do not have a mirror.

- **Digital single lens reflex (dSLR).** The dSLR is by far the most popular type of camera used in nature photography today. dSLRs come in a wide range of sizes, prices, and available options. dSLRs are discussed in more detail in the following section.

THE DIGITAL SINGLE LENS REFLEX (DSLR) CAMERA

A *single lens reflex* is a camera design that uses one lens and a mirror to show the image in the viewfinder. When the shutter is pressed to make the shot, the mirror moves out of the way, and then the *shutter curtain* opens to expose the picture on the sensor. When the lens is removed from the body you can see the mirror, as you can see in 5-2. (If you run a sensor cleaning operation, the mirror remains up so you can see the sensor.)

In many ways, the fundamental design of a dSLR is just like a film SLR except that the film has been replaced by a digital sensor; so if you've used an old Pentax K1000 or a Nikon FM in the past you will recognize the main camera controls.

dSLRs are generally priced around three levels: entry-level, prosumer, and professional. In a low-end, consumer-grade dSLR, you might find some features are limited compared to professional models. Conversely, some of the features that you might find useful when just getting started in photography are lacking on pro models. Pro cameras offer many specialized controls that are useful for specific types of photography. All this being said, it's important to understand that many cameras cross these strictly defined boundaries. Features, rather than price, most often differentiate the categories, and prosumer cameras often provide the same image quality as pro models. Price often comes down to the available bells-and-whistles.

Camera bodies (and lenses) vary widely in the quality of their construction and materials. Low-end models are made mostly of plastic. In the mid-range, it's a combination of plastic and metal, offering moderate durability. High-end, professional equipment uses the highest quality materials, is often mostly assembled by hand, and is made to withstand extreme weather conditions.

DSLR FORMATS AND SENSORS

There are two main types of dSLRs: *35mm* and *medium format*. The format refers to the size of the image sensor that captures the pictures.

5-2

ABOUT THIS PHOTO
*Canon EOS 5D Mark II body.
This is a prosumer-level cam-
era used by many professional
photographers. ©Canon USA.*

Within the general category of 35mm dSLRs, there are several size variations; in fact, many of these sensors are not actually 35mm. Advanced Photo System (APS)-sized sensors are very common and are physically smaller than so-called *full-frame* sensors, which are very close to the same size as 35mm film.

The main difference between full-frame and smaller APS formats is the way the lens projects the image onto the sensor. APS cameras have what's known variously as *magnification factor, crop factor,* or *focal length multiplier*. The lens projects an image circle that results in cropping of the captured image that shows more magnification than the lens focal length would indicate. For example, a 100mm lens at a 1.5x crop factor results in photo cropping like a 150mm lens would on a full-frame model, as shown in 5-3.

This is neither good nor bad; many photographers prefer APS-format cameras for their smaller size, lower weight, and longer "reach" of their lenses. Just understand that if your camera body is not full frame, you need to make your lens selections according to the magnification factor. A full-frame camera allows you to get wider coverage while an APS camera gives you longer zoom range with the same lens.

Medium-format (MF) dSLRs are larger, heavier, and more expensive than 35mm dSLRs (see 5-4). They also can provide significantly higher quality due to a larger sensor and generally higher quality lenses. MF systems use interchangeable parts; most notably the body is not permanently attached to the recording medium. Medium-format camera backs are interchangeable between bodies of the same brand, and you can use a film back on the same body as a digital back.

ABOUT THIS PHOTO
*Image shows coverage of APS-
sized and full-frame sensors.*

APS

Full frame

Many MF digital camera backs offer much higher resolutions than is available on 35mm format cameras. For nature photography, the primary advantage of an MF system is image quality and enlargement potential. The larger sizes of the sensors and photosites results in very high quality images with relatively low noise compared with 35mm captures.

Lens focal lengths are also different on MF systems versus 35mm. Whereas a focal length of around 50mm is considered normal for 35mm, on a MF system the normal focal length is closer to 80mm.

Besides cost, the main drawback to working with MF cameras is their size and weight, plus most are not sealed to repel the elements. (Medium-format cameras are most often used in studio work.) However, if you're able to use a medium-format dSLR for your nature photography, you'll often see a notable difference in image quality versus 35mm cameras. 5-5 shows a small crop of the opening chapter photo. Even at a distance of several hundred yards, stalks of grass are clearly visible on the far shore. This detail would not have been possible to achieve with a 35mm dSLR.

5-4

ABOUT THIS PHOTO
Image of Mamiya 645, a medium-format camera.
©MAC Group.

RESOLUTION

In digital photography, *resolution* is used in different ways to describe various aspects of the imaging process. In digital camera terms, resolution is measured in megapixels (MP) and refers to how much detail a camera can capture. The resolution of a capture also determines the size at which it can be printed at good quality.

A high-resolution photo contains lots of digital data; low resolution has less data. More resolution might mean that you can see the tiny veins of a leaf (see 5-6); with lower resolution all you can make out are the general outlines of the leaf (see 5-7). In today's terms, cameras of around 5MP are at the low end of available resolution; 15MP and above are high resolution.

tip
Always capture your nature photos at the highest resolution available.

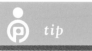

tip
If you're planning to buy your first dSLR, I recommend starting out with a camera with a minimum sensor resolution of at least 12 MP.

DSLR SHUTTERS

The shutter curtain sits behind the mirror and in front of the sensor. When you press the shutter button to take a picture, the mirror goes up and an opening in the shutter curtain passes in front of the sensor for the specified amount of time. As the shutter curtain moves, the image is exposed on the sensor. The amount of time the shutter is open is called the *shutter speed.*

5-5

ABOUT THIS PHOTO
Detail of image of Teewinot Peak reflected in String Lake, Grand Teton National Park, Wyoming (ISO 100, f/11, 1/45 sec. with a Hasselblad 35-90mm lens). On this MF system, the focal length of the 35-90mm lens is not as wide as the same focal length would be on a 35mm system.

Shutter speeds are measured in whole or partial stops based on full seconds or fractions of a second. Some cameras are capable of much higher shutter speeds than others. The fractional whole stop shutter speed values are

1/1 (shutter remains open for one full second)

1/2 (shutter remains open for one-half second)

1/4 (...one-quarter second)

1/8 (...one-eighth second)

1/15 (...one-fifteenth second)

1/30

1/60

1/125

1/250

1/500

1/1000

...and so on.

Shutter speeds can also be set for multiple seconds in whole or partial values, such as 1.6 sec., 4.5 sec., and 10 sec. Most cameras also have a

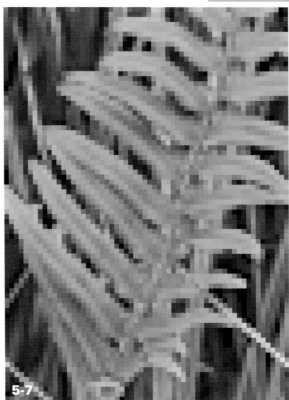

ABOUT THESE PHOTOS *Close-up images show varying level of detail depending on resolution. 5-6 is high resolution; 5-7 is low resolution.*

Bulb or B setting, in which the shutter remains open until you manually close it (or the battery runs out).

Fast shutter speeds stop motion. Long shutter speeds show the blur of motion in the picture. When you're making pictures in nature, you need to consider the shutter speed necessary to either freeze or show motion in the scene. For example, if you're photographing a waterfall, as shown in 5-8 and 5-9, use a slow shutter speed to blur the water and show motion in the picture. If you're photographing a stand of aspen trees when there's a breeze, you need a relatively fast shutter speed if you want the leaves to be sharp.

EXPOSURE MODES

The *exposure mode* dial sets how the camera determines aperture, shutter speed, or all automatic settings (see 5-10). The following list explains typical exposure modes:

■ **Mode Presets.** Consumer cameras have options for landscape, portrait, sports, and nighttime photography, while pro cameras often do not offer these modes. Though they may seem to offer convenience, using these automatic shooting modes has two notable disadvantages: (1) most cameras won't allow RAW capture in these preprogrammed

ABOUT THESE PHOTOS *Images of Whangarei Falls, New Zealand. 5-8 taken at ISO 800, f/4, 1/250 sec. 5-9 taken at ISO 100, f/14, 0.8 sec. Both photos taken with a Canon EF 24-105mm f/4 L IS lens. 5-8 shows the effect of a fast shutter speed stopping the motion of the falling water; in 5-9 the shutter speed is long enough to render the motion of the water as blurred.*

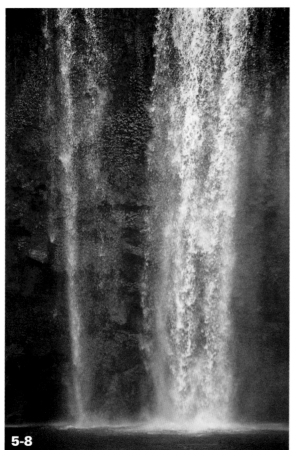

5-8

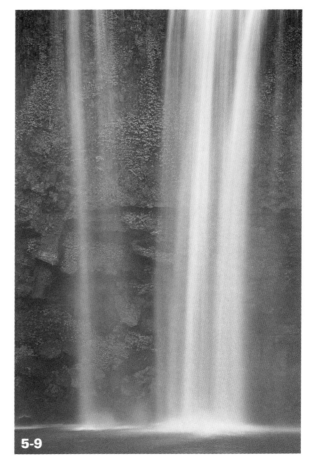

5-9

modes, and (2) you're letting the camera make all the exposure decisions instead of learning to control the camera yourself.

■ **Full Automatic.** In this mode, the camera calculates aperture, shutter speed, and sometimes ISO. On most dSLRs, Full Auto does not allow RAW capture.

■ **Program.** This mode is similar to Full Auto, but it lets you change the value of some settings and the others are adjusted accordingly. It may allow RAW capture.

■ **Shutter Priority.** You set the shutter speed; the camera determines the aperture based on the meter reading.

■ **Aperture Priority.** You set the aperture, and the camera determines shutter speed. Aperture Priority is one of the most useful exposure modes for the nature photographer.

■ **Manual.** You set shutter speed and aperture. The camera will take a picture using whatever setting you apply. This can result in overexposure or underexposure. Manual mode provides the most control over all aspects of the exposure and is essential for nature photography.

achieve very precise focus, even in relatively low light. However, it uses a lot of battery power to both hold the mirror open and display the preview image; you'll notice a significant difference in your battery life when frequently using Live View.

> **tip** All digital cameras have a clock in them. When you're traveling, remember to change the time to keep it current. In nature photography, you want to make sure the capture times for your photos are accurate. If you photograph something spectacular on a specific day at a certain time, later on you may want to know precisely when that image was taken.

DSLR LENSES

The purpose of a camera lens is to collect the incoming light and focus it at the focal plane. The type and quality of your lenses have a huge effect on the quality of your pictures. The way a lens transmits light to the sensor is a unique characteristic to that lens model and can also vary between different lenses of the same make and model. Sharpness, distortion, vignetting (darkening) of the corners, and lens artifacts such as chromatic aberration are properties that should be carefully evaluated when comparing the quality of the pictures a lens can make. It's always better to have fewer, better lenses than a lot of cheap, low-quality lenses.

TYPES OF LENSES

Most nature photographers carry several lenses in their bag. There are three basic types:

- **Prime lens.** Also called a *fixed focal-length* or *single focal-length lens*, a *prime lens* is set at one specific focal length. In general, prime lenses are the sharpest, highest-quality lenses available from a given manufacturer, but if you want to get closer to or farther from your subject you must move the camera.

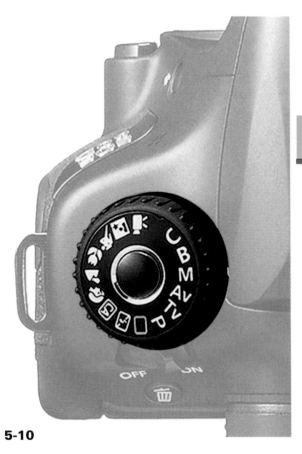

5-10

ABOUT THIS PHOTO *Exposure mode dial on a consumer-grade dSLR. Note the many automatic modes available on what appears as the left side of the dial. ©Canon USA.*

> **x-ref** Two other critical camera settings that affect your captured photos are white balance and ISO, which are covered in Chapter 3.

LIVE VIEW

Most current model dSLRs offer a feature called Live View, which is a live preview on the rear LCD screen. To show a live preview, the mirror is moved to its up position. Live View can be extremely helpful in applying the ideal settings for a photograph, including focus, depth of field, and exposure simulation. Many photographers (me included) love using Live View for its ability to

■ **Zoom lens.** This type of lens allows you to increase or decrease the focal length to change the magnification of an object or scene by turning a ring on the lens barrel. Zoom lenses offer the most flexibility of any lens type; with just a couple of them you can cover an extensive range of needs. The potential downside is that most zoom lenses are not quite the quality of prime lenses. Also, very high quality zoom lenses can be heavy, large, and bulky (though many consumer-grade zooms are made of plastic to be compact and lightweight). An example pro-grade zoom lens is shown in 5-11.

■ **Specialty lens.** Many lenses are made for specific situations or to create special photographic effects. For example, a tilt-shift lens provides controls for moving the lens elements to adjust focusing and distortion. Dedicated macro lenses allow great magnification and focusing at very close distances. Lensbaby makes a line of manual adjustment lenses for a wide range of special focusing effects.

FOCAL LENGTH AND MAGNIFICATION

The *focal length* of a lens determines the magnification and angle of view. Focal length is measured in millimeters (mm). Longer focal length provides higher magnification and narrower angle of view, as shown in 5-12. With a short focal length you get a wider angle of view and less magnification. Following are the general classifications of lens focal lengths:

■ **Wide-angle.** Super wide-angle dSLR lenses currently range from approximately 8-18mm at their shortest focal length. Standard wide-angle lenses range from 18-35mm. With a wide-angle lens, foreground elements are exaggerated and distant objects are minimized. If you photograph a tall mountain with a wide-angle lens it appears much smaller in the photo than it does to your eye. Wide-angle lenses inherently have a great depth of field.

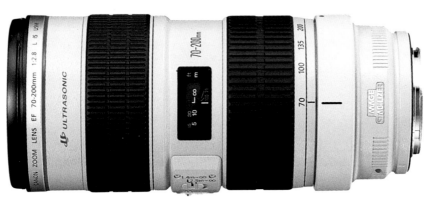

5-11

ABOUT THIS PHOTO
Canon EF 70-200mm f/2.8 IS L lens.
©Canon USA.

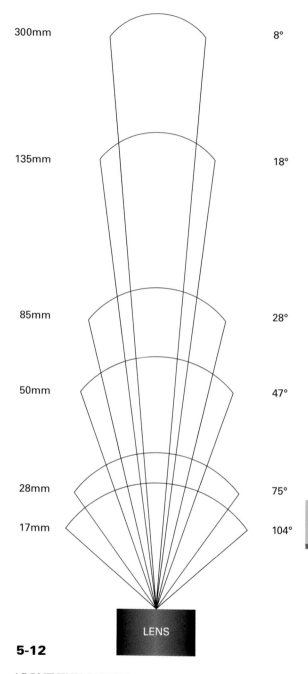

300mm — 8°

135mm — 18°

85mm — 28°

50mm — 47°

28mm — 75°

17mm — 104°

LENS

5-12

ABOUT THIS FIGURE *Focal length determines magnification and angle of view.*

■ **Normal.** Normal focal-length lenses for 35mm dSLR cameras typically range from around 35-70mm. The spatial relationships and distances of elements within the frame on photos made with normal focal-length lenses appear about the same as they do to your eye, although the peripheral vision on these lenses is significantly less than what you see. A normal focal length is roughly equivalent to the diagonal of the sensor; for example, on a 35mm sensor, the diagonal is approximately 43.3mm, so lenses with focal lengths around that same length are considered normal.

■ **Long.** On a 35mm or APS dSLR, most lenses above 70mm fall into this category. Most are also *telephoto* lenses, so named for the effect that compresses perspective and shortens the depth of field due to a focal length greater than the distance between the rear lens element and the sensor. With a telephoto lens, distant objects appear larger and closer in the frame and objects at varying distances in the scene appear to be stacked closely together. Beyond 300mm, lenses fall into the super-telephoto category. Long lenses, especially telephoto lenses, have very shallow depth of field.

> *tip*
>
> For very long lenses you should use a lens collar with a foot that attaches to the tripod head, rather than attaching the camera body to the head. This provides more balanced weight distribution.

You should have lenses that allow you to capture a range of different angles of view. For a grand scenic photograph, as you learn in Chapter 6, you'll often use a wide-angle lens with a short focal length. For close-ups and abstracts, you'll use longer focal lengths to get in tighter into the

scene (see 5-13 through 5-15). Your choice of focal length has the biggest effect on the composition and the final picture. By simply zooming in and out, you can create an unlimited number of pictures from a single scene. With time, you can learn what your lenses see at different magnifications so you can quickly choose the right lens for the picture you want to make.

> **note** Wide, normal, and long focal lengths are based on the format. For example, on a 35mm camera, 50mm is in the normal range, but on a medium-format camera, 80mm is normal and 50mm is closer to wide angle.

> **note** A photo made with a wide-angle lens may show perspective distortion at the sides of the frame. This can be avoided using a tilt-shift lens or corrected later in computer processing.

APERTURES

A lens *aperture* is the hole that lets light in. The aperture opening is created by a *diaphragm*, a series of overlapping metal blades that open and close to make the hole bigger or smaller. The aperture is indicated by an f-number (f stands for "factorial").

Apertures are often referred to as *f-stops*, with physical sizes measured as fractions of the lens focal length. For example, a 50mm f/1 lens has a 50mm aperture diaphragm.

A full stop is a difference of twice or half as much light coming into the camera. The aperture for each whole stop is equal to the previous aperture multiplied by 1.4. The standard whole f-stops are shown in 5-16.

5-13

5-14

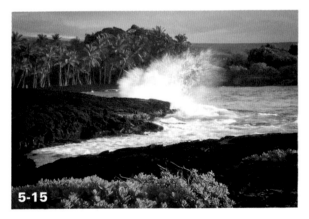

5-15

ABOUT THESE PHOTOS *Images of Punalu'u, Big Island, Hawaii, simulate wide, normal, and telephoto zoom (ISO 400, f/10, 1/13 sec. with a Tamron 18-200mm XR Di II lens).*

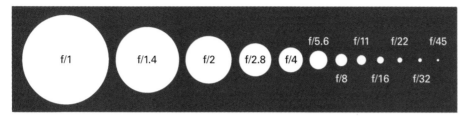

5-16

ABOUT THIS FIGURE
Diagram shows the decreasing size of standard apertures as the f-numbers increase.

In addition to the whole stops shown in the preceding diagram, most dSLRs also allow aperture values of third and half stops that give you very precise control.

A smaller aperture renders more of the scene in sharp focus. With a larger aperture, only a small range of distance will be sharp and everything in front of and behind that point will be blurred. This principle is called *depth of field* and is discussed in more detail in later chapters.

The maximum aperture of a lens (the smallest f-stop and the largest opening) is a major factor in the quality and construction of a lens. Lenses with very wide maximum apertures, such as 1.4 or 2.8, are called *fast lenses* because they can let in a lot of light, which allows faster shutter speeds.

Some zoom lenses have variable maximum apertures depending on focal length; for example, f/3.5 at 28mm and f/5.6 at 128mm. However, a zoom lens with a fixed maximum aperture at all focal lengths is ideal; these are usually the highest quality and most expensive lenses.

Turn off your camera's power before switching lenses.

Every lens has a "sweet spot" — an aperture that provides the absolute sharpest image. Usually the sweet spot is near or at the middle of the range of available apertures. If you have a lens that goes from f/4 to f/22, the sweet spot is around f/11. A lens with a range of f/2.8 to f/22 would have

a sweet spot closer to f/8. As you get closer to either end of the range of available apertures, the image is softened due to diffraction of the light between the lens elements.

x-ref Using the sweet spot to make the sharpest possible landscape pictures is discussed in Chapter 6.

FOCUSING

When you focus, the lens elements align to pinpoint one place in the scene that is precisely sharp. Focus happens on an imaginary plane directly parallel to the camera. This *plane of critical focus* can be very near the camera, all the way at infinity, or anywhere in between, but understand that there is technically only one point where the lens is exactly focused.

x-ref Many lenses have a scale on the lens barrel that indicates the distance at which the lens is focused. This is especially useful when using manual focus, but you can also use AF and then look at the distance markers to see where the lens is focused. For more about this, see Chapter 6.

All lenses have a minimum distance at which they can focus. The farthest distance you can focus is called infinity, indicated by the infinity symbol on the lens distance scale. At infinity, everything in the frame is considered to be on the same plane of focus, with no distance between them.

All modern lenses have autofocus capability. When this is enabled and you press the shutter button halfway, the lens looks for edges of strong contrast in the scene to lock onto. Sometimes this works, but in many cases the autofocus system does not focus at the perfect point in the scene. After all, it's just looking for something to lock onto; it doesn't know where you want to focus unless you tell it.

Even if your lens AF system does appear to lock onto a specific autofocus point, this doesn't mean the internal lens elements are at the optimal position for perfect sharpness. On most lenses, there is a significant amount of play between what the AF system considers in focus versus what you can achieve manually. See 5-17 for an example of precise manual focus.

There are two ways you can tell the lens where to focus:

■ **Set a specific autofocus point.** Your dSLR viewfinder shows a set of points that light up to indicate where focus has been achieved. You can pick one to force the lens to focus at that point in the scene. However, if the AF system can't focus there for any number of reasons, such as low light, low contrast, or lack of edge definition, the system continues to hunt for focus and may never find it. If multiple points light up, it means those areas are within the range of focus provided by depth of field.

■ **Use manual focus.** Mastering manual focus is one of the most important skills you can learn to produce excellent photography. Most lenses you can buy today allow you to use manual focus — there's either a switch on the lens barrel or an electronic setting in the camera (or both) where this is set. After changing to manual focus, you turn the focusing ring to set the focusing distance.

tip

If your camera has Live View capability, use it along with manual focus to get the sharpest possible pictures. With Live View on, zoom in close on the preview to check focus in different areas of the picture.

IMAGE STABILIZATION

Camera shake is a significant problem when shooting handheld or when wind or other sources of vibration are moving a camera mounted on a tripod. Many modern lenses include an *image stabilization* mechanism that can help you get sharper pictures. This is accomplished through the use of a servo — a tiny, mechanical motor that when activated allows the internal elements of the lens to float freely, so that vibration or camera shake is not transmitted through the lens elements. This is especially useful when shooting handheld in low light. Image stabilization systems can provide up to two full stops of exposure, allowing you to shoot with slower shutter speeds and lower ISO for higher-quality captures. Image Stabilization (IS, Canon) or Vibration Reduction (VR, Nikon) lenses are usually the top of the product line; if you can afford these lenses I recommend you seriously consider them.

note

Some camera bodies provide image stabilization on the sensor.

ABOUT THIS PHOTO

Image of Sweet Creek Falls, Oregon (ISO 100, f/22, 0.8 sec. with a Canon EF 24-105mm f/4 L IS lens). The focusing in this scene was critical, so I used manual focus and Live View to pinpoint the focus on the front of the rock near the middle of the frame. I also used a relatively slow shutter speed to control the blur of the water motion.

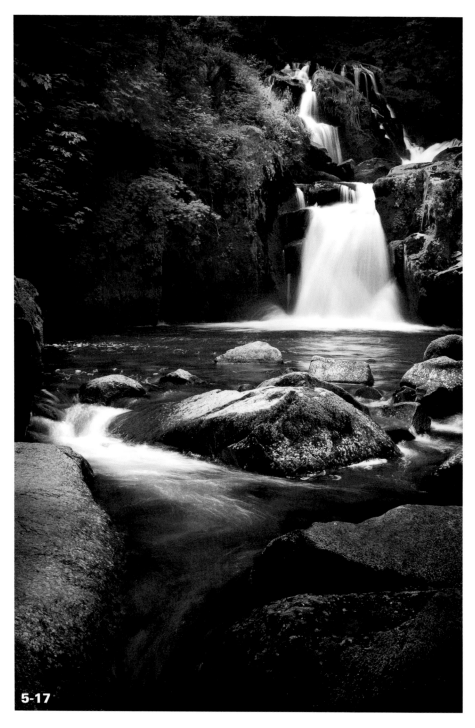

5-17

EXTENSION TUBES, TELEPHOTO EXTENDERS, AND ADAPTERS

You can choose from a huge variety of accessories that modify lens functionality. The following examples are all designed to attach between the lens and the camera body:

- **Extension tubes.** These allow closer focusing distances than a lens alone can provide. They are hollow tubes that place the back lens element farther from the sensor.

- **Telephoto extenders.** These are actually lenses in and of themselves; they contain glass elements and increase the magnification of the attached lens. Tele-extenders can cause light loss — as a rule of thumb, the amount of lost light is approximately equivalent to the extension factor: a 1.4x extender results in roughly 1.4 stops of light loss.

- **Adapters.** These allow you to use a lens from one manufacturer on a body from another manufacturer, such as putting a Nikkor lens on a Canon body or vice versa.

LENS FILTERS

Filters go on the end of the lens to modify the light coming in. They typically alter the color or clarity of light. Because filters cut the light entering the lens, they are often given a rating to tell you how much the light is reduced. This is called the *filter factor* and is assigned a number as shown in the following list:

2 = 1 stop

4 = 2 stops

8 = 3 stops

16 = 4 stops

Following is a list of the most common kinds of lens filters:

- **Clear.** The main purpose of a clear filter is to protect the front of the lens. It should be removed before shooting.

- **Ultraviolet (UV).** Also called skylight filters or haze filters, ultraviolet filters are marketed as producing clearer photos. However, they are usually of very low quality and really only serve to protect the front lens element. They should be removed before shooting; if you need to cut glare or haze, use a polarizer.

- **Polarizing.** A polarizer is an essential accessory for the nature photographer. A polarizer realigns the light waves coming into the lens. You can use a polarizer to cut glare, reduce reflections, and cut haze in the sky (see 5-18 and 5-19 for examples). A polarizer is especially useful when shooting in a wet forest; it makes your pictures appear much more vivid, rich, and vibrant by cutting the glare from the leaves. A polarizer has little or no effect when the light source is directly behind or in front of you. A polarizer can lose up to 2 stops of light.

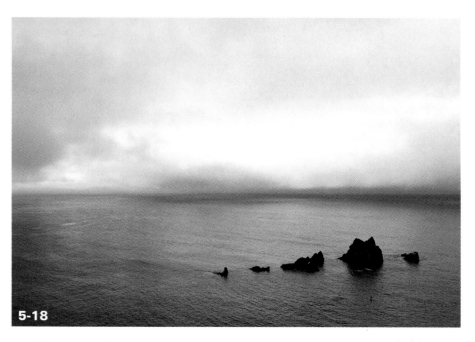

5-18

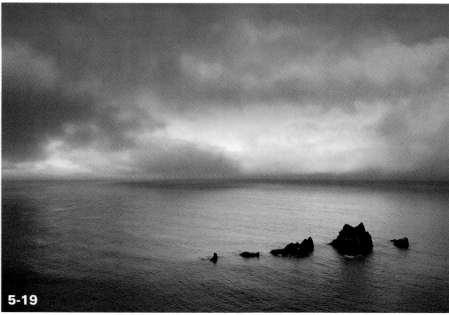

5-19

ABOUT THESE PHOTOS *Images of Ecola State Park, Oregon, show the dramatic effect created with a polarizing filter. Both images taken at ISO 200, f/8, 1/160 sec. with a Canon EF 24-105mm f/4 L IS lens. The only difference is that the second image is fully polarized. Because my angle of view was nearly 90 degrees to the rising sun at my left, the polarizer produced the strongest possible effect on the scene, darkening the blue sky, creating separation between the sky and clouds, and intensifying color.*

- **Neutral density.** A neutral density (ND) filter reduces the amount of light entering the lens, ideally without changing the color or distorting the light waves. Neutral density filters are especially useful for shooting waterfalls. ND filters also come in graduated (split) versions, where only part of the filter is darkened and the rest is clear. You can use these to balance the exposure between a bright sky and a darker foreground, allowing you to capture a wide dynamic range in a single exposure.

- **Special effects.** Many specialty filters available are for the nature photographer, such as those that provide special color effects. For example, the Singh-Ray LB Color Intensifier enhances greens as well as warm colors resulting in dramatic, colorful photos without appearing unnatural.

tip

For the highest quality captures, you should use as few filters as possible to achieve the effect you want. If you have a clear/UV filter on your lens and it isn't required for the conditions, take it off. You want the light coming onto the sensor to be as minimally modified as possible. Especially if you've spent a lot of money on a good lens, the last thing you want to do is degrade the image by adding extra layers of inferior glass.

LENS HOODS

Lens hoods help block bounced light and thus reduce lens flare (see 5-20). Manufacturers make unique lens hoods specific to each lens based on the way that lens captures light. You should always use the correct hood for each particular lens, but for some lenses no hood is available. In these cases you can block flare with your hand, your hat, or a piece of cardboard.

CAMERA ACCESSORIES

Besides a good camera and lens, a number of simple, inexpensive accessories make your nature photography easier and help you make better pictures. This list is not exhaustive; certainly you'll come across other small items that make a big difference. However, I suggest that you resist the urge to have every possible gadget in your bag. Your trips will be more enjoyable and your photography more productive if you carry only what you need.

TRIPOD AND HEAD

A good tripod is very often a necessity to produce good nature photos. Although shooting handheld allows freedom of movement and spontaneous working with the scene, in most cases you need a tripod to make sharp pictures. Making pictures in nature, you'll often be working with longer shutter speeds than you can effectively shoot handheld. Using a tripod is the single biggest factor in producing the sharpest possible pictures.

Look for a tripod that extends to a height that is comfortable for you and also collapses to a small enough size to be convenient. Also, you want a tripod that allows you to get down very low when necessary. For this purpose I prefer a tripod with a pivoting center column.

I highly recommend carbon fiber tripods. They are lighter and stronger and dampen vibrations better than aluminum. As for brands, Induro (see 5-21) and Gitzo are good choices.

5-20

ABOUT THIS PHOTO
Nikkor AF-S 70-200 VR lens with hood attached. ©2010 Daniel Stainer.

5-21

ABOUT THIS PHOTO *Induro CX-114 carbon fiber tripod with pivoting center column. ©Induro.*

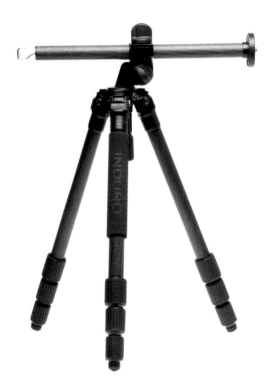

You also need a good tripod head. Several types of designs are available. The ball head design is the most popular and versatile. I highly recommend the ball heads from Acratech (see 5-22). Really Right Stuff, Markins and Kirk are also good choices.

A pan-tilt head has separate controls for moving the camera in different directions. A pan-tilt head is good for creating impressionist effects in your photos because you can move just one direction at a time.

Whichever type of head you have, make sure it's sturdy enough to hold your camera with the longest or heaviest lens you have without slipping or sagging under the weight of the camera.

> **note** Monopods are not very useful for nature photography, with the possible exception of wildlife, because for most of your pictures you need the camera to remain totally stationary.

5-22

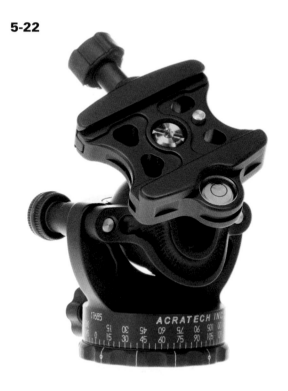

5-23

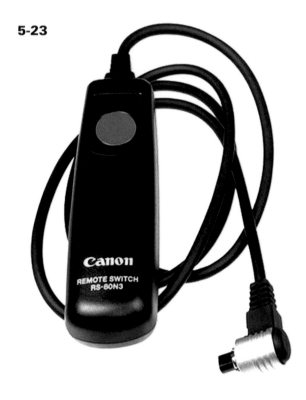

CABLE RELEASE

When you're shooting with your camera on a tripod you should also use a cable release, also called a remote shutter or remote switch (see 5-23). When you trigger the shutter with a remote release, you don't run the risk of blurring the shot by having your hand on the camera. Cable releases are usually made to connect with only one or a few camera models of the same brand.

note

Wireless remote triggering systems are also available.

tip

If you don't have a cable release, use your camera's self-timer when shooting on a tripod; this way you won't risk camera shake by pressing the shutter button yourself.

BATTERIES AND CHARGERS

It's always a good idea to have a spare battery or two on hand, especially if you're shooting in cold weather. Cold temperatures cause batteries to not perform as well as they do in warm weather. You may also drain your battery during a long day of heavy shooting (or when using Live View extensively), and you don't want to run out of juice when the afternoon golden light comes around.

MIRROR LOCKUP You might get slightly blurry photos as a result of "mirror slap," caused by camera vibration occurring when the mirror mechanism goes up as the shot is taken. If your camera offers an option for mirror lockup, you should use it when you're shooting with a cable release and your camera on a tripod. When mirror lockup is enabled, you press the shutter once to lock up the mirror and a second time to make the capture, after which the mirror goes down again.

All modern cameras come with a battery specially designed for that camera; it's not often that you can use the same kind of batteries in different dSLR models.

When buying replacement or extra batteries, I usually recommend buying the manufacturer's official products. However, I've used many third-party battery brands in the past with excellent results. The difference with more recent camera models is that the batteries have special computer chips in them that talk to the camera to provide more accurate information about the condition of the battery. Cheap knockoffs normally don't have these chips, and in some cases can damage your camera. Batteries are one accessory where you're best to not skimp on price alone.

Make sure to have several ways to charge your batteries; you can get chargers for wall outlets and car chargers.

CLEANING SUPPLIES

Keeping your camera and lens clean is a necessary and frequent task for the nature photographer. Here are a few supplies you should carry at all times:

- **Microfiber cloth.** Keep the front of your lens clean; a quick wipe with a lens cleaning cloth helps eliminate spots, blurry areas, and odd diffraction that may appear on your photos.

- **Blower.** A large, powerful rubber blower helps remove dust from your lens and sensor. When you're shooting in rain or other kinds of moisture, strong "rocket" blowers can blow water droplets off the front of your lens, avoiding the streaks caused when you wipe water off with your lens cloth.

- **Sensor cleaning kit.** Though you should periodically send your camera in to the shop for a thorough cleaning and recalibration, you can clean your dSLR sensor yourself. Cleaning kits are available in dry and wet versions. A dry brush, charged with static, lifts dust off the sensor. When you have spots on the sensor that can't be brushed off, a wet cleaning kit removes them.

REFLECTORS

There are many situations in which you'll be shooting close up and you can improve the shot by bouncing additional light into the composition. Get a double-sided reflector (gold/silver is handy) that is small enough to carry in your pack.

ODDS AND ENDS

Here are a few other items you'll want to have in your camera bag:

- **LCD loupe.** Hoodman and other companies make optical loupes that serve the dual purpose of magnifying the LCD preview and

blocking out external light. You can use the loupe along with Live View to zoom in close to check for perfect sharpness (see 5-24). A loupe is invaluable for reviewing captured images in bright sunlight.

■ **Angle finder.** An angle finder extends the viewfinder preview like a submarine periscope, providing an easier way to look through the camera when it's low to the ground or at an awkward angle. In my experience, using an angle finder has reduced the often uncomfortable and painful results from contorting my body for long periods of time.

■ **Bubble level.** Especially useful for creating grand scenic landscapes, a bubble level helps ensure your camera is level and parallel to the horizon. Some new cameras have a built-in electronic bubble level.

■ **Rain cover.** Some of your best pictures will be made in the rain. You can buy custom-fit plastic covers for your camera and lens, or use a plastic bag or shower cap.

■ **Miscellaneous.** Velcro straps, carabiners, clips, filter wrench, flashlight (head-mounted models are handy), a notebook and pen, plastic Ziploc bags, and a large towel or microfiber cloth may also be useful.

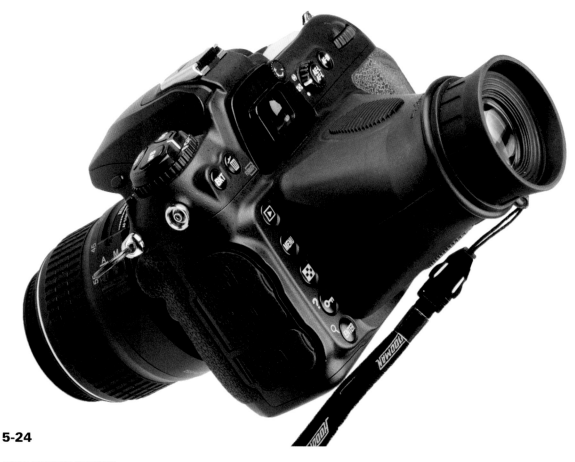

5-24

ABOUT THIS PHOTO *Hoodman HoodLoupe 3.0. ©Hoodman USA.*

DIGITAL PHOTO STORAGE

Ones and zeros, bits and bytes are the new "film." Electronic storage is fundamental to digital photography; the systems and devices you use to record the original capture and work with the pictures in the computer make a big difference in your workflow and the protection of your photographs.

CAPTURE FILE FORMATS

The way your camera saves files onto the memory card makes a difference both in image quality and the number of images you can fit on a card. Most cameras offer two basic choices: JPEG and RAW. (Some cameras also offer TIFF format.)

Your camera saves a JPEG file by rendering the captured data, applying any active style settings, and compressing the file to reduce the size. Your camera offers several levels of quality for saving JPEGs. These quality levels are based on the amount of compression: higher quality preserves more data and results in larger files, and lower quality discards more data and yields smaller files. When the camera is compressing data to save a JPEG, a lot of the original capture data is discarded; this data can never be restored. See 5-25 for an example of destructive JPEG compression.

The main advantage of JPEG is that you can fit more photos on a memory card; another advantage is that you can immediately view the files without additional processing and share them with other people by e-mail and on the Web.

A typical RAW capture is not compressed. The data from the sensor is encoded in a specific way based on the camera model and then saved as a RAW file on the memory card. No other modification of the capture data is performed. The main advantage to RAW capture is quality; for the absolute highest-quality images, always capture in RAW format. Another advantage of RAW capture is that it provides much more flexibility for editing in the computer than JPEG does.

A RAW capture is usually roughly equivalent in megabytes to the megapixels of your sensor. For example, RAW files from a 16MP camera are typically somewhere around 16MB in size, whereas a JPEG file from the same camera may be only 4 or 5MB.

Some cameras also offer variations in RAW capture settings, such as lower resolution and/or compression. Canon's sRAW and Nikon's RAW Lossless Compressed are examples.

> **note** Some cameras allow you to choose the bit depth for RAW captures. Bit depth determines the amount of data used to encode the image capture. Most dSLRs offer 12- or 14-bit capture modes; some MF systems provide true 16-bit capability.

5-25

ABOUT THIS PHOTO *Close-up of image saved with low-quality JPEG reveals compression artifacts.*

MEMORY CARDS

Depending on your camera, you have different memory card options for storing your photos. The most common and popular format for dSLRs is a CompactFlash (CF) card. Some cameras can also use Memory Stick or SD (Secure Digital) cards. Here are some tips regarding memory cards:

■ Like any electronic device, all memory is not created equal. I recommend buying name brands like SanDisk, Lexar, and Kingston.

■ It's possible that any memory card will eventually fail. It's important to always have several cards with you. Also, try not to shoot to the point where your card is entirely full as errors are more likely to occur.

■ It's better to use more, smaller cards than fewer large cards. If you're shooting for days on a single 32 GB card and it fails before you download the files, you could lose significant amounts of work. I use 4 and 8 GB cards for still images; if I'm shooting video I use 16 or 32 GB cards.

■ Keep your cards in a card wallet or sleeve to have them readily available and protected from the elements.

■ Always format your cards in the camera before each use.

■ As you're working in the field, make time to frequently copy your image files from your memory cards to your computer and/or back them up to another portable storage device.

 tip If you capture in RAW format, make sure to have plenty of memory cards available!

PHOTO VIEWERS

While you're out shooting you can copy your pictures from the memory card onto a portable storage device. This is a good way to make immediate backups and also to view the photos at a larger size than what your camera can provide. The most popular photo viewers are made by Epson (see 5-26); other notable manufacturers include Jobo and Hyperdrive.

5-26

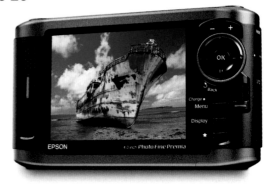

ABOUT THIS PHOTO *Epson P-6000 Multimedia Viewer. ©Epson.*

COMPUTERS

Computers are essential parts of a digital photo system. Just like your camera equipment, you should research and purchase computers with care. In Chapter 9, you learn more about the digital processing workflow, but at this point, you just need to be aware of a few considerations for building your digital photo system to include computers.

Whether you prefer working on Mac or Windows, you need to set up your computer with as much power as you can afford. A day of digital nature photography can produce hundreds or thousands of images. You need ample hard drive space and plenty of memory (RAM).

Ideally, you'll have a laptop for working on the road and a desktop machine at home. Carrying a laptop when you're shooting in the field offers

two distinct advantages: (1) you can download and back up your photos soon after the shoot, and (2) you can review and process your photos in the downtime between shooting. Both situations make your work easier when you return home to your main computer. If you only use a laptop, you should get a desktop display for working on your photos when you're at home. More about this is covered in Chapter 9.

CARD READERS

You should always use a dedicated card reader to copy files from your memory card to the computer; don't attach your camera directly to the computer with a cable. Doing so creates much slower copies and could corrupt files because the camera and computer don't necessarily communicate well. A card reader is faster and safer, and it's cheap. For the best performance, buy a dedicated card reader for the brand of cards you're using.

TRANSPORTING YOUR GEAR

Carrying your stuff around can be easy or difficult depending on your choice of bags. For nature photography there are a few obvious solutions. Shoulder bags usually aren't good. Most nature photographers instead prefer photo backpacks because long hikes are often required to access prime shooting locations.

A backpack securely holds a lot of gear and most allow fast, easy access when you're in the field. Like tripods, the weight of your pack is important.

Also very popular are the modular pack systems like those from Think Tank and LowePro. Using a harness and belt system and movable pouches, these systems provide the most flexibility and custom fit.

When you're choosing a pack, be sure to try it on before buying. You need a pack (or modular system) that fits your body well, holds all your gear and gives you fast, easy access.

WHAT'S IN MY BAG Over the years I've had many cameras and lenses, tripods and heads, and more backpacks than I'd like to admit. These days, I'm into carrying minimal equipment. Here's what I currently use:

dSLR: Canon 5D Mark II

Lenses: Canon 24-105 f4 L; Canon 28-135 IS; Canon 70-200 f2.8 L; Canon 2x Extender

Flash: Metz 54Mz4

Tripod/Head: Induro CX114/Acratech GP ballhead

Backpacks: Think Tank StreetWalker Pro

CF cards: SanDisk Extreme series

Filters: B+W, Singh-Ray

Reflectors: PhotoFlex

This list isn't always the complete kit that I take on every trip; when I want a special lens, an additional camera body, or a medium-format system I rent equipment or get loaner gear from a sponsor.

Be careful buying a huge pack that fits more gear than you can comfortably carry. Some shooting locations require long hikes, and you'll wish you'd left a lot of that stuff back in the truck. 5-27 and 5-28 show carrying systems from Think Tank.

tip If you need to fly with your camera gear and must check it, you should get a hard-sided case like those from Pelican. It's not safe to check a regular backpack. If you're taking your pack as a carry-on, be sure it will fit in the storage of smaller aircraft.

CLOTHING AND OTHER ACCESSORIES

When you're shooting outside, the most important equipment is your clothing. If you're uncomfortable you're not likely to make your best pictures.

Cold, wind, sunburn, bugs, sand, rain — anything you can imagine might come at you when you're outdoors. Nature photography requires preparation for the elements.

Dress in layers. When I'm shooting in the cold, I start with Polartec long underwear, over which I wear weatherproof pants and a fleece jacket. If it's really cold I might add a sweater or sweatshirt. On top of the fleece I wear a weatherproof shell. As the day gets warmer I take off layers.

Gloves are a must; finding a pair that's easy to shoot with can be a challenge. I'm currently using a pair from Sirius, which make it easy to manipulate the equipment and keep my hands warm in all but the coldest environments, in which case I have a heavier pair that I take on and off. You can also get gloves with removable finger tips.

Here's a basic list of clothing and accessories you need, and depending on your circumstances you should do more research to find out what else you might need:

- Long underwear
- Weatherproof (windproof and waterproof) pants and jacket
- Lighter rain jacket
- Good boots
- Umbrella and clamp for tripod
- Bug spray
- Sunscreen

caution If you use any bug repellent with DEET, keep it far away from your camera. For that matter, keep it away from anything you care about, besides your skin. DEET eats everything, especially rubber, plastics, and anything made from petrochemicals. I can't state this strongly enough: if you let DEET loose in your camera bag it will damage your gear.

5-27

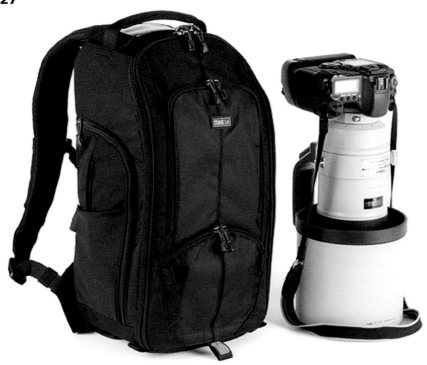

5-28

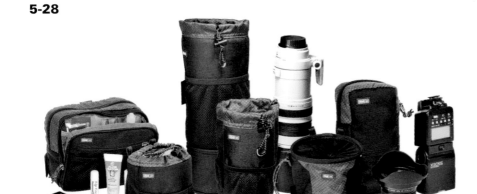

ABOUT THESE PHOTOS *5-27 shows the Think Tank StreetWalker Pro backpack. 5-28 shows an example of Think Tank's modular system. ©Think Tank.*

Assignment

Experiment with Exposure Modes

You need to get comfortable changing between exposure modes, especially Aperture Priority and Manual. For this assignment, first photograph a location using Full Automatic mode. Make sure your lens is set to use autofocus. As you're working, pay attention to the decisions the camera makes for you. Aperture, shutter speed, and possibly ISO will be adjusted automatically. Note the settings the camera uses for each picture. In particular, look at the depth of field provided by different apertures. Also note how the camera attempts to autofocus on elements within the scene. Sometimes it focuses where you want, other times not.

Next, try Aperture Priority mode. Set the aperture yourself, ranging from wide open to fully stopped down. Note how the camera automatically determines the appropriate shutter speed based on your aperture setting. Finally, switch to Manual mode. Start by entering the settings used for your last round of Aperture Priority shots; this should give you a reasonably accurate starting exposure. As you work in Manual mode, change both the aperture and shutter settings and evaluate the results.

For this assignment, I started shooting in Aperture Priority mode. As the light waned, the camera began to have difficulty producing correct exposure readings. Autofocus doesn't work when it gets too dark, either, because there isn't enough contrast for the camera to lock focus. At that point, I switched to full Manual exposure mode and manual focus. This image was made at Saguaro National Park, Arizona (ISO 800, f/16, 1.3 sec. with a Canon EF 24-104 f/4 L IS lens).

Remember to visit www.pwassignments.com after you complete the assignment and share your favorite photo! It's a community of enthusiastic photographers and a great place to view what others readers have created. You can also post comments, read encouraging suggestions, and get feedback.

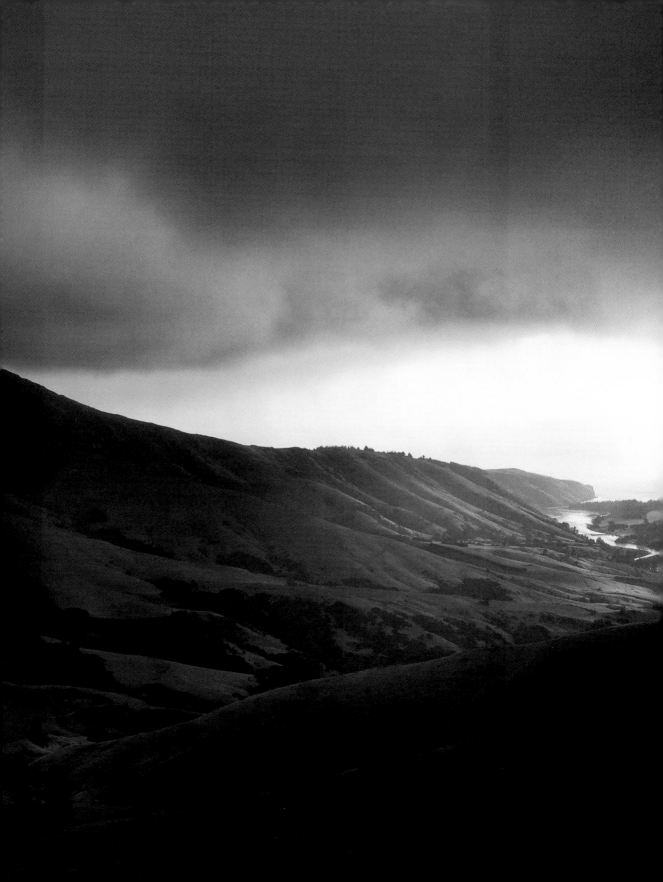

The grand scenic photograph is one of the most common types of nature images. It's usually the first kind of outdoor photos people begin making (this ties in with those ever-popular vacation pictures mentioned in Chapter 1). Usually, the wide-open, breathtaking vista is the most obvious photograph you want to capture.

So how do you make something so obvious into something special?

Making a compelling landscape photo showing a grand vista is one of the more difficult types of nature photography — straight landscape images are often the least interesting nature photos. Why? Because the photo fails to (1) envelop the viewer in the scene and (2) express the photographer's unique vision through effective design.

With these types of photos, you want viewers to feel as though they are standing at the same spot you were and become immersed in the picture. You must communicate what this special place means to you in an intellectual and emotional sense.

CHOOSING A LOCATION

In Chapter 1, you learned some methods for location research. When you're planning a grand scenic landscape shoot, scouting is invaluable. To know about the place before you arrive makes a big difference in the success of your photographs.

Starting out, you should choose locations with easy access. The difficulty of getting to a place shouldn't get in the way of practicing your photography. Depending on the time of year you plan to visit, you need to know about sunrise and sunset times, weather conditions, and hours of access.

PHOTOGENIC SPOTS

Of course, you'll be looking for locations that you find visually appealing. But you should also use the concepts presented in previous chapters to guide your choice of locations with purpose and intention. Look for places where you are free to roam around, at least a bit. Locations where there's only one place to shoot from aren't a lot of fun. Also, try to find places that offer a broad

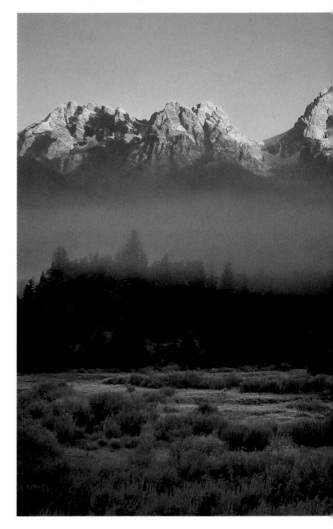

range of vistas, from long-distance views to more intimate areas where you can get close to your subject matter. Examine the relationships between foreground and background elements.

Look for places with character and a unique visual story to tell. Some places are much more photogenic than others, and if you find a good shooting location the success of your photographs will provide inspiration to keep working on your craft.

PUBLIC LANDS

National parks are great places to photograph, and most are open 'round the clock (see 6-1). If you can get in before sunrise and/or stay after sunset you'll often make your best images during these times. Entrance fees are required for all U.S. national parks. National monuments and state parks are a little more challenging; they usually have strict opening and closing times; fees are

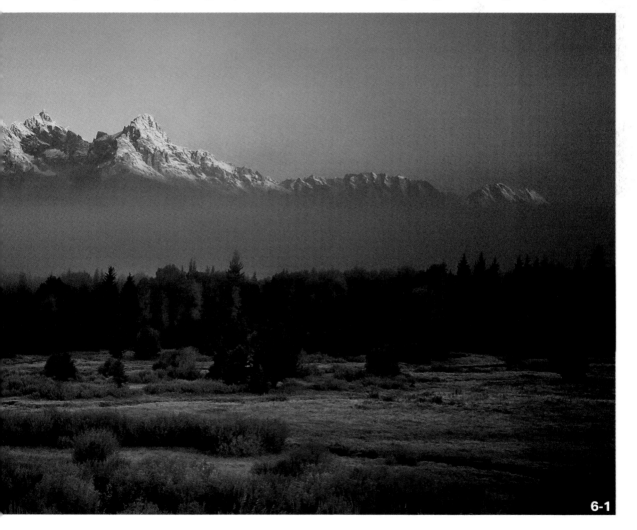

6-1

ABOUT THIS PHOTO *Image of the Cathedral Group from Blacktail Ponds Overlook, Grand Teton National Park, Wyoming (ISO 100, f/20, 0.6 sec. with a Canon EF 17-40mm L lens). This photo was made as the sun first started to illuminate the peaks. I arrived long before dawn to set up my gear and refine my composition; as a result I was the only person to witness this spectacular scene from that location. The Tetons and Jackson Hole offer an astounding variety of opportunities for nature photography.*

also required here. Public lands such as Bureau of Land Management (BLM) property and wilderness areas are often the most accessible locations and many offer spectacular opportunities for photography with no entrance fees. Finally, there are many wonderful shooting locations along the side of public roads — but these are often bordered by private property. You should never trespass on private property to do your photography — if there's a place you want to shoot, get the owner's permission.

caution Nearly all government and public lands in the U.S. have strict policies regarding commercial photography within their boundaries. Commercial photography requires a special permit on government land. If you are a private party just practicing your photography as a hobby, you shouldn't have any trouble and won't need any special permits to shoot on these lands. However, know that if you have a nice set of camera gear and are shooting with a tripod you might attract attention. In recent years rangers have often decided that a photographer is a "professional" because she has a pro camera with a long lens on a tripod and have issued tickets and fines to innocent folks. If you're approached by a ranger, never give any indication that you may be shooting for any kind of commercial purpose. Being an amateur practicing your photography as a hobby is the way to go!

POINT-AND-SHOOT VERSUS PERSONAL INTERPRETATIONS

Many photographers just starting out will rush to the spot that provides the best view of a grand scene and start snapping away. This is the same spot that countless hordes of other photographers and tourists have made their pictures. You know the ones I'm talking about — the pictures of places you've seen many times. In the United States, places like the Maroon Bells in Colorado (see 6-2), Haystack Rock in Oregon, Yosemite National Park, and the Great Smoky Mountains are favorite destinations both for serious photographers and casual tourists. In these cases, your job is to produce something unique from a place that's been photographed a gazillion times.

POINT-AND-SHOOT MENTALITY

If you walk to a spot, quickly set up your tripod, and immediately start shooting, you need to have a good reason for working this way, such as rapidly changing conditions that you don't want to miss. If the sun is about to set, the rainbow is fading fast, or those giant rain clouds are only minutes away, work quickly to make your photographs. To do this you need to know your gear and be able to quickly previsualize on location.

But in every case where you can slow down and really work the location, you should. The point-and-shoot mentality most often produces mediocre pictures at best. Many photos published as postcards and calendars are straight shots with little creative interpretation (see 6-3).

Whether the location is a place nobody's photographed before or an iconic tourist wonder, plan to *take your time* to make a great landscape photograph that speaks for your personal vision. When you slow down, previously unseen creative opportunities may unfold before your eyes.

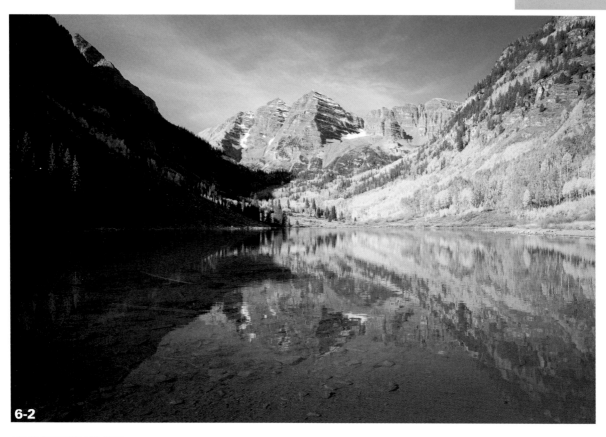

6-2

ABOUT THIS PHOTO *Image of the Maroon Bells near Aspen, Colorado (ISO 100, f/11, 1/10 sec. with a Canon EF 24-105mm IS L lens). The Bells are among the most frequently photographed locations in Colorado.*

ESTABLISHING CREATIVE PRIORITIES

The most common problem with unsuccessful grand scenic images is that the photographer tried to get too much in the picture. Even when you're working with a wide-open vista, the rules of composition and the process of elimination apply. Your landscape pictures will be most effective if you break down the picture into its elemental graphics and remove everything that doesn't guide the eye around the frame and to a main point of interest. To do this, you need to establish priorities.

When arriving on location, first look for the obvious. It might help to jot down some notes or make a quick shot list if you don't already have one. Be thorough. Identify all the photographic opportunities that provide the strongest immediate attraction for you. Pick the view you like the

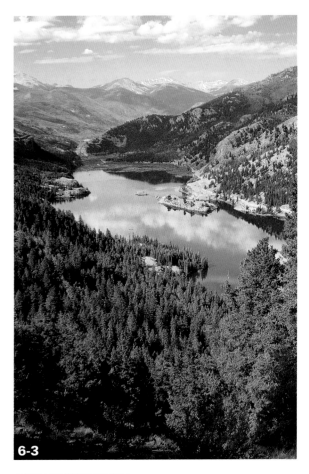

6-3

ABOUT THIS PHOTO *Image of Lake San Cristobal, Colorado (ISO 200, f/18, 1/60 sec. with a Canon EF 28-80mm lens). Although it's a pretty location, this photo doesn't have a lot going for it. The composition is unimaginative; the light is harsh and unflattering. I made this snapshot while I was quickly passing through the area. Had I found the location to be particularly inspiring I would have returned at a different time of day and scouted a more interesting location from which to shoot.*

best and set up for your first shot. Carefully compose the picture, check your camera settings, and make the photograph.

Then think about why you chose this over the other options. What is the picture about? What are the dominant elements? What is the story you're trying to tell? Be as clear as you can about your motivation for this picture. After doing this, you might choose to continue working to refine that shot: cleaner composition, better exposure, a bracketed series, and so on.

After you have that first photograph under your belt, consider what other images you want to make. Then focus your attention entirely on making the *next* picture. And the one after that, and so on.

When you've exhausted all the obvious shots, look closer. Dig deeper into the potential of the scene. Look high. Look low. Look behind you. Look up; look down. See 6-4 for an example photograph I made at a location with little obvious potential.

Change your position to create different visual relationships like those described in Chapter 4. Continuously ask yourself *why* you're doing what you're doing. What are you trying to accomplish; what do you want to say with each photo?

WORKING THE LOCATION

There will come a time when you believe you've exhausted all the possibilities at a location. This is a critical moment during which you will make your most progress as a photographer if you choose to push further. 6-5 shows a location where I worked for hours to produce my favorite image.

Take your time, don't rush, and don't pressure yourself to make something perfect right away. Fully working a scene requires you to persist in exploring *all* the possibilities, far beyond those that immediately jump out at you. In doing so, you'll make much better pictures than the ones you first envisioned when arriving on scene.

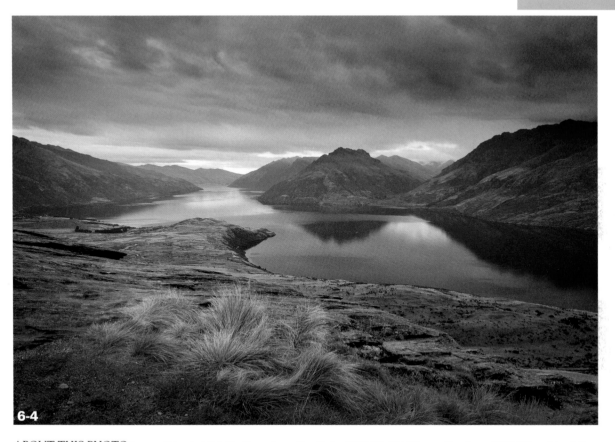

6-4

ABOUT THIS PHOTO *Image of Deer Park Heights, Queenstown, New Zealand (ISO 100, f/22, 3.2 sec. with a Canon EF 24-105mm L lens). The top of this hill was mostly barren rock. It was important to me to find an interesting foreground element to anchor the composition and lead the viewer's eye into the scene. I found this patch of grass, which helps complete the story of the place and creates balance in the picture.*

To fully exploit the potential of any given scene, ask yourself the following questions as you work:

■ What am I making a picture of?

■ Why is it important that I show this?

■ How do I think and feel about the subject and subject matter?

■ What direction is the light coming from? What are its qualities? Might the light be more appealing at a different time of day?

■ Could I get in closer or pull out farther to make the composition more effective?

■ Are there other photos available within the most obvious picture?

■ What's happening to the sides and behind me?

■ What if I get down lower or rise up higher?

■ What's the view like around that boulder or up on that ridge?

■ Would a different lens or a change in orientation help achieve the composition I'm previsualizing?

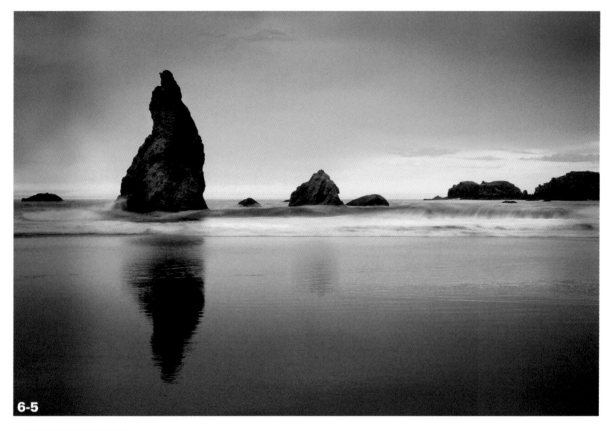

6-5

ABOUT THIS PHOTO *Image of Bandon Beach, Oregon (ISO 100, f/20, 1.3 sec. with a Canon EF 24-105mm L lens). I worked this location for several hours leading up to sunset. The many rocks and incoming tide presented an infinite number of compositions. I wanted to feature one dominant rock; I changed my position many times until I found the composition I was looking for. I ended up capturing nearly 120 frames during the shooting session.*

■ What is happening with the weather and other variable conditions?

■ Am I able to think clearly and concentrate on my photography, or am I distracted by anything?

■ Does this scene or subject matter truly resonate with me, or am I just going through the motions?

Remember: be patient!

CREATING VISUAL RELATIONSHIPS

As you learned in Chapter 4, a strong composition is achieved by careful placement of the elements within the frame. The relationship between the size and position of the main subject and surrounding/supporting elements determines the effectiveness of the picture. You need to decide on the main subject, focal point, and/or

center of interest first, and then arrange the elements in the composition to support your primary subject matter. Create these visual relationships with purpose and intention.

POINTS OF VIEW

The most important thing you can do to work a scene and establish the ideal visual relationships in the composition is *move the camera*. You'll find that even with very slight adjustments to the camera position you can create an amazingly diverse range of compositions from the same physical location (see 6-6 through 6-8).

Before choosing a place to set up your tripod, take a few minutes to just look around. Crouch down low, climb up high on a ridge, or move from side to side to evaluate how changing your view position affects the possible compositions. When you have a good idea of the composition you're looking for, set up the camera on the tripod.

tip Use the one-eye and invisible frame tricks explained in Chapter 2 to previsualize your shot.

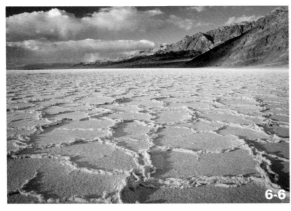

6-6

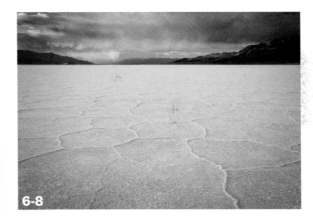

6-8

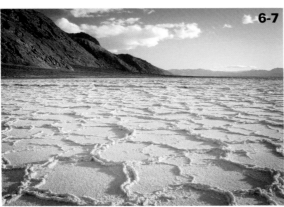

6-7

ABOUT THESE PHOTOS *Images of Badwater, Death Valley National Park, California. As the sun dropped toward the horizon, I made some images to get a sense of the kind of composition I wanted. I looked north and south (6-6 and 6-7), got lower, and raised higher. I wanted to find some salt polygons that were smoother and more delicate than the spot I was standing, so I hurried to get farther into the salt flats while there was still light available. 6-8 was made after sunset, with the soft glow of the sky illuminating the wispy cracks in the salt. 6-6 taken at ISO 200, f/22, 1/13 sec. 6-7 taken at ISO 200, f/22, 1/13 sec. 6-8 taken at ISO 250, f/22, 0.4 sec. All photos taken with a Tamron 18-200mm XR Di II lens.*

APPLYING DOMINANCE AND PROPORTION

As you're choosing how you want the viewer's eye to move around the frame, remember that most pictures benefit from one dominant element, as shown in 6-9. Often this can be achieved by changing the proportions of elements in relation to one another and to the frame.

Also keep in mind that strong graphics and contrasts attract more visual attention than areas with less detail and less color or tonal variation.

6-9

ABOUT THIS PHOTO *Image of Joshua Tree National Park, California, taken at ISO 320, f/20, 1/60 sec. with a Tamron 18-200mm XR Di II lens. Note how the burned Joshua tree at the right side of the frame is clearly the dominant element in the composition. Even though there are many complex details throughout the frame, the positioning of the dominant element gives a sense of simplicity to the picture.*

tip Before setting up your tripod, make a few handheld test shots to get an understanding of the camera settings to use, such as exposure requirements and aperture needed for appropriate depth of field. There are many factors to consider when setting up your shots. Establishing your optimal settings one at a time can help you be certain of them when you're ready to make the ultimate shot.

The most important element in the picture doesn't need to be the largest; in fact, quite the opposite is true. In a grand scenic photograph, you want the viewer's eye to move through the picture and resolve at the main focal point. Careful placement of each element in the frame, especially the main subject matter, helps guide the viewer through the frame.

ANCHORS AND LEADING LINES

Some of the most dramatic, engaging photos you make will include a strong foreground element that serves as a visual *anchor*. In these pictures you should allow the viewer's eye to travel into the frame and resolve at the background (see 6-10). A strong foreground element, such as a rock, plant, or tree, can draw the viewer into the picture, emphasizing spatial relationships and distance and making it feel like you're really there. But you don't want the foreground to create visual barriers that make it difficult to fully traverse the frame.

Look for objects in the scene with strong lines and shapes that can direct the eye in toward the distance, and try to leave some room around these objects so they don't create a barrier across the bottom of the frame.

AERIAL PERSPECTIVE

You can use *aerial perspective* to create great depth and a sense of vast distances in your landscape photos. Aerial perspective is caused by haze in the atmosphere (in this case it doesn't mean aerial

6-10

ABOUT THIS PHOTO *Image of the Totem Pole, Monument Valley Tribal Park, Arizona (ISO 160, f/29, 1/25 sec., taken with a Canon EF 28-135mm IS lens). The diagonal lines in the foreground sand lead the eye up and to the left, past the plants in the middle ground and to the rock spire in the background.*

photograph or shooting from a helicopter or plane). Objects near the camera appear strong in tone and color contrast; as the distances increase, the haze makes objects farther from the camera appear softer with less contrast and color and much less detail. This gives a strong front-to-back eye motion through the picture, as shown in 6-11.

note Photographs of the Great Smoky Mountains seen from Clingman's Dome are classic examples of aerial perspective.

ABOUT THIS PHOTO *Image showing aerial perspective, Tuscany, Italy (ISO 400, f/13, 1/200 sec. with a Canon EF 28-135mm IS lens).*

6-11

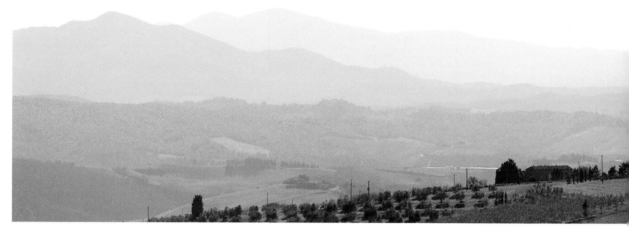

DEPTH OF FIELD FOR LANDSCAPES

Depth of field (DOF) is the range of distance in a photo that appears to be in sharp focus. The aperture and focal length used are the primary factors that determine DOF (see 6-12).

For most grand scenic photographs, having sharp focus from near to far is essential. Though there are exceptions (discussed in Chapter 7 with regard to selective focus), in a wide-angle landscape shot when some elements are sharp and others are not, viewers usually become distracted.

This means that the elements in the frame that are nearest the camera should appear to be the same sharpness as those at the farthest distance visible in the frame. To get maximum sharpness throughout the frame you need to handle two factors: focusing distance and depth of field.

Set the focus first, and then choose your aperture.

> **note** Depth of field is a creative decision and one of your most important choices when composing nature photographs. Whether everything is in focus is up to you. Because depth of field is one of the first decisions to make when you're setting up a shot, you should work in Aperture Priority mode, at least starting out, so that you choose the aperture and the camera sets the shutter speed for the optimal exposure. After determining the optimal aperture and shutter speed, you can switch to Manual exposure mode for maximum control.

SETTING FOCUS

After you've created your composition, the next thing to do is determine focusing distance. The distance at which the lens is focused is the most important factor in controlling what's sharp in the picture. If you focus at 10 feet the depth of field is different than if you focus at 30 feet. Focus distance and aperture work together to create the range of sharpness in the picture. Here are the steps for figuring out your focus distance:

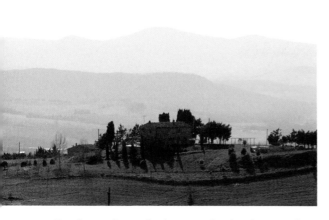

1. **Looking through the viewfinder (or on the live LCD preview), identify the point in the frame that's closest to the camera.** In most landscape shots this is somewhere near the bottom edge of the frame. (Of course, there are exceptions; if you have a tree branch or rock outcrop coming in overhead or to the side of the frame it might be the closest thing in the scene. Whatever is the case, find the object closest to the camera.)

2. **Step away from the camera and estimate (as accurately as possible) the actual distance from the camera to the closest object.** You can use feet or meters.

3. **Double that measurement.** The resulting distance is the point at which you should focus. For example, if the nearest object in the composition is a tree 12 feet away, you focus at 24 feet.

See 6-13 for an example of a scene where I focused at a specific distance from the camera.

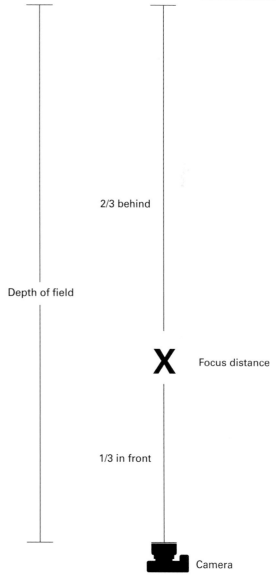

2/3 behind

Depth of field

X Focus distance

1/3 in front

Camera

6-12

ABOUT THIS FIGURE *Diagram shows range of depth of field based on focusing distance.*

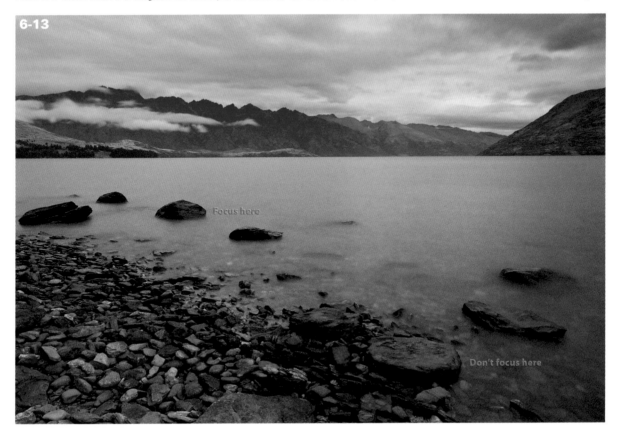

6-13

Focus here

Don't focus here

Remember the fundamental principle that depth of field is always 1/3 in front of the plane of critical focus and 2/3 behind it, up to infinity. (The plane is the point where you set the focus and is also the basis for hyperfocal distance calculations.)

Here's a recap of the focusing process for a typical landscape shot:

1. **Frame your composition.**

2. **Find the object in the frame that's closest to the camera.**

3. **Determine the distance from the camera to the closest object.**

4. **Multiply that number by 2.**

5. **Focus at the resulting distance.**

For maximum depth of field, don't focus on the nearest object in the frame!

To focus at a precise distance, you can use autofocus if there's an AF point that will lock onto that location. Otherwise, your best bet is always to use manual focus and set a precise distance using the distance scale on the lens barrel (see 6-14). Some lens distance scales also show distances based on aperture.

tip If your camera has Live View, use it to focus. Live View allows you to zoom in close enough to make focusing absolutely certain.

6-14

ABOUT THIS PHOTO *Focus distance scale and aperture range on lens barrel. © Canon.*

If your lens doesn't have a distance scale, you can establish focus at a specific point by looking through the viewfinder or on the Live View and making sure that part of the scene is in focus.

After you establish the focusing distance, move on to determine the appropriate aperture.

note Many dSLRs have an exposure mode called A-DEP (Auto Depth of Field). This exposure mode is not useful for nature photography.

APERTURE SETTINGS FOR GRAND SCENICS

Using a wide aperture produces a shallow depth of field with only a small area in focus; the rest is blurry. The farther outside the DOF range, the more blurry the image becomes, both in front and behind. *Deep focus* means a very long distance in focus — you get a great depth of field with smaller apertures (higher numbers, like f/16 and f/22).

Many photographers believe that you should always use the smallest possible aperture to get the most sharpness in a photo. This isn't necessarily true; in fact, you can often use much wider apertures and get plenty of depth of field and more sharpness. You'll notice that many of my wide-angle landscape photographs were made using f/5.6, f/6.3, f/8, and so on. (See 6-15 for an example.) This simple premise is one that will make a huge difference in the quality of your photography — if you're always using the highest numbered aperture, chances are your photos aren't as sharp as they could be.

tip As you study the effect of apertures in different types of shots, review the aperture settings used for the various photos in this book to see the aperture I used for each image. This goes a long way toward illustrating the concept.

Of course, with some lenses you'll need to go *higher* than f/22 for maximum depth of field. Also, depth of field varies with apertures on different lenses: f/8 at 35mm would yield much greater depth of field than f/8 at 70mm. You need to know when it's necessary to use a small aperture like f/16 or f/32 and when it's not.

First, know that when you're at either extreme — wide open (such as f/2.8) or fully stopped down (such as f/22), you lose sharpness due to diffraction that occurs as light bends around the blades of the aperture diaphragm. (This can happen at both extreme ends of the available range of apertures; to avoid this, whenever possible, don't shoot wide open or fully stopped down.)

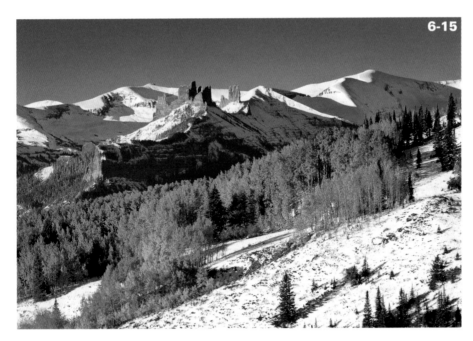

6-15

ABOUT THIS PHOTO
Image of the Castles, Ohio Pass, Colorado (ISO 100, f/8, 1/60 sec. taken with a Canon EF 70-200 f/4 lens). Because I was focused at infinity, the aperture didn't matter, so I used an aperture close to the "sweet spot," or middle range of the available apertures.

All lenses have a sweet spot, an aperture that is the absolute sharpest. On most lenses, this is near the middle of the available range; somewhere around f/8 or f/11 is usually the sharpest aperture. The general rule of thumb is that a lens's sweet spot is two full stops down from wide open. You can determine the sweet spot of a lens by making a series of photographs (all in sharp focus) at the full stop apertures, and closely evaluating the resulting photos at high magnification on the computer to see which ones are sharpest.

> **tip**
> In general you should always use the aperture closest to the middle of the lens's range as long as it gives you the depth of field you need.

However, depending on the distances involved in your photograph, using the sweet spot aperture might not provide enough depth of field. Your choice of aperture needs to be based on (1) where you're focused, and (2) the distance between the nearest and farthest objects in the frame.

If you're focused at infinity, the aperture doesn't matter at all; there is no depth of field — it's a flat plane of focus. You could shoot wide open or fully stopped down and the range of sharp focus will be identical, save for any differences in diffraction. So when you're focused at infinity, always use the sweet spot aperture: f/8, f/11, or somewhere thereabouts.

If you're focused at anything *less* than infinity, you need to pay very careful attention to your aperture selection, based on your need for depth of field. Remember that your depth of field is 1/3 in front of and 2/3 behind the plane of focus. The determining factor in the ideal aperture depends on the distance to the object closest to the camera.

For example, if you need to maintain sharp focus from 16 feet to infinity, you might not need to use f/22. If you want to get the ground at your feet and infinity in sharp focus, you'll likely need f/22 or higher.

Every lens model has an inherently different depth of field. A wide-angle lens has much more depth of field than a long telephoto lens. With a wide-angle lens, you might be able to use f/11 or f/16 to get everything sharp. With a longer lens, you might well need f/22 or higher. How will you know? You can use a printed chart, you can do the math, you can keep taking shots and checking them on the LCD preview, and you can preview the DOF before you make the picture.

note Hyperfocal is a combination of focus distance and aperture that produces the sharpest image and greatest depth of field possible for a given lens. You can get hyperfocal charts that show the aperture and focusing distance for various lenses.

DOF PREVIEW

Nearly all modern dSLRs provide a *Depth of Field (DOF) Preview* button. When you look through the viewfinder, what you see is the view with the lens aperture wide open. So what you see does not show the depth of field that will result when you set a higher aperture, such as f/16. But if you set your aperture value to f/16 and press the Depth of Field Preview button, the lens is stopped down to f/16. Now what you see through the viewfinder accurately shows depth of field.

However, it's also very dark. So dark, in fact, that in some cases DOF Preview is unusable through the viewfinder (especially with APS-sized cameras, which usually have darker viewfinders than full frame models). Enter Live View.

If your camera has the ability to show a live preview on the LCD, use it! Live View often also enables you to use *exposure simulation*, which applies all the current exposure settings to the preview. When you press the DOF Preview button, the camera compensates the exposure to show you a much brighter, very workable preview.

You can also zoom in on the preview to check focus. If the depth of field isn't enough to render sharp the distances you want, increase the aperture. This is one of the most useful applications of Live View and one reason why I strongly recommend you get a camera with this feature.

tip If your camera doesn't have Live View, you can make a photo and zoom close into the preview to check sharpness.

Over time, using your different lenses, you will come to know the depth of field needed for different shots with various distances involved. In the meantime, or if you don't have Live View, you can capture a photo and preview it on the rear LCD to check for sharpness.

In truth, I often do all these things: I carefully evaluate distances and use manual focus with the lens distance scale to determine the focusing point, I select the aperture appropriate for the distances and the lens being used, I activate Live View and DOF Preview to check the near and far objects in the scene for sharpness, and after taking the shot I preview the final image on the LCD. This eliminates surprises, and my photos are sharper than ever.

mobile technology A growing number of mobile apps (such as the DOFmaster iPhone app) make calculating depth of field and hyperfocal distances easy.

ACHIEVING MAXIMUM SHARPNESS

You can consistently make perfectly sharp pictures. Here are some tips:

- Use a tripod. If it's windy and your tripod has a hook on the bottom of the center column, you can hang your camera bag or another weight on it to further stabilize the tripod.

- When shooting with a tripod, turn off Image Stabilization/Vibration Reduction on the lens.

- Remove all lens filters that you don't absolutely need for the shot.

- Use manual focus.

- Set the appropriate aperture for the depth of field you want. Try to use an aperture in the sweet spot of the lens. Consider using hyperfocal focusing.

- Use Live View with Depth of Field Preview and exposure simulation.

- Use a cable release, wireless trigger, or the camera's self-timer.

- Use mirror lockup.

- Use the lowest ISO possible.

- Use a fast enough shutter speed to stop any motion in the scene.

> **note** In some circumstances you may not be able to achieve the depth of field you want, even at the smallest aperture available on the lens. This is especially true with long telephoto lenses, which have an inherently shallow depth of field. In these cases your only choices are to switch lenses or bracket focus.

EXPOSURE FOR LANDSCAPES

You'll experience wildly varying lighting conditions shooting grand scenic vistas. Sometimes exposure is simple and straightforward; most of the time it's not. Depending on your composition, you need to carefully determine the ideal exposure settings to produce a captured file with correct tonal values and as much image data as possible.

- **Whenever possible, don't underexpose.** Underexposing a digital capture results in much less data than a correct (or slightly overexposed) capture.

BRACKETING FOR DEPTH OF FIELD The term *bracketing* refers to taking a series of shots, instead of just one, in order to ensure that you have the captures you need to make the highest quality image. In cases where you cannot possibly achieve the depth of field and distance of sharpness you want, you can bracket focus. Changing the point at which you're focused in the scene effectively shifts the range of perfect sharpness. You can make one image focused on the foreground, one in the midground, and one at the far distant background, and blend these images together in Photoshop or similar software. This is the best way to get the absolute sharpest photo from front to back, even if your current lens and/or aperture settings can't quite get there.

■ **When in doubt, "shoot to the right" of the histogram.** If you can't nail the exposure dead-on, it's actually better to be a little bit overexposed. Your camera histogram will show when there's more image data to the right (toward the highlights) than toward the shadows at the left. Remember, more captured light equals more data in the image files. On the computer, it's much easier to work with a digital image that's overexposed than one that's underexposed. Just make sure to avoid clipping the highlights (as discussed in Chapter 3).

If you're working in Aperture Priority (Av), you'll adjust shutter speed and/or ISO to get the correct exposures. In Full Manual mode, you can adjust all three settings independently. If you pay close attention to your exposures you will soon find you can quickly adapt to changing lighting conditions and your photos will look much better, even before processing.

EXPOSURE VARIATION

At times, you'll compose a shot and the camera meter will provide settings for a perfectly exposed capture. More often than not, you'll need to override the camera's metered settings to produce the optimal exposure.

Your camera attempts to produce a balanced exposure equivalent to 18 percent gray. Green grass in sunlight is around 18 percent gray in terms of brightness. But what if you're not shooting green grass? The camera meter averages all the brightness values in the frame and comes up with exposure settings based on that. Surprisingly, this sometimes works very well. But the camera meter is sometimes easily fooled.

If you are shooting a field of snow, sand, or bright sky, the camera lowers the exposure to get to 18 percent gray, so your shot would come out underexposed. If you're shooting black lava rock in the shade, the camera brightens the exposure, again, to get it to 18 percent gray. Your photo would come out overexposed.

So your job as a nature photographer is to apply camera settings that will create the exposure that fulfills your creative vision. If you want the snow to be bright and white like real snow, you would override the camera's metered settings by increasing the exposure (see 6-16). You can do this in Aperture Priority mode using exposure compensation (which would adjust the shutter speed) or you can go Full Manual and adjust whatever settings you want. The camera meter always shows you whether it thinks the scene is under- or overexposed.

tip For photos of snow or those including a vast expanse of bright sky, you need to expose over the camera's metered reading by 1 to 2 stops.

BRACKETING EXPOSURE

As explained earlier, dynamic range describes the range of tones, from light to dark, in the scene. Sometimes there's more than what the camera can capture in a single frame. In these cases you can bracket your exposures to capture the entire dynamic range in separate photos and later, in computer processing, you can blend the images together to make High Dynamic Range (HDR) images.

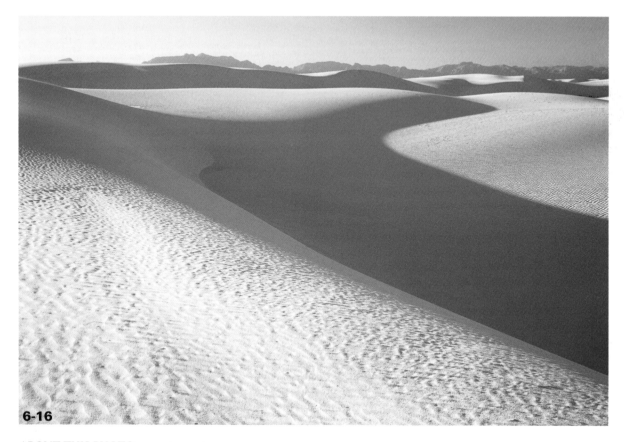

6-16

ABOUT THIS PHOTO *Image of White Sands National Monument, New Mexico (ISO 200, f/18, 1/25 sec. with a Canon EF 24-105mm L lens). This scene was so bright that I had to apply positive exposure compensation to force the camera to use a longer shutter time that would render the scene realistically instead of underexposing it.*

> *note*
>
> Whenever you merge multiple images in any way the result is a *composite* image. Panoramics, HDR blends, and so on are all composite images.

In all cases, if you're not sure about the exposure, bracket at least a few frames above and below the metered exposure just to cover your bases.

When you're shooting a grand scenic landscape, you have two practical options for bracketing exposure. The first is to shoot in Aperture

Priority and use *exposure compensation* to adjust the shutter speed. Exposure compensation, available on all modern dSLRs, allows you to override the camera's metered exposure by adjusting the other variable that you *haven't* set. For example, if you specify f/11 in Aperture Priority mode, and the camera meters the shutter speed at 1/125 sec., when you apply exposure compensation either up or down, the shutter speed adjusts accordingly: a 1-stop underexposure results in a shutter speed of 1/250 sec. A 1-stop overexposure produces a

BDE/SUNNY 16 RULE There's a principle photographers have used for decades to characterize a standard set of lighting conditions during broad daylight. Basic daylight exposure (BDE), also called the Sunny 16 rule, goes like this: At f/16 the ideal exposure is 1/ISO. So if your ISO is 200, on a clear sunny day the BDE is f/16 at 1/200 sec., or the nearest possible equivalent.

shutter speed of 1/60 sec. (remember, halving and doubling). The aperture value remains at f/11 because you're in Aperture Priority mode.

tip

> Most modern dSLRs offer auto-exposure compensation features that help making bracketed shots easier.

Your other option is to switch to Full Manual mode. Carrying the preceding example further, you could set the aperture to f/11 and set shutter speed yourself to 1/60 sec., 1/125 sec., and 1/250 sec., which would yield the exact same results in terms of exposure. This is an example of equivalency, introduced in Chapter 3. This demonstrates two ways to accomplish the same thing; use the method with which you're most comfortable.

See 6-17 for an example of bracketed exposures.

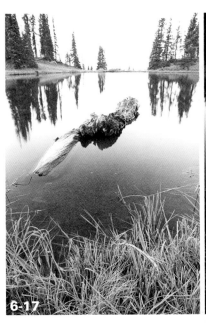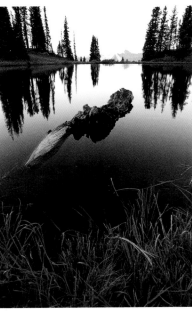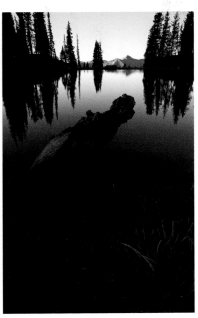

6-17

ABOUT THESE PHOTOS *Images of Paradise Divide, Colorado, taken at ISO 200, f/11 with a Canon EF 24-105 L lens. Exposures of the images from left to right were 1/3 sec., 1/13 sec., and 1/50 sec.*

PANORAMIC IMAGES

A *panoramic* photo is a single image made of multiple frames *stitched* together on the computer to form one long photograph. A "pano" is often the ideal representation of a grand scenic landscape, and you can make it yourself.

You need to have your camera mounted on a tripod to make a good pano, and regardless of the type of head you use, one key to capturing a good sequence of shots is to keep the camera level. Using a tripod head with a built-in spirit level makes this much easier.

> **tip** Capturing the individual images in portrait orientation provides more image data to work with.

Use Manual exposure mode. Take a meter reading and/or a test shot from the part of the frame that contains the midrange of tones and use those settings to use for the full sequence of captures. You should use manual focus to avoid problems caused when the lens automatically focuses on different parts of the scene. Take all the shots with exactly the same settings; this makes stitching more accurate.

Start at one side and create your sequence of images by overlapping each frame 30-50 percent over the area covered by the last one. It's always better to have too much overlap rather than not enough. Instructions for stitching together a pano are provided in Chapter 9. 6-18 shows an example panoramic photo.

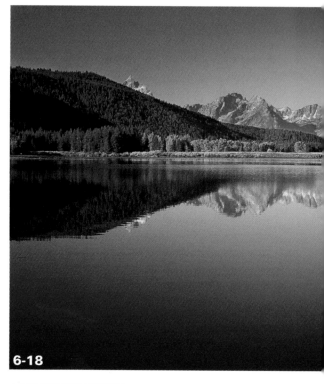

6-18

ABOUT THIS PHOTO *Image 6-18 of Oxbow Bend, Grand Teton National Park, Wyoming, created with three stitches taken at ISO 100, f/11, 1/25 sec. with a Tamron 18-200mm XR Di II lens.*

> **tip** Don't use a polarizer when making a pano; it will cause variation in the appearance of the sky in each shot, making them very difficult to stitch together.

> **note** Panoramic photography is a specialized genre unto itself. There are myriad specialized equipment and techniques for producing panos; for more information, see the appendix.

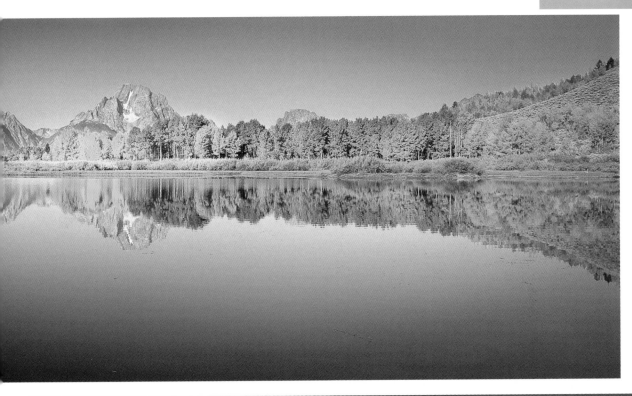

PANO GEAR Though it's possible to make decent panos using any tripod and head, you'll get the best results if you use head gear specially designed for panoramic shooting. The main factors are tilt and distortion. As you pan horizontally across the scene, even slight variation in the tilt of the camera becomes compounded, and when it's time to stitch the photos together it can be difficult to match the edges. Worse, when you crop the final image you might lose a lot of image area at the top and bottom of the frame. Distortion occurs with some lenses, especially around the edges and especially with wide-angle lenses. Ideally, your camera should be positioned to pivot around the *nodal point* of the lens — the ideal pivot point where there is little or no visible parallax error (distortion) as the lens is rotated to make a sequence of photos. (There are numerous tutorials on the Web for determining lens nodal points.) Using a dedicated pano rig can also significantly improve your results. Really Right Stuff, Manfrotto, and Nodal Ninja make well-designed solutions. Using a dedicated pano rig, you easily can make very large composite images using multiple rows and columns of captures.

REFLECTIONS

When you find a very still body of water in nature you can make beautiful photographs of the sky, landscape, and foliage reflected in the water. Even a slight ripple can destroy a reflection, so you need to shoot reflections while there is no wind.

Some reflections look best when there is something in the water near the front of the scene. This creates a focal point; as the eye traverses the image, the symmetry can become mundane. Breaking up the symmetry with a rock, grasses, reeds, tree branch, and so on in the foreground can make a very dynamic image (see 6-19). Of course, other images look great when they are

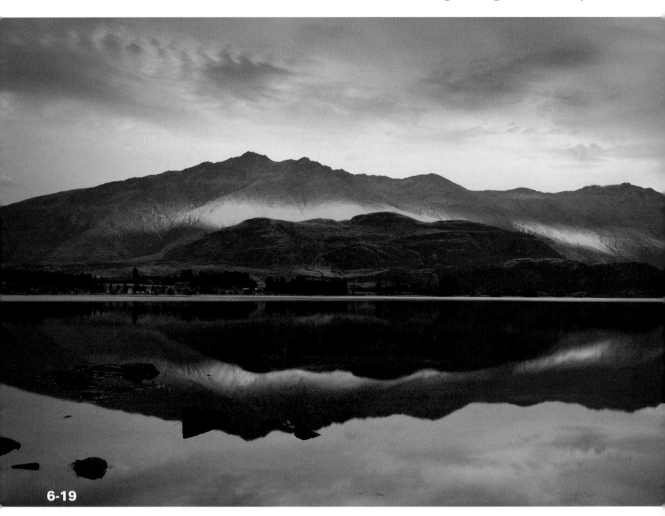

6-19

ABOUT THIS PHOTO *Image of West Wanaka, New Zealand (ISO 200, f/22, 2.5 sec. with a Canon EF 24-105mm L lens). I wanted to emphasize the symmetry of the reflection, so I placed the horizon near the vertical center of the frame. As the shaft of light moved across the landscape I refined the composition to anchor the bottom half of the image by including some rocks in the foreground.*

perfectly symmetrical with no variation between the top and bottom halves. This is one instance where placing the horizon in the middle of the frame can be very effective.

Reflections also benefit from a wide range of tones and variation in the details within the shapes in the image. If everything is lit uniformly there are no obvious places for the eye to go. Try to use a combination of lighting within the composition, as shown in 6-20.

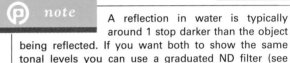

> **note** A reflection in water is typically around 1 stop darker than the object being reflected. If you want both to show the same tonal levels you can use a graduated ND filter (see Chapter 5) or darken/lighten one half during computer processing.

WEATHER

An otherwise drab and boring landscape can be dramatically transformed by weather. Consider the photographs you've seen of wide, sweeping

6-20

ABOUT THIS PHOTO *Image of Paradise Divide, Colorado (ISO 200, f/16, 0.4 sec. with a Canon EF 24-105mm L lens).*

plains with little variation and detail, overshadowed by huge, billowing storm clouds. In these photos, the landscape plays a diminutive role; weather and atmospheric conditions themselves become the subject matter. As you scout locations and build your personal lists of favorite shooting locations, always bear in mind the influence of weather and how it changes throughout the year. See 6-21 for an example of how dramatic weather can influence a photo.

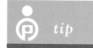

tip

In most cases, a clear blue sky doesn't present a visually interesting element in a nature photograph; the same goes for a sky covered with solid gray clouds. If the sky isn't interesting, in most cases it may be best to not include it in your composition (but of course, like other rules, there are always exceptions).

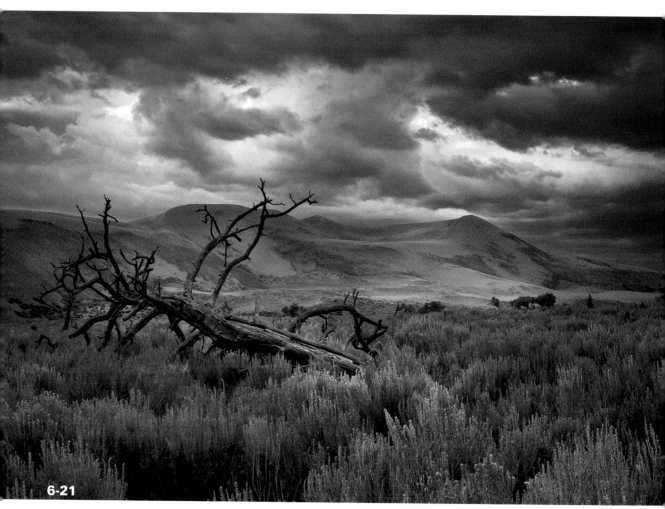

6-21

ABOUT THIS PHOTO *Image of Great Sand Dunes National Park, Colorado, before a summer thunderstorm (ISO 100, f/14, 1/10 sec. with a Canon EF 28-80mm lens).*

You can also manipulate how the sun appears in your photos. If you stop your lens down to a small aperture, usually around f/16 or higher, you can capture a sunburst, as shown in 6-22.

THE GRAND SCENIC AT NIGHT

You might want to try your hand at night photography — you may find it's your favorite time to shoot! All over the surface of planet Earth, just because there may be very *limited* light never

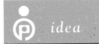 **idea** While shooting at night or very low light, try using a flashlight to "paint light" on objects in the scene. Light painting can create dramatic artificial lighting effects in your pictures.

means there is *no* light. All the camera needs is a long enough exposure and you're bound to capture something. To the human eye on a cloudy, moonless night there may appear to be no light, but in many cases you will find that with long exposures the camera can capture much more light than what your eye can see.

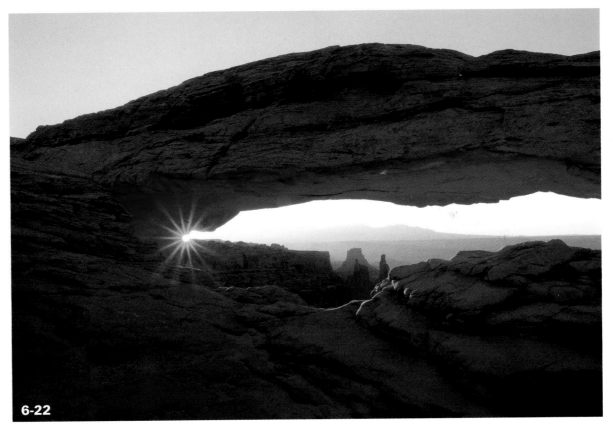

6-22

ABOUT THIS PHOTO *Image of Mesa Arch, Canyonlands National Park, Utah (ISO 100, f/22, 1/4 sec. with a Canon EF 17-40mm L lens).*

PHOTOGRAPHING STARS

On a clear night you can make photographs of stars. With short exposures you can capture the pinpoint lights of celestial bodies. Long exposures, from a few minutes to several hours, produce star trails. These kinds of images have lots of dramatic effect and demonstrate the power of the camera to render imagery you can't see with your own eyes.

See 6-23 and 6-24 for examples of different types of star photos.

> *note* To make photos of stars, you need to be far away from cities. They produce light pollution that makes stars invisible.

SHOOTING THE MOON

Including the moon in your composition can add a lot of interest. The challenge is exposure. Because the moon is reflecting the sun, it's usually much brighter than the surrounding sky and landscape. Timing makes a big difference; if you can photograph the moon while the landscape is still brightly lit you can make exposures that show the full detail of the moon (see 6-25). If the sky and landscape are very dark, there's not much chance of holding detail in the moon; it will be blown out to white, as shown in 6-26.

As for focus and depth of field, the moon is at infinity, so if you use an appropriate aperture and focusing distance you can show sharp detail in the surface of the moon.

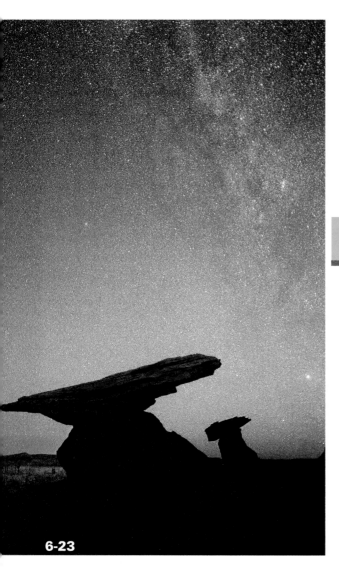

6-23

ABOUT THIS PHOTO *Image of Settler's Point, Arizona (ISO 6400, f/2.8, 30 sec with a Nikkor 14mm lens). The Milky Way (upper right) has a high density of stars visible from Earth and provides ample photo opportunities. In most cases 30 seconds is the maximum time you can leave the shutter open to render stars as sharp points of light. ©Grant Collier.*

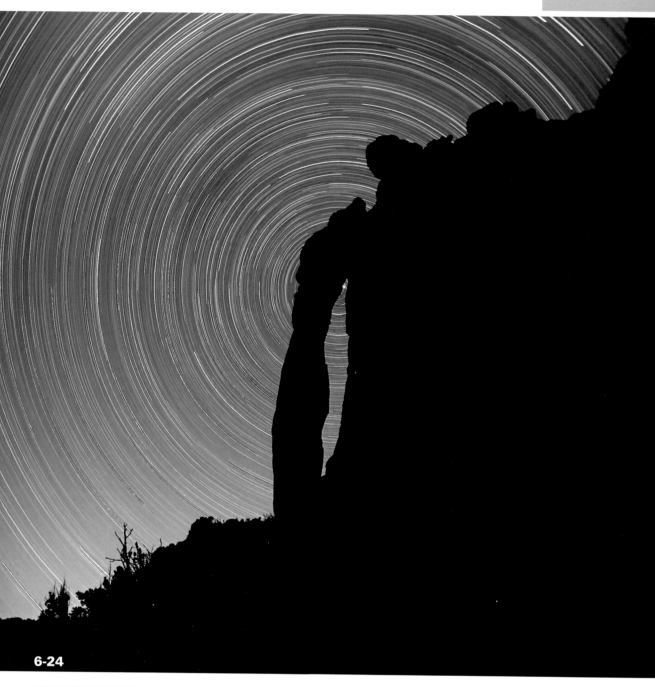

6-24

ABOUT THIS PHOTO *Image of arch at San Rafael Swell, Utah taken with a 35mm film camera (Fuji Provia 100F, ISO 100, f/4, 3.5 hour exposure with a Canon EF 17-40mm L lens). Stars in different parts of the sky appear to move at varying rates. During a long exposure, the North Star moves very little; stars farther from the North Star show progressively more motion, resulting in a pattern of concentric circles. ©Grant Collier.*

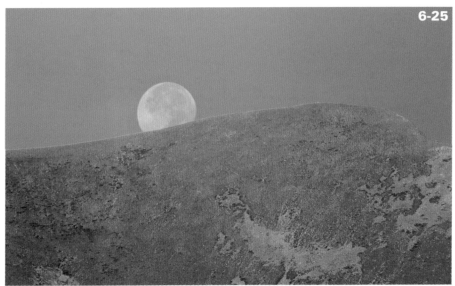

6-25

ABOUT THESE PHOTOS
Image 6-25 taken at ISO 100, f/8, 1/125 sec. with a Canon EF 75-300mm lens. 6-26 taken at ISO 400, f/29, 2.5 sec. with a Canon EF 100-400mm IS L lens.

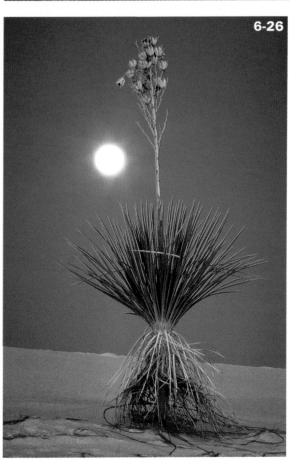

6-26

Assignment

Make a Grand Scenic Photograph

Here is a suggested sequence of steps you can typically use when shooting grand scenic photographs. Of course, these steps may be done in a different order or modified as the situation warrants.

First, arrive on location. Look around in all directions. Generate ideas for the kinds of shots available. Take a few photos while handholding the camera to get a sense of required camera settings. Work quickly, responding to the environment. Then decide on the first "real" composition. At this point it's time to slow down and work carefully with your ideal compositions in mind.

Set up your tripod, secure the camera to a ballhead, attach a cable release, and so on. Frame the composition using the viewfinder (this saves battery power over using Live View). Check for straightness (if necessary) using a bubble level. Consider the need for filters; attach those as necessary. Check all camera settings: sufficient battery power, ISO (as low as possible), exposure mode set to Aperture Priority, no exposure compensation to start, and mirror lockup on. Determine focusing distance and initial aperture setting. Check the focus and DOF using Live View. Then make the first exposure. Preview your image on the LCD; check the histogram. Continue refining the composition, exposure, and sharpness as necessary.

My example photo for this assignment shows Turret Arch through North Window in Canyonlands National Park, Utah. This image was taken at ISO 100, f/8, 1/500 sec. with a Canon EF 17-40 L lens.

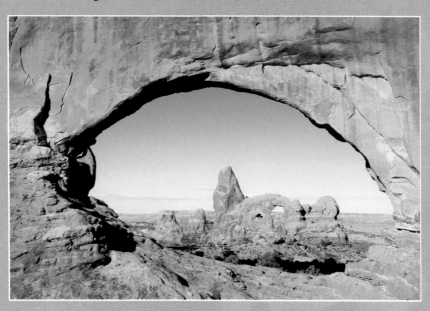

Remember to visit www.pwassignments.com after you complete the assignment and share your favorite photo! It's a community of enthusiastic photographers and a great place to view what other readers have created. You can also post comments, read encouraging suggestions, and get feedback.

After you've made photographs of wide, sweeping vistas, it's time to get in closer. Photos of the "intimate landscape" bring the viewer into the scene for a feeling of immersion, of being surrounded by nature. Intimate landscape photos, as shown in 7-1, give you unlimited freedom to dramatically change the emphasis of a photograph with very slight adjustments to composition.

In this chapter, you learn how to isolate parts of the landscape, use selective focus to emphasize and de-emphasize elements in the frame, master the relationships between foreground and background, stop and blur motion, and apply special in-camera effects like zooming and panning. The chapter finishes with sections on wildlife, close-up, and abstract nature photography.

ISOLATING ELEMENTS

Nature is visually chaotic. Standing in the midst of a forest, on a mountaintop, or on a beach, you're surrounded by photographic opportunity in all directions. Your challenge is to make order from chaos and reduce the visual clutter to create photos with beauty, impact, and clarity.

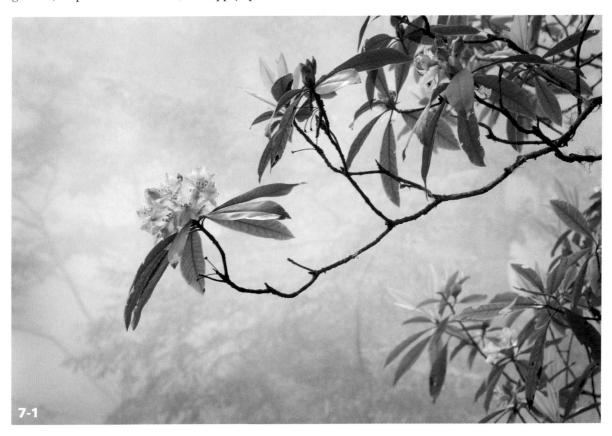

7-1

ABOUT THIS PHOTO *Image of Redwood National Park, California (ISO 320, f/13, 1/15 sec. with a Canon EF 24-105mm L lens). Even though there was no wind, the very slight swaying of the thin branches required that I use a fast enough shutter speed to stop the motion for a sharp shot. I experimented with many apertures to achieve the look I wanted for the background.*

CHOOSING SUBJECT MATTER

In Chapters 2 through 4 you learn how to see subtle differences in your surroundings and how to use the frame to isolate compositions from within the larger scene.

When you select objects to feature as your primary subject matter and supporting composition, look for the strongest elements first. Find tonal and color contrasts and variation in textures and patterns. Identify juxtapositions between elements that create the strongest variations — or do just the opposite, and find things that naturally seem to go together.

Keep in mind the principles of dominance and proportion and restrict your choices to as few key elements as you can. A picture of an aspen forest can be uninteresting and uninspired; a closer shot of a single tree with interesting bark, visually isolated from its surroundings, is better (see 7-2).

While you're looking for interesting subject matter, remember to relax and let the process carry you. Be consciously aware of your thoughts and feelings and your response to visual stimuli, but do your best to not become self-conscious about the process. Some objects will immediately jump out at you; these easy pickings aren't always going to produce compelling images. Slow down and let the most interesting subject matter reveal itself to you — sometimes it's very subtle.

THE PROCESS OF ELIMINATION

Filmmakers use a technique for gradually getting in closer to a scene while also providing context for the viewer. You've undoubtedly seen it many times: the sequence starts with a wide-angle shot (called an *establishing shot*) that sets the scene.

7-2

ABOUT THIS PHOTO *Image of aspen leaf in bark (ISO 400, f/7.1, 1/200 sec. with a Canon EF 28-135mm IS lens). I made many handheld images of this scene before putting the camera on a tripod for the final shot. I had set the ISO to 400 for the handheld work and forgot to lower it for the tripod shot. Though the quality is still excellent, I always prefer to use the lowest ISO possible when shooting on a tripod.*

Think of this like the bird's-eye view — you get only a general sense of what's going on in the environment. The next shots move in a little tighter, conveying a feeling of immersion and a better sense of place. The last shots of the sequence are very close and reveal lots of detail about only a few elements. This is truly intimate;

you get up close and personal with the subject matter. Whether the scene is lovely and pleasing or disturbing and uncomfortable, it's this intimacy that draws viewers in and engages their attention.

When you find an object or subject matter that you choose to work with, practice eliminating everything that doesn't support the main subject. Always remember the principal goal of simplicity within your photographs, even those that contain a lot of detail, as shown in 7-3. Anything that ends up in the final picture needs to be placed there deliberately as a result of your creative process.

Following is an exercise you can use to begin working more interactively with the environment. This process demonstrates how your photographic vision becomes clearer as you study and photograph objects within the larger environment:

1. **Find a scene in which you can move freely and find many different compositions.**

2. **Choose a point in the scene that interests you and that offers good photographic potential.**

3. **Without thinking too much about it, begin photographing that object or part of the scene.** Make five to eight images of the subject from your starting position, making subtle adjustments to refine the compositions. This will be your establishing shot.

4. **Move closer to the subject matter and/or zoom in tighter.** Make another five to eight images, again changing your position and camera angle little by little as appropriate to improve the composition. These should be your medium distance.

7-3

ABOUT THIS PHOTO
Image of shells on the beach at Kaiteriteri, New Zealand (ISO 800, f/7.1, 1/10 sec. with a Canon EF 24-105mm L lens). I made many compositions of the shells on this beach, many only slightly different than the one before. When I work this way I prefer to shoot handheld; in this case I did not see a need to reframe the shot using the tripod. Though there is a lot of detail in this scene, note how the three or four largest shells create eye lines and anchor points and help provide balance to the composition.

5. **Once again, move closer or zoom tighter.**
 At this point you should be making very tight, close-up photos that represent only the simplest forms of the subject matter. Remember to fill the frame and watch for subdivisions of the frame.

with the main subject matter so that it appears to extend beyond the frame in all directions (see 7-4). This enhances the feeling of immersion. Patterns and textures are examples of graphic elements that work well when they are allowed to extend beyond the edges of the frame.

> **note** When you work in the way described in the preceding list, try to resist the urge to stop and preview every photo after you take it. Just keep shooting and evaluate the results later.

FILLING THE FRAME

A technique that often makes stronger images and simultaneously helps you eliminate clutter is called *filling the frame*. Cover the entire picture

NO HORIZON

Most intimate landscape photographs don't need to include the horizon, and often the opposite is more effective: Eliminating the horizon creates a stronger, simplified composition that places the viewer directly in the scene. This principle can also apply to images where the earth's actual horizon isn't visible — other objects such as the bank of a creek, a fallen tree, or a crack in a rock face can create

7-4

ABOUT THIS PHOTO *This image of aspen leaves illustrates the technique of filling the frame (ISO 250, f/14, 1/8 sec. with a Tamron 18-200mm XR Di II lens).*

artificial horizons in the composition. Learn to identify these subdivisions of the frame and consciously choose how they're handled for the best effect. See 7-5 for an example of not including the horizon or sky in the photo and how lines and shapes subdivide the frame into smaller parts.

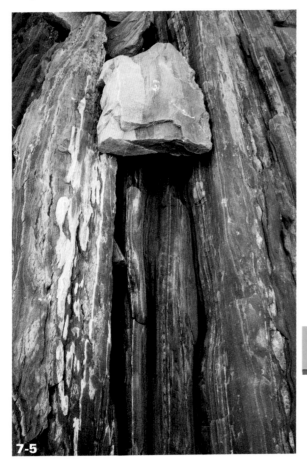

7-5

ABOUT THIS PHOTO *Image of cliff rocks at Pemaquid Point, Maine (ISO 500, f/11, 1/250 sec. taken with a Tamron 18-200mm XR Di II lens).*

SHOOTING HANDHELD

Making photos of the intimate landscape is one situation in which you can frequently shoot with the camera handheld. Try photographing handheld first, working quickly and reactively as you discover the essence of the scene, and when you get a clear idea of the images you want to make, put the camera on the tripod. However, you'll find that if there's enough light to produce fast shutter speeds for sharp images, some of your handheld shots can become the final renditions.

When photographing closer to the subject matter you'll also often be using wider apertures to simplify the background of your photos. This allows much more light into the lens and can make the difference in being able to produce sharp handheld shots, as shown in 7-6.

When you shoot handheld you can lock focus and exposure on one part of the scene and then, while still holding down the shutter button halfway, recompose the picture and take the shot. This allows you to work quickly and still be able to attain the focus and exposure you want.

> **tip** When shooting handheld, I strongly recommend you use Continuous drive mode on your dSLR. In this mode, holding down the shutter button produces multiple consecutive captures. If you burst capture a sequence of two or three photos instead of just a single photo, you'll often find that one image is sharper than the others due to very slight variation in focusing distance, mirror slap, and camera shake.

7-6

ABOUT THIS PHOTO *Image of flowers taken handheld (ISO 400, f/5.6, 1/1000 sec. with a Canon EF 100-400mm L lens).*

SELECTIVE FOCUS

In Chapter 6, you learn about maximizing depth of field for grand scenic photographs. Working in the intimate landscape, it's more likely that your pictures will utilize a shallow depth of field. In these cases, one part of the image is fully sharp and elements in front of or behind it are out of focus. This is called *selective focus*, and it's done using a combination of large apertures and manually focusing at specific points.

FOCUS DISTANCE AND APERTURE

As explained in Chapter 6, depth of field is determined by the distances between the camera and objects within the scene. At distances less than infinity, depth of field can be characterized by a ratio of 2:1, with one-third of the depth of field extending from the camera to the point of focus and two-thirds behind the point of focus.

For intimate landscape pictures, the most common technique you'll use is to blur the background. In these pictures, the distance between

the focused subject and the elements behind it determines how out of focus the background becomes. If you photograph an object that's close to its background (as shown in 7-7), you won't get as much blur as when there's a lot of distance between the object and the background.

To render an appealing background blur, the distance from the camera to the subject matter must be significantly less than the distance from the subject to the background. If you can't get the blur you want you need to either move closer to

the subject or change your position to frame the composition with a background that's farther away.

As introduced in Chapter 6, the choice of aperture is one of the most important decisions for the nature photographer. To have everything sharp in the picture, use smaller apertures (higher numbers); to have some parts sharp and others blurred based on distances between objects, use wider apertures (smaller numbers). In cases where you want to use selective focus to blur the background, you should start out by shooting wide open; that is, with the aperture at its smallest number (largest opening). You can then further refine the look of the background blur by choosing different apertures. Use Aperture Priority or Manual exposure mode so you can set the aperture value yourself (covered in detail in Chapters 5 and 6).

 note

> Remember to use the Depth of Field Preview feature on your dSLR to see what the background will look like.

USING MANUAL FOCUS

Working at close distances to your subject matter, you'll encounter many situations where manual focus provides the easiest solution and the best results. Especially when combined with wide apertures, you'll find that controlling focus yourself gives you enormous latitude for the rendition of sharp and blurry objects in the scene (see 7-8). When you become comfortable focusing manually you'll be able to get more of the results you want.

(You can also try the focus lock technique previously mentioned, but in many cases autofocus will not lock onto the part of the scene you want sharp.)

ABOUT THIS PHOTO *Image of autumn grasses near Crested Butte, Colorado (ISO 200, f/5.6, 1/200 sec. with a Canon EF 28-135mm IS lens). Note that due to the distances involved, the wide-open aperture was not enough to completely blur the background, which was only several inches from the main subject.*

ABOUT THIS PHOTO
Image of milkweed pod near Union, Maine (ISO 100, f/6.3, 1/50 sec. with a Tamron 18-200mm XR Di II lens). The background was several feet from the point of focus, providing a lot of blur. Note the effect of the lens bokeh on the shapes of the out-of-focus background.

7-8

BOKEH This Japanese term refers to the characteristics of the blur a lens creates when areas of the image are out of focus. The bokeh of some lenses is thought to be more appealing than others. When reviewing your images, see if you can discern a difference in bokeh between photographs made with different lenses.

Switch your lens to manual focus and use your left hand to turn the focusing ring as you shoot. You can do this either on a tripod or shooting handheld.

> **tip** Remember to check DOF Preview again after adjusting your focusing distance; the relationships between sharp and blurry objects change as the range of depth of field is moved.

The following exercise will help you become comfortable using manual focus and critically evaluate the backgrounds of your photos. First, try this shooting handheld, and then do it again using a tripod. If possible, also do this exercise using various lenses, as you may see a significant difference in focusing, depth of field, and bokeh characteristics with different lenses.

1. **Find a subject that is a long distance from its background.**

2. **Make sure your camera is set to Aperture Priority mode.**

3. **Set your aperture to the widest setting.**

4. **Switch the lens to manual focus.**

5. **Zoom in to create the desired composition.** Keep the same zoom for a few shots.

6. **Move closer to the main subject matter, and using the focusing ring on your lens and looking through the viewfinder, adjust the focus so that different parts of the subject appear sharp or blurry.** When you turn the focus ring, you are setting the focus at a certain distance. If your lens has a distance scale, refer to it to see the current focusing distance.

7. **Make a series of different shots with selective focus set at varying distances.** Try some different aperture settings, too.

While shooting on the tripod, practice using your Live View along with the Depth of Field Preview function. With DOF Preview enabled, zoom in and out and view the results on the rear LCD.

> **note** Remember that when you shoot with a wide-open aperture, you will not see a difference when you press the DOF Preview button. When you see the "regular" view (without DOF Preview active) this is showing you the aperture wide open. Pressing the DOF Preview button stops down the lens to the current aperture value set on the camera. (This is why the preview gets darker in the viewfinder.)

FOREGROUND/BACKGROUND RELATIONSHIPS

When you previsualize your photos and set up compositions, maintaining a clear understanding of the relationships between foreground and background is crucial. Most intimate landscape photographs that fail are the result of the photographer not paying enough attention to the background, especially allowing the background to create a distraction from the main subject matter. Usually you should ensure there is clear definition between the foreground and background elements (although, of course, there will be exceptions to this rule).

FRAMES WITHIN FRAMES

In nature photography, a *frame in a frame* is created when you use a foreground element to help frame or isolate background elements, or vice versa. Using frames within frames is a powerful technique that, when used effectively, brings viewers into the picture and carries them through the foreground element to the more distant objects, as shown in 7-9. This gives a strong sense of depth to the picture and helps accomplish what's known as *figure/ground reversal*, wherein the viewer's eye goes back and forth between the foreground and background elements.

As in more straightforward compositions, it's important that the foreground and background elements don't compete with one another. It's easy for the front frame to dominate the picture. Juxtaposing foreground and background elements with contrasting shapes, tones, colors, and textures helps keep the objects distinct within the frame; however, be careful to make one element dominant and make sure no graphic elements compete with one another or create awkward intersections. When using a frame within a frame, the points and lines that create eye travel in the frame are especially important.

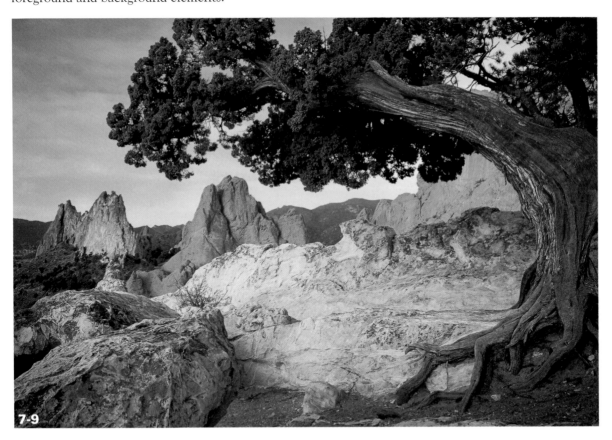

7-9

ABOUT THIS PHOTO *This image of an old juniper tree at Garden of the Gods, Colorado, uses the frame-in-a-frame technique (ISO 100, f/20, 3.2 sec. with a Canon EF 17-40mm L lens).*

ELIMINATING DISTRACTIONS

Always be aware of any distracting elements in the background. When you identify something that is calling attention away from the main subject and disrupting the eye travel through the frame, change your focus, aperture, or recompose the image to eliminate the distraction.

AVOIDING MERGERS

In addition to removing distractions, you also need to watch out for elements that merge in the composition. Sometimes you can allow mergers for creative effect, such as when blurring a background into what appears to be a solid field of color. But keep in mind that mergers diminish the appearance of depth and make objects appear indistinct from one another. This is especially pertinent when dealing with separate elements that fall within and outside the range of depth of field.

Some scenes (like the one in 7-10) are potentially full of mergers, where elements of the photo with similar tone, color, or texture appear to merge into single objects within the frame. (Note how the dark leaves in the background of 7-10 appear as one large mass.) To make successful pictures in such an environment, first decide if the mergers detract from the intention of your composition — sometimes mergers are not bad. To reduce the effect of mergers, change camera position to juxtapose and separate elements in the foreground, midground, and background by arranging contrasts of tone, shape, and texture against one another.

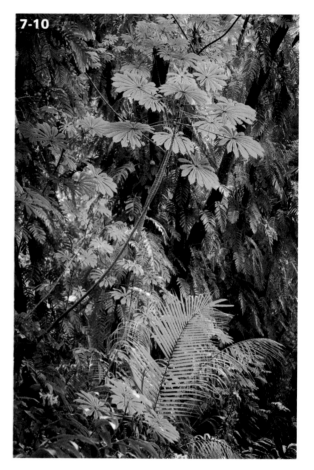

BLURRING FOREGROUND ELEMENTS

Blur isn't just for backgrounds; you can achieve beautiful effects by "shooting through" objects in the foreground (see 7-11). When objects are thrown way out of focus, they become partially or fully transparent. This technique is particularly useful for shooting through colorful wildflowers, resulting in soft, pretty orbs of blurred color.

7-11

ABOUT THIS PHOTO *Image of summer wildflowers in Colorado (ISO 200, f/2.8, 1/1600 sec. with a Canon EF 70-200mm lens). The yellow orbs in the bottom half of the frame are flowers near the camera, well in front of the main point of focus.*

Sometimes you can even blur a foreground element so completely that it's eliminated from the scene entirely. For example, if you're shooting through tree branches or stalks of grass, setting the focus distance far beyond the foreground elements can actually blur them so that they are no longer visible in the picture.

WORKING WITH MOVING SUBJECT MATTER

When you photograph moving subject matter you have two choices: freeze the motion or let it blur. Unlike the human eye, the camera can freeze motion in a photograph or render the blur of motion over a period of time. Fast shutter speeds stop motion; slow shutter speeds reveal motion blur. For example, a shutter speed of 1/500 sec. is fast enough to freeze the motion of many natural objects you'll encounter (except possibly animals), while a shutter speed of one full second is long enough to show significant blur in the photo.

CONTROLLING SHUTTER SPEED

Because most of the time you'll be shooting in Aperture Priority or Manual exposure mode, the first key to controlling the shutter speed is to pay attention to the metered shutter speed the camera recommends based on the exposure values for the available light. If the camera-recommended shutter speed is appropriate for the picture you want to make, you don't need to do anything else. However, there will be many situations in which the metered shutter speed is either faster or slower than what you want. See in 7-12 how a slow shutter speed can allow elements in the scene to blur as they move during the exposure.

If the metered shutter speed is too fast, you can lower the ISO or use a polarizer and/or graduated neutral density (ND) filter, or both. Lowering the ISO decreases the sensitivity of the sensor, so longer shutter speeds are required to produce an equivalent exposure. Adding an ND filter cuts

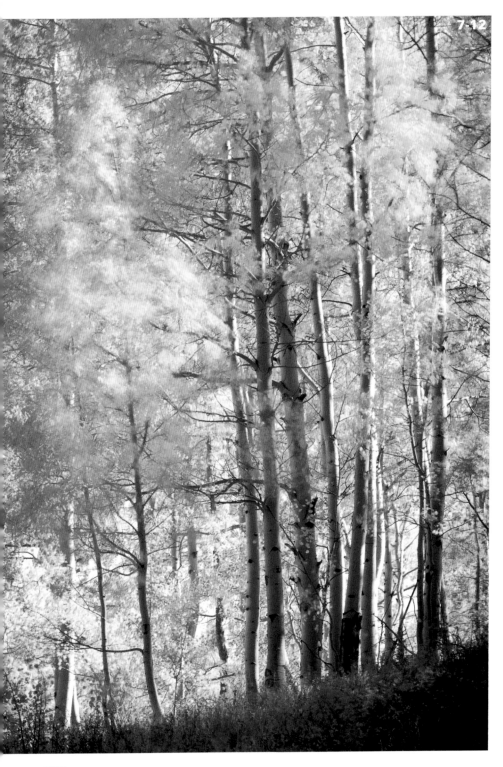

7-12

ABOUT THIS PHOTO

Image of aspen trees on Ohio Pass Road, Colorado (ISO 50, f/32, 1.0 sec. with a Canon EF 70-200mm lens). I used a low ISO, the smallest possible aperture, and a polarizer to create a moderately long exposure. The painterly blur in various parts of the photo is from the aspen leaves blowing in the wind while the shutter was open. Even at only 1 second, with a stiff breeze you will capture motion in tree leaves.

the amount of light entering the lens and thus also increases the time required for an equivalent exposure. In some cases, you'll want to lower the ISO as far as it will go, put on your polarizer and ND filters, and even stop down the lens a little bit, all so you can get a longer shutter speed. This is an example of how having the right accessory equipment can make the difference in getting a good image or getting no shot at all — there are situations where the camera alone simply cannot produce the long exposures you want due to the abundance of available light.

If you want to produce *faster* shutter speeds, you can increase the ISO, remove any attached lens filters, and open the aperture. Or, you can add artificial light or reflected light. But like the previous example, there will be times when all the factors combine to produce an unworkable exposure.

tip You can often use a flash to freeze the motion in a photograph.

PHOTOGRAPHING FLOWING WATER

Photographs of flowing water often look best when the water is blurred (see 7-13). This nearly always means using a tripod or other camera support because the camera needs to remain stationary for the duration of the exposure. (If the camera shifts during the shot you'll also have blur caused by the movement of the camera.)

With the camera stabilized, apply the aperture setting for the depth of field you want for the image. If you're photographing a waterfall from several meters away and there are elements in the

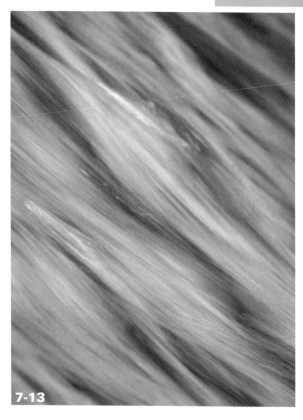

7-13

ABOUT THIS PHOTO *Image of the Slate River, Gunnison County, Colorado (ISO 160, f/8, 1/25 sec. taken with a Canon EF 500mm lens). The effect of motion blur is exaggerated with close-up images.*

near foreground, you'll need to use the depth-of-field principles explained in Chapter 6. Otherwise, if the waterfall and its surroundings are all on the same plane of focus, use the widest aperture that will allow a shutter speed of at least 1/2 second. For many waterfalls, a shutter speed of a full second or longer is necessary for the photo to look its best; in these situations you'll need to use a combination of low ISO, lens filters, and small apertures to achieve the necessary shutter speed.

For this reason, it's best to photograph waterfalls before sunrise, after sunset, in shade (see 7-14), or on a cloudy day. A waterfall illuminated by bright midday sun won't often produce an appealing photograph.

7-14

ABOUT THIS PHOTO *Image of a waterfall in North Carolina (ISO 100, f/18, 10.0 sec. with a Canon EF 17-40mm L lens). The heavy cloud cover and drizzling rain allowed for a long shutter speed, which was further increased by my use of a polarizer to cut the glare from the wet leaves.*

x-ref Chapter 5 presents more examples of fast and slow shutter speeds on photographs of a waterfall and also explains the use of filters.

ZOOMING AND PANNING DURING THE EXPOSURE

The alternative to keeping the camera still during the exposure is to deliberately move it.

Zooming during a long exposure produces interesting bull's-eye effects, as shown in 7-15. This is best done with a zoom lens, but you can also just try moving the camera forward and backward. Experiment with this technique by applying camera settings that result in an exposure of 1/2 to 1 second, and while the picture is being captured zoom the lens in or out.

Panning while the shutter is open is a technique that has gained enormous popularity over the past several years. The principle is similar to zooming; however, instead of getting closer to or farther away from the subject you move the camera in a specific direction parallel to the plane of focus. The longer the shutter speed the more blur results. Experiment by changing both your shutter speed and the speed at which you move the camera; you'll find you can make an infinite variety of interesting effects.

Try this effect both using the tripod and hand-held. Some of my favorite pictures of this style were made with very long exposures of 2 seconds or more while moving the camera in various

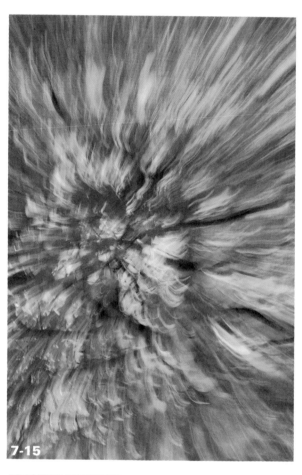

7-15

7-16

ABOUT THIS PHOTO *Image of zoom blur effect on aspen trees (ISO 100, f/36, 1/10 sec. with a Canon EF 28-135mm IS lens).*

ABOUT THIS PHOTO *Image of pan blur effect (ISO 100, f/32, 1/15 sec. with a Canon EF 70-200mm lens).*

directions with my hands. If you can pan vertically straight up and down, you get nice renderings of trees; also try spinning the camera around in a circle.

The resulting images have been referred to as *photo impressionism*, *photo expressionism*, and other terms that allude to a painterly effect. See 7-16 for an example.

CLOSE-UP NATURE PHOTOGRAPHY

When you get very close to a natural subject it takes on different meaning and new life (see 7-17). To see what I mean, get down on all fours and crawl around the forest floor for a while. You can do close-up nature photography without expensive, specialized equipment, but there are some limitations.

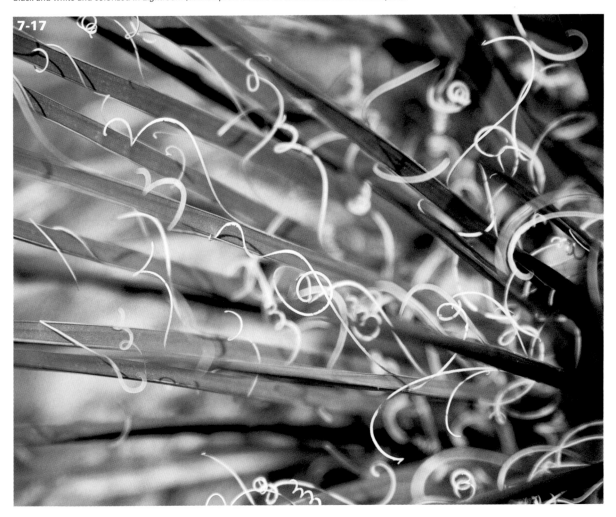

ABOUT THIS PHOTO *Image of yucca plant spines and fibers (ISO 200, f/5.6, 1/640 sec. with a Canon EF 28-135mm IS lens). Converted to black and white and colorized in Lightroom (see Chapters 8 and 9 for more about these techniques).*

7-17

CLOSE-UP VERSUS MACRO

Macro photography, or simply "macro," describes images made at very close distances and at great magnification. Historically, the technical definition of a macro photograph meant that the object in the picture was rendered (on film) at life size. If you photograph a bumblebee that is 12mm in length, the recorded macro image of the bee is also 12mm or larger. This relationship is expressed as a ratio of 1:1, or the same size, so true macro photography produces pictures that are 1:1 or greater. However, this distinction has not held over time and macro is a term now used to describe many kinds of images that show the subject matter at great magnification, even if it's not really 1:1. While not truly a macro shot, 7-18 shows a close-up of water drops suspended on a plant's leaves.

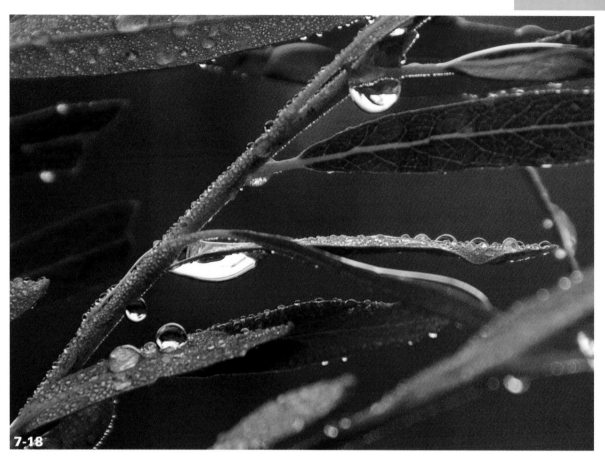

7-18

ABOUT THIS PHOTO *Close-up image of water droplets (ISO 200, f/7.1, 1/13 sec. taken with a Tamron 18-200mm XR Di II lens). This lens, while not a true 1:1 macro lens, is labeled macro and demonstrates that you can make close-up shots with almost any kind of lens — I've made some of my favorite close-ups using a 500mm telephoto lens!*

LENS SELECTION FOR CLOSE-UPS

Many lenses claim macro capabilities but most are not true macro lenses. A true macro lens has two distinguishing characteristics: significant depth of field and relatively close focusing distances. These two factors combine to be able to render life-size images.

All lenses have a minimum distance at which they can achieve focus. This distance is labeled on the lens along with the aperture and zoom specifications. This can range from several inches to many feet. Long telephoto lenses usually require much more distance to focus than do wide and normal focal-length lenses.

> **tip** Long telephoto zooms can make great close-up lenses provided you can get far enough from your subject matter to get it into focus.

STAGING CLOSE-UPS WITH FOUND OBJECTS

One of my favorite photographic activities is to pick up interesting objects I find while I'm out in nature and place them in a variety of places to make many different pictures, as shown in 7-19. This helps solidify your understanding of the interaction of graphic elements in the frame and allows you to change those relationships as you see fit in order to design more interesting pictures.

USING ARTIFICIAL AND MODIFIED LIGHT

Much close-up photography — and true macro in particular — can benefit greatly from the addition of *fill light* into the scene (see 7-20). Fill light can reveal more detail in shadow areas and help balance the overall exposure. You can add fill light using on-camera or off-camera flash (a ring flash is superb for this) or use a reflector to bounce light into the scene.

You can also remove light from a close-up scene using a *diffuser*, a stretched sheet of fabric that lets some sunlight through. Consider blocking light (creating shade) from parts of the scene in order to balance the exposure, eliminate hot spots, and more deliberately direct the viewer's eye. Traditionally, small pieces of cardboard, plastic, or other flat, lightweight material have been referred to as *flags* or *gobos*. You can use a clamp to attach a flag or diffuser to your tripod; often you can just use a hat or your hand to create shaded areas in the scene.

Here's an exercise to help you discover the innumerable close-up photographs available in a very small area. As with the other exercises, start by finding an interesting location. Use a lens that allows you to get close to the subject matter.

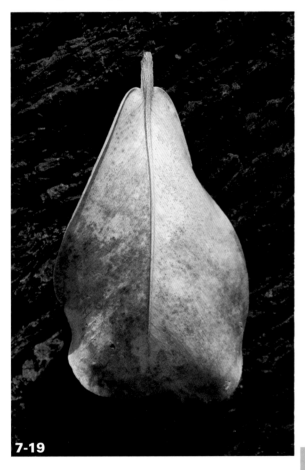

7-19

ABOUT THIS PHOTO *Image of avocado leaf on lava (ISO 320, f/8, 1/250 sec. taken with a Tamron 18-200mm XR Di II lens). I found this leaf while I was walking on the beach and spent the next several hours making photographs of the leaf on different backgrounds and in different light.*

tip One of the handiest accessories you can carry for close-up/macro work is a flexible clamp. You can use a clamp to hold a flower still or to position a reflector or flag. Many styles and sizes are available; one of the most popular brands is called the Plamp.

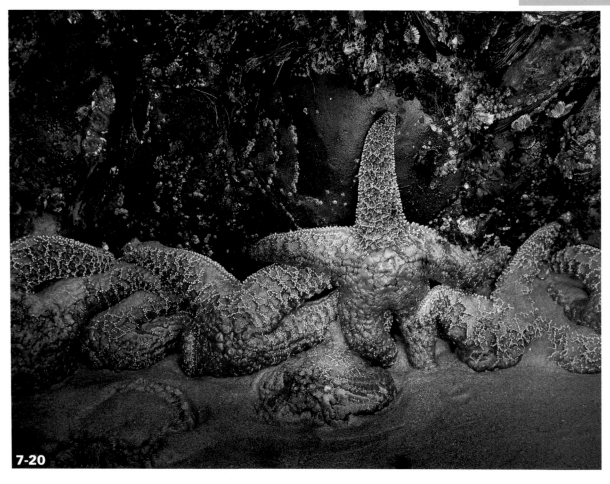

7-20

ABOUT THIS PHOTO *Image of starfish at Seal Rock State Park, Oregon (ISO 100, f/8, 1/13 sec. with a Canon EF 28-135mm IS lens). This scene was in the shade with very little light and virtually no three-dimensional depth. I used a gold reflector to bounce sunlight onto the scene.*

For the next 25-30 minutes, make as many different close-up photographs as you can within a circle no more than 8 feet in diameter. Shooting 25-30 pictures is good; 50 is better. As you work, remember the principles of design, make your compositions carefully, and stay in control of your exposures. You can also try different effects with focusing and aperture.

ABSTRACT NATURE PHOTOGRAPHY

In previous examples, you've seen photographs made to represent the essence of the objects. These "representational" photographs are meant to clearly depict a recognizable subject in the

most visually appealing way, using the visual clues provided by effective seeing, nice light, and good composition.

Abstract nature photography is something else all together. It's pure design. Think of it like being in kindergarten and working with many different craft materials to make a picture. Multicolored construction paper, string and yarn, glitter, and, of course, crayons and markers. When putting together a picture like this, you don't need to worry if it clearly shows something identifiable; all that matters is that it's interesting and visually appealing. See 7-21 for an example.

What matters most is that the composition provokes the viewer's curiosity and contemplation without providing any concrete answers. This is abstract nature photography.

WHAT IS ABSTRACTION?

An abstract photograph presents a generalized, broad depiction without details or clues to influence the viewer's comprehension of the subject matter. In any photography, true abstraction can be very challenging. Abstraction in nature photography is especially difficult because most people immediately recognize something for what it is.

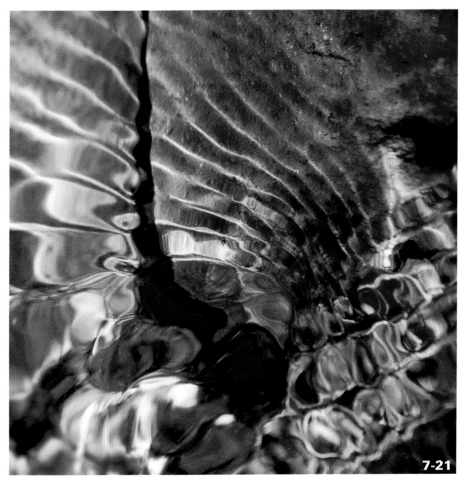

ABOUT THIS PHOTO
Abstract image of water and pebbles (ISO 320, f/5.6, 1/500 sec. taken with a Canon EF 75-300mm lens).

7-21

A rock looks like a rock, a leaf looks like a leaf. Because you're taking pictures of the natural world, the objects in the picture are usually very easily identifiable.

If a viewer can immediately recognize what it's a picture of, it's not a true abstract. Of course, the level of abstraction is entirely based on the viewer's experience. A viewer seeing something for the first time may not recognize it for what it is. Look at 7-22 and see if you can figure out what it's a picture of.

7-22

ABOUT THIS PHOTO *Image of tree bark (ISO 100, f/8, 1/5 sec. taken with a Tamron 18-200mm XR Di II lens).*

One way you can break the connection between an object and its context is to consciously avoid the use of names and labels. It's not a "rock:" it's a flat, rough patch of grainy black and gray material. It's not a "leaf:" it's a smooth, green surface laced with a fine pattern of lines. Avoiding labels helps you think in more abstract terms and make more abstract pictures.

REMOVING CONTEXT

The most important action for you to produce an abstract nature photograph is to remove the subject from its context. Context is mainly what helps a viewer identify what something is; in many cases, simply removing the context creates levels of abstraction.

To begin removing an object from its context, start the process of elimination described earlier in this chapter. Similar to intimate landscapes and close-ups, abstract nature photography is all about distilling an object down to its purest essence — but then you must go further.

This process of elimination must continue until all you're left with are basic compositional elements, as depicted in 7-23.

APPLIED DESIGN

Abstract design of photographs can be one of the most challenging and rewarding kinds of nature photography. This is where your compositional skills can really shine. Shapes, lines, intersections, proportion, balance, tension, textures, and patterns can all become useful components of a successful abstract nature photograph.

Previsualization is also essential in creating abstract nature photographs. You must imagine what a photo would look like with different framing, depth of field, and focus. Being able to superimpose the rectangle as discussed in Chapter 2 is very useful here.

7-23

ABOUT THIS PHOTO *Image of rock wall and moss (ISO 1000, f/13, 1/40 sec. taken with a Tamron 18-200mm XR Di II lens).*

Find a subject that you find interesting enough to become an abstract. Look for contrasts like those discussed in Chapter 4: color, tone, texture, and so on. Contrasts are incredibly important in an abstract photograph because they define the shapes or forms that make up the distinct parts of the photograph.

After selecting your subject matter, shoot handheld for a while, working quickly and fluidly, reacting and interacting with the subject matter. While shooting, look only through the viewfinder, making slight adjustments with each successive photo. Zoom in and out; rotate the

camera; change your position. Work through the process of extraction and subtraction to identify and eliminate unwanted elements from the composition. Make a series of photographs that progressively gets you closer to the composition you see in your mind's eye.

At some point you will find your ideal composition. If you've been working handheld, at this point you need to check your shot settings and determine if setting up on the tripod would produce the perfect, final shot.

See 7-24 for an example of an abstract I made after shooting at one location for several hours.

WILDLIFE PHOTOGRAPHY

You will likely encounter situations where you're out shooting nature, and lo and behold, there's a wild animal (see 7-25). Photographing wildlife in nature is an entire genre of its own and as such deserves its own study, not to mention books that specialize on the subject.

Being able to work quickly and confidently without disturbing the animal is essential to getting good wildlife shots. Wildlife will often be at some, possibly great, distance from you, which requires long lenses for good pictures. 300mm is a reasonable minimum for most situations; many serious wildlife photographers use lenses of 500mm, 1000mm, and more to get right into the action.

With all wildlife photography, paying close attention to the animals' behavior and anticipating their movements helps you make better photographs. Some photographers set up camouflage blinds, similar to those used by hunters, to hide their presence and allow them to observe the animals unnoticed. Though you may not choose to go to these lengths, remaining calm and quiet while you work is critical.

ABOUT THIS PHOTO
Image of rock and water (ISO 800, f/14, 1/2 sec. taken with a Canon EF 70-200mm lens). The rock was in shade; the bright highlights are reflections of the cloudless sky. I wanted to distill the photo down to its simplest elements and emphasize the glow of the water as a field of color juxtaposed against the texture of the rock. The bright line of specular reflection separating the water and rock creates a strong design element; I worked for a long time to place that line in the part of the frame that would provide the best balance.

tip

One of the most important techniques for making a successful wildlife photograph is to ensure the animal's eyes are in sharp focus.

LARGE MAMMALS

The most important thing to keep in mind when photographing large mammals is to keep your distance. All wild animals can be dangerous (search YouTube for ample proof of this). Given the distances involved, a long lens is most often a requirement. Of course, there can be times when a large animal quietly sneaks up behind you, as shown in 7-26.

ABOUT THIS PHOTO *Image of bear in Jackson Hole, Wyoming (ISO 400, f/8, 1/1250 sec. with a Canon EF 75-300mm lens). I must admit that being this close to a bear was a little scary, especially because her two cubs were foraging in the scrub brush beneath her. (Mama bears get very antsy when people approach their cubs!) I encountered this scene just off the main road at Grand Teton National Park, where bear sightings are common, and stayed close to my car in case the situation got dicey.*

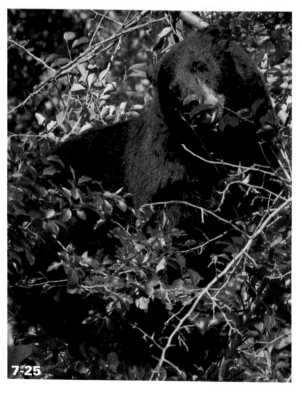

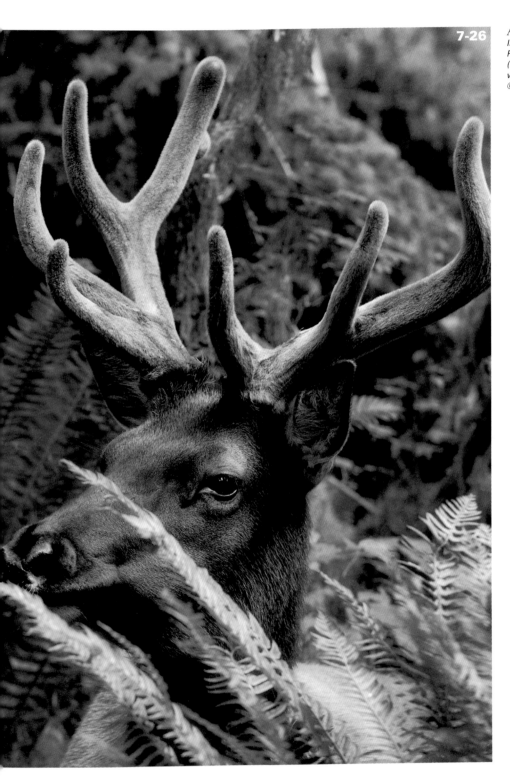

ABOUT THIS PHOTO
*Image of a young elk in Hoh
Rain Forest, Washington state
(ISO 800, f/5.6, 1/60 sec. taken
with a Nikkor 70-200mm lens).
©Daniel Stainer.*

SMALL CRITTERS

Even when you're photographing smaller creatures nearby, their size dictates that you need a long lens to render the animal large enough within the frame. Small animals usually move quickly, too, so you need fast shutter speeds if you want to freeze their motion. Photographing small animals with the camera handheld is usually the way to go, so you can track along with their movements. (This is called *follow focus*.) 7-27 shows an example of a small creature in its natural environment.

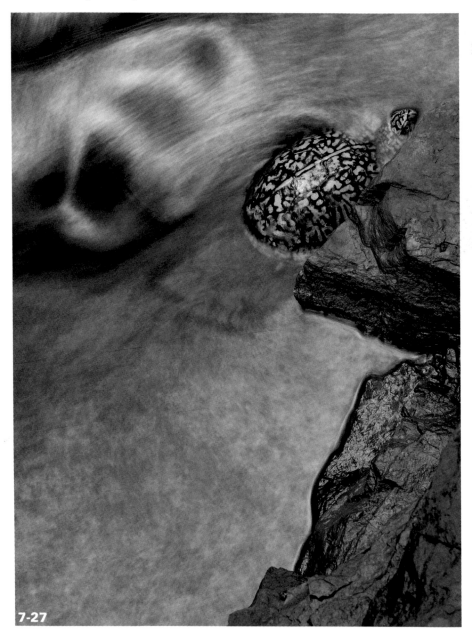

ABOUT THIS PHOTO
Image of a turtle in a creek, Pipestem Falls, West Virginia (ISO 100, f/11, 1.0 sec. taken with a Nikkor 17-55mm lens). ©Daniel Stainer.

7-27

BIRDS

If wildlife photography is a genre unto itself, bird photography is its largest constituent. Some nature photographers have built entire careers around photographing birds. When making avian pictures, you have a wide range of choices of pictures of the birds in flight and standing still. Remember that if you're making a picture that has an implied direction, such as a flying bird, you need to leave room in front of the path of travel so the viewer's eye remains in the frame (see 7-28).

Because birds can be inherently visually complicated creatures, keep a close eye on the background so that it doesn't compete with the bird in the composition.

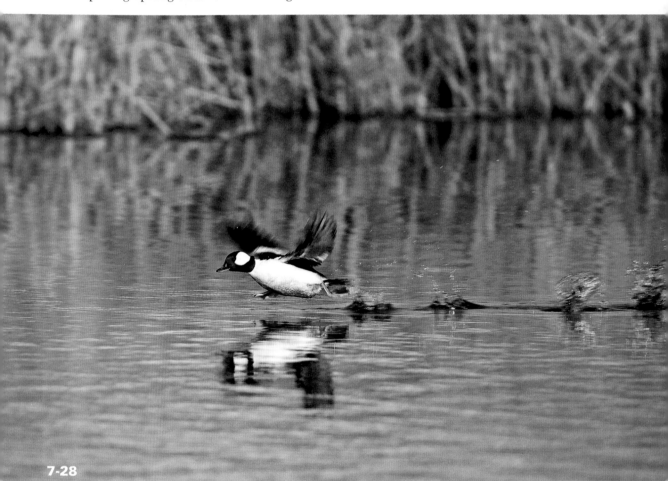

7-28

ABOUT THIS PHOTO *Image of bufflehead duck, Monte Vista National Wildlife Refuge, Colorado (ISO 200, f/5.6, 1/400 sec. with a Canon EF 500mm L lens). ©Monte Trumbull.*

Assignment

Make Botanical Close-Ups

Plants are often ideal subject matter for close-up photographs. Because many of the interesting details in plants and trees can't be seen from a distance, use this opportunity to get up close and personal with your subject matter.

Apply the techniques you learned in this chapter to produce a series of photographs of plants:

- Isolate subject matter from its surroundings
- Eliminate distractions
- Get in closer
- Pay special attention to backgrounds
- Use manual focus
- Try different apertures

Put together a series of 10-12 images for this assignment and upload your best shots to the Web site.

My example photo was taken on the beach in California (ISO 800, f/6.3, 1/200 sec. with a Canon EF 28-135mm IS lens). A monochromatic color palette contrasts with extreme detail and variation in the grasses in the background, which in turn is juxtaposed against the contrasting shapes of the fern. This photo was taken under cloudy skies — ideal conditions for detail shots of plants and flowers.

 Remember to visit www.pwassignments.com after you complete the assignment and share your favorite photo! It's a community of enthusiastic photographers and a great place to view what other readers have created. You can also post comments, read encouraging suggestions, and get feedback.

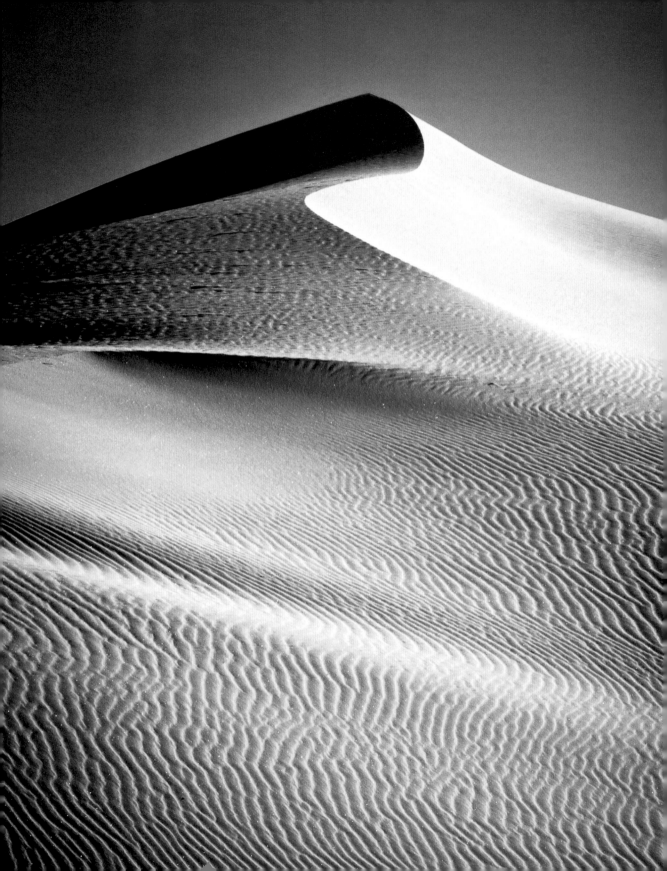

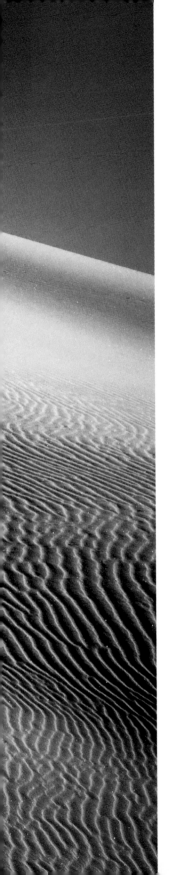

BLACK-AND-WHITE NATURE
PHOTOGRAPHY

Black-and-white photography has existed much longer than color photography, and some of the very first photographs ever made were of nature. In the early days, black-and-white was the only solution for most photographers. Even in the modern age of color digital capture many nature photographers enjoy working in this genre, albeit with a much different digital process.

Black-and-white photographs can convey a very artistic impression. Most notably, a black-and-white photograph inspires the imagination. Whereas a color image is naturally *visually* stimulating, a black-and-white photo is *intellectually* stimulating if for no other reason than it's not the way most people see the world. This lends a great deal of drama to a black-and-white photograph, as shown in 8-1.

ABOUT THIS PHOTO
Image of cactus at Bosque del Apache National Wildlife Refuge, New Mexico (ISO 200, f/10, 1/100 sec. with a Canon EF 28-135mm IS lens). Converted to black and white in Lightroom.

8-1

The majority of historical fine-art photographs were black and white; the great nature photographer Ansel Adams worked mostly in black and white and his most beloved photographs are black and white. Of course, as he was making the photographs on location he saw the actual scenes in color, just as you will. This underscores that the essential key to making good black-and-white nature photographs is the ability to previsualize the final image.

Today, working in black and white requires you to imagine a scene as it might look when converted from color to black and white, select subject matter that translates well into black and white, and capture color images and apply a digital postproduction process to convert the captured images to black-and-white photographs.

SEEING IN BLACK AND WHITE

When you look at a scene in real life, color most often dominates your perception. Thus, the first step in black-and-white photography is seeing past the color. The process begins by evaluating the subject matter and making composition decisions based on what the photo could look like when it's converted to black and white later during post-processing.

TONAL PERCEPTION

Most scenes in nature contain a wide range of tones from near- or pure white highlights to solid black shadows with many levels of brightness in between. Always evaluate tone and color separately. To make strong black-and-white nature photographs, you need to mentally break apart the tonal components from the color components in the scene. Think purely in terms of light and dark and the tones in between.

There are some common references you can use. Using the example from previous chapters, green grass is close to midgray, meaning about halfway between black and white on the tone scale. With practice, you can learn to recognize the color of objects under different kinds of light and determine what their tonal values would be if they were converted to gray levels without any adjustment to their inherent brightness (see 8-2).

8-2

ABOUT THIS PHOTO *Close-up image of tree bark shows gray-scale tone levels after conversion from color to black and white (ISO 100, f/16, 1/20 sec. with a Tamron 18-200mm XR Di II lens). Converted to black and white in Lightroom.*

It's especially important to closely observe the appearance of the lit and shaded sides of objects, because without color, this variation in light and dark must provide all the visual clues to the viewer. The variation and transition between the light and dark sides of three-dimensional objects and textures is called *chiaroscuro*.

> **tip** Practice looking at scenes and imagining them without color. Before long, you'll begin to do this naturally, and you'll find that the practice of seeing tones will also have a positive effect on your color photography.

GRAPHIC ELEMENTS

In black-and-white photography, what remains after the color is removed are lines, shapes, forms, patterns, textures, and so on — the core graphical elements described in Chapter 4. But without color, the effects of these graphic properties become much more pronounced. This principle is important for you to use in your black-and-white process.

Like the perception of tones in a scene, the appearance of the primary graphic elements is determined by the qualities of light present and how the light affects surfaces.

8-3 shows an example of a photo with strong graphics that translate well to black and white.

COLOR COMPONENTS

A scene with lots of variation in color can be difficult to previsualize as black and white, but monochromatic scenes (those with little hue variation) can more easily be visualized as black and white. Provided the graphic properties are strong enough to differentiate objects from one another, monochromatic subject matter often makes the best candidates for black-and-white photographs. See 8-4 for an example.

CHOOSING SUBJECT MATTER FOR BLACK AND WHITE

Some subject matter is better than others for black-and-white nature photography. Rocky outcrops, flowing water, dramatic skies, and craggy trees are good examples because they are tone- and shape-based objects. Look for natural scenes with

- a wide range of tones from very bright to very dark

- strong graphic shapes such as silhouettes and geometric objects

- strong three-dimensional forms with dramatic side- or backlighting

- strong patterns and textures

- simple compositions with clean divisions between elements

VISUAL CUES

The brain derives a lot of information from color — remove it and visual relationships can become muddled. Unlike color photos, black-and-white photos rely entirely on the visual cues provided by graphic and tonal relationships

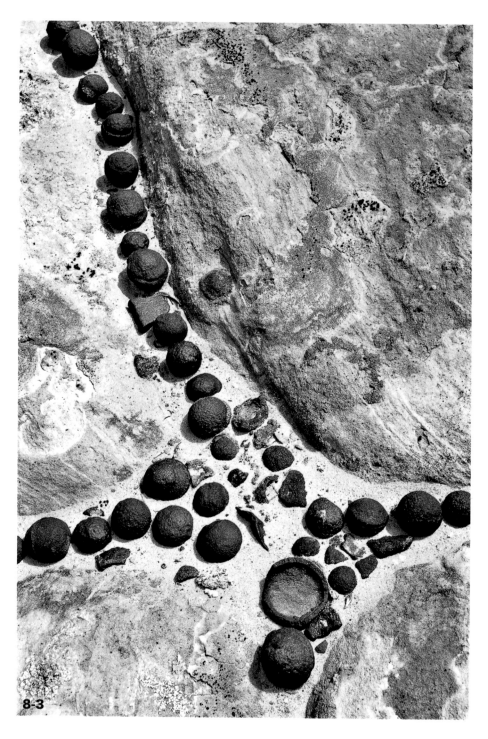

8-3

ABOUT THIS PHOTO
Image of "moki marbles" in Harris Wash, Escalante National Monument, Utah (ISO 100, f/16, 1/60 sec. with a Canon EF 17-40mm L lens). The geometric shapes of the stones, the texture of the surrounding rock, and the lines created by the arrangement of the stones within the rock crevices are strong graphic elements that translate well to black and white.

ABOUT THIS PHOTO *Image of palm fronds, Kawainui, Hawaii (ISO 100, f/10, 1/20 sec. with a Tamron 18-200mm XR Di II lens). The palm leaves were all very similar in color, which helped me to imagine it in black and white.*

8-4

in the image. Subject matter that reliably makes a good candidate for black-and-white photos contains strong visual elements that provide clues to the viewer without relying on color. An example of a photo that relies heavily on color components for visual information and therefore doesn't translate well to black and white is illustrated in 8-5 and 8-6.

ABOUT THESE PHOTOS *This image of Dry Creek Valley, Sonoma County, California relies heavily on color and doesn't work well when converted to black and white (ISO 200, f/14, 1/60 sec. with a Tamron 18-200mm XR Di II lens).*

You've probably noticed that the majority of photographs in this book are in color. However, there may be images that could also be effective in black and white. Flip through the book and evaluate the tones and shapes in the color photos to identify some images that you think might also work in black and white.

CENTER OF INTEREST

Another key to a strong black-and-white photo is usually a strong focal point or center of interest. Of course, there are exceptions, but without the visual clue of color, the viewer needs guidance as to where to look in the frame. If you create a strong center of interest, or focal point, in the composition, the viewer's eye travel will resolve there (see 8-7).

DIGITAL CAPTURE FOR BLACK AND WHITE

There are two basic ways to make a black-and-white digital photograph: (1) capture it in color and convert in on the computer later, or (2) use the built-in processing in your camera to record black-and-white images to your memory card.

In most cases, you should capture in color and perform the conversion to black and white on the computer.

IN-CAMERA VERSUS COMPUTER PROCESSING

Many modern cameras provide options for making black-and-white images entirely within the camera. Some also offer special color processing effects. However, I strongly recommend that you always capture in straight, neutral color and convert your photos to black and white later during post-processing in the computer.

There are several reasons for this. First, most cameras can only capture JPEG images. In these cases, your camera captures the original RAW data in color, converts it to black and white using the camera settings, and then saves the JPEG to the memory card. The RAW data is not preserved. You lose lots of quality and lots of options for later processing.

As discussed in other chapters, *you should capture in RAW format whenever possible.*

The second reason not to process in-camera is that you might want to produce both color and black-and-white versions, as shown in 8-8 and 8-9. If you only have the converted version made in the camera, you're out of luck if you want to make a color version later.

Some dSLRs do allow you to capture in RAW format and apply a black-and-white conversion in-camera, but understand that the image is still in color and the instructions for the black-and-white conversion are only stored as *metadata*. Metadata is textual information about a computer file that describes attributes about the content of the file. (Metadata is discussed in more detail in Chapter 9.)

To preserve black-and-white metadata settings for RAW files on the computer you need to use the dedicated software that came with the camera. For example, you can capture a RAW image on a prosumer level dSLR with an in-camera black-and-white style applied, and if you import that image into the camera manufacturer's dedicated software the style will be recognized and preserved.

However, you have much more flexibility and choice in how you process your black-and-white conversions if you leave them in color on the camera and use software other than what came with the camera. I highly recommend Adobe Photoshop Elements and/or Adobe Photoshop Lightroom for this, which is discussed further in Chapter 9.

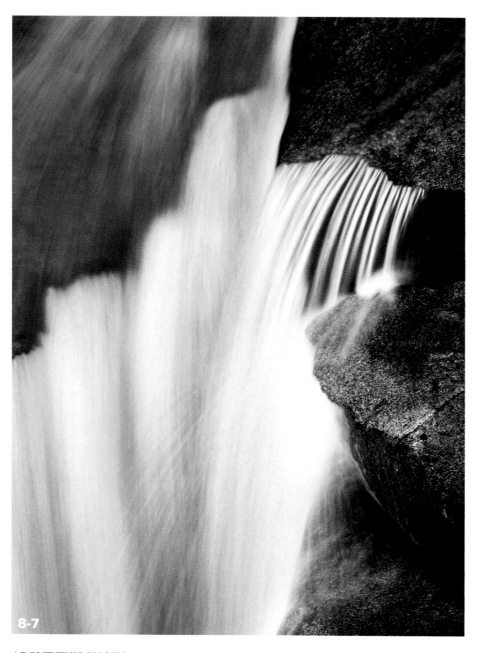

8-7

ABOUT THIS PHOTO *Image of waterfall at the Grottos, Independence Pass, Colorado (ISO 100, f/14, .4 sec. with a Tamron 18-200mm XR Di II lens). I presented a strong center of interest in this photo by juxtaposing the soft, flowing blur of the water against the strong, sharp, unmoving rocks. The intersection of the resulting shapes creates the focal point. Also, remember that the eye is drawn to sharply focused objects more so than blurry ones.*

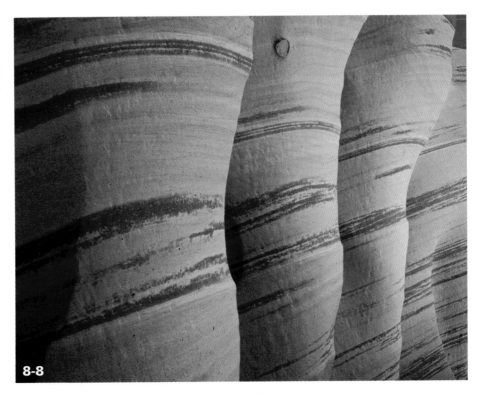

8-8

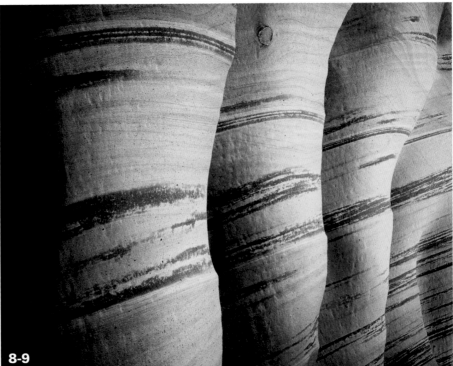

8-9

In any case, when you capture RAW color images you need to previsualize how you'll convert color photos to black and white in the computer.

> **note** A few recent camera models allow you to create a black-and-white conversion in camera without overwriting the original capture. This can be helpful for quickly previsualizing in the field whether a photo makes a good candidate for black-and-white conversion later in post-processing.

PREVISUALIZING TONE CONVERSIONS

As you set up your shots, look carefully at the objects in your composition. Compare their brightness relative to one another. What's the brightest spot? The darkest? How do the varying levels of brightness relate to the shapes and textures of the objects?

Pay special attention to mergers of tone and color (mergers are discussed in Chapters 4 and 7). When you convert a photo to black and white, all the elements of a specific color are essentially converted to the same level of gray. Also, two overlapping objects of different colors might be the same tone, in which case the default black-and-white conversion may merge them into one indistinguishable object.

Think about how you will convert the various elements in the compositions to black and white. Based on color, you can decide which elements will become darker or lighter in the conversion.

CONVERTING COLOR PHOTOS TO BLACK AND WHITE

There are many ways to convert a color photo to black and white using software on your computer. Some methods provide more control than others. In most image-editing programs, there's an option

to automatically convert to black and white. This sometimes produces acceptable results but offers the least amount of control.

There is some confusion surrounding the distinction between "black and white" and "grayscale." Photoshop has a color mode called Grayscale, which is a single-channel grayscale image. Normally, you should not use Grayscale mode. In nearly all cases you need to keep the image in RGB color. During the conversion, the three color channels are equalized so they have the same values, resulting in a neutral, grayscale image that still contains three channels. An RGB image provides many more options for high-quality printing than does a true grayscale image. Regardless of the ultimate intended print destinations for your photos, you should always keep your master working photo files in the RGB color space and only convert to other color spaces using derivative files specifically made for each print application.

> **note** Some specialized, dedicated black-and-white digital printing systems are designed to work with single-channel grayscale images. The Piezotone system developed by master printer Jon Cone is a good example.

MAPPING COLOR TO GRAY LEVELS

Ideally, you'll use software that allows you to map individual colors to specific gray levels. For example, you could choose to have the blue sky rendered as a very dark tone, a light tone or somewhere in between (see 8-10). If you can separate the colors of elements in the image, you can control how those colors are converted to gray levels.

If your software provides separate controls for the conversion of individual colors to gray levels you'll have the most control over the look of the final conversion. The B&W panel settings in Adobe Photoshop Lightroom are shown in 8-11.

For nearly all original color photos, controlling the conversion of color to gray levels produces a much better result than automatic conversion.

SOFTWARE CHOICES

You can convert RAW images to black and white using Adobe Lightroom or Camera Raw. You can use Photoshop and Photoshop Elements to convert other file formats like JPEG and TIFF.

Some proprietary camera software can make black-and-white conversions, too, but these programs offer relatively limited control and most provide an awkward user experience.

Many nature photographers prefer the capabilities offered by dedicated software to make their black-and-white conversions. Silver Efex Pro from Nik Software is tops in this category. Most of these dedicated programs (often called plug-ins) can operate in conjunction with Photoshop and/or Lightroom.

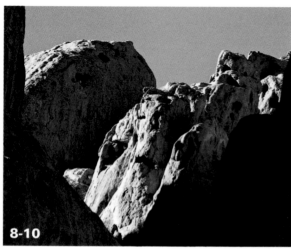
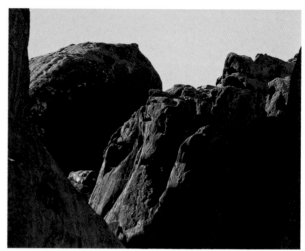

8-10

ABOUT THIS PHOTO *Image of rocks at Garden of the Gods, Colorado illustrates how changing the gray-level mapping can produce radically different black-and-white conversions from a single, original color image (ISO 400, f/8, 1/350 sec. taken with a Canon EF 75-300mm lens).*

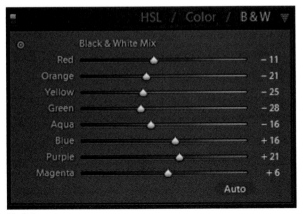

8-11

ABOUT THIS FIGURE *The B&W panel in Lightroom's Develop module provides slider controls to determine how individual color ranges are converted to grayscale levels. (Note that there's also an Auto button for automatic tone mapping.)*

COLOR TINTING

After converting an image to black and white, you may find that some photos benefit from applying subtle color overlays, or *tints*, to the converted image. Color-tinting effects range from a single color wash, such as the old-fashioned sepia tone treatment (see 8-12), to more modern effects like *split-toning* that applies different color tints to highlight and shadow regions and *cross-processing* that simulates the wet darkroom process of the same name (8-13 and 8-14).

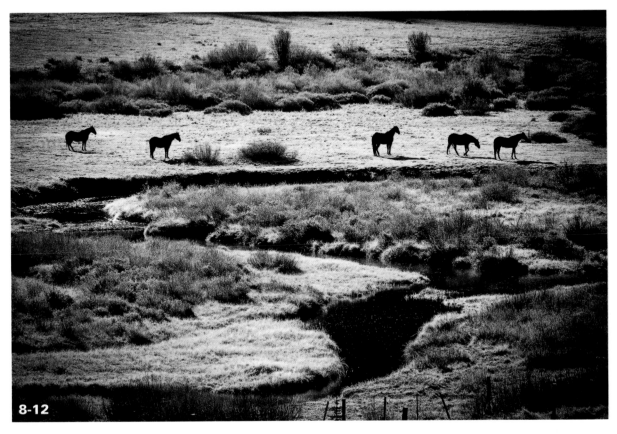

8-12

ABOUT THIS PHOTO *Sepia tone treatment on a photo of horses near Crested Butte, Colorado (ISO 200, f/7.1, 1/800 sec. taken with a Canon EF 28-135mm IS lens).*

ABOUT THESE PHOTOS *Two versions of a single image of The Mittens, Monument Valley Tribal Park, Arizona, show the straight black-and-white conversion (8-13) and a simulated cross-processed version (8-14) with highlights tinted gold and shadows tinted blue (ISO 100, f/16, 1/30 sec. with a Canon EF 17-40mm L lens).*

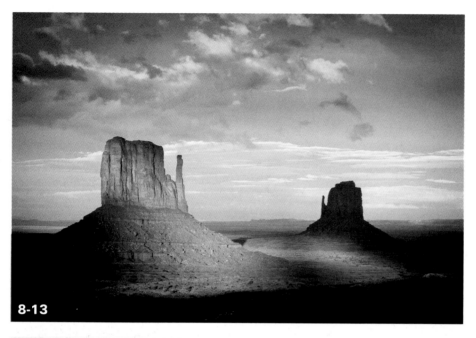

8-13

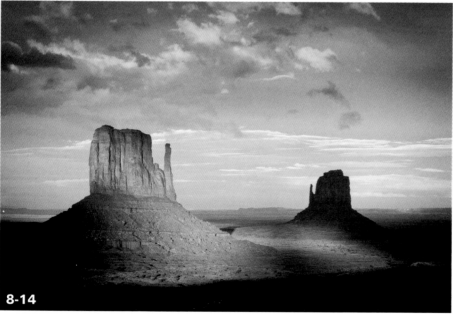

8-14

Assignment

Photograph a Theme for Black-and-White Conversion

For this assignment, produce a series of photographs all relating to a single theme. The goal is to create a body of work about a specific subject or subject matter and unify the series by converting to black and white.

Capture your images in natural color using RAW capture format if possible. You'll need between eight and 12 images for the series, so make as many photographs as necessary to be able to edit down to that range. Themes could include geometric shapes in nature, textures and patterns, tree trunks and branches, leaves, water, snow, and/or ice.

Whatever your choice of theme, it's important that all your images ultimately work together as a group. When you finish making your photographs and choosing your final selections, convert them to black and white using any available software. Try to make the final conversions for the series look consistent. (For help with editing and processing your photos, see Chapter 9.)

My example photograph is part of a series titled Zen Rocks. I photographed many small rocks and pebbles in a shallow, slow-moving stream. The final series contains nine images. The photograph shown was taken at ISO 50, f/18, 1/5 sec. with a Canon EF 300mm L lens.

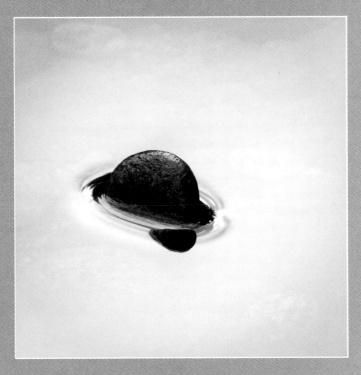

 Remember to visit www.pwassignments.com after you complete the assignment and share your favorite photo! It's a community of enthusiastic photographers and a great place to view what other readers have created. You can also post comments, read encouraging suggestions, and get feedback.

PROCESSING AND SHARING YOUR
NATURE PHOTOGRAPHS

The Digital Photography Workflow

Asset Management

Color Management

Editing a Shoot

Enhancing Your Photos

Printing Your Photos

Creating Photography Web Sites

This chapter discusses processing and sharing your photos: how to organize your images using a good asset management strategy; get consistent, accurate color reproduction using color-management systems; edit the image files from a nature photography shoot; and enhance your photos with Lightroom and Photoshop. You also learn about making digital prints and presenting your work on photo Web sites.

THE DIGITAL PHOTOGRAPHY WORKFLOW

Creative people like to be spontaneous, and nature photographers are no exception. You want the freedom to react instinctively and work intuitively with your pictures. Ironically, to accomplish this you benefit greatly by operating within some kind of framework. Random action produces random results — as explained in other chapters, working in a methodical way and allowing your process to flow along a sequence of clearly defined steps provides greater creative freedom because you don't have to think as much about the technical details.

Post-processing refers to the work you do to your digital photos using a computer. In recent years, the term *workflow* has become widely used (and maybe overused) in all areas of business, and photography in particular. For digital nature photographers, the post-processing workflow you follow can make your work tedious and labor intensive or fast and easy. A workflow is simply a standard sequence of steps that you use to produce a specific result. A good workflow saves you lots of time by consistently following the same steps and automating the process wherever possible.

The typical digital photography workflow (see 9-1) is really comprised of many smaller workflows, each related to a specific task. For example, you can use one workflow to make sure you have the right camera settings, another workflow can help you get your photos onto the computer, and others can help you pick your favorites and process them to completion. (And making prints certainly involves a workflow of its own.) Your choices in workflow will be based on available hardware and software and personal preference. There's no one perfect workflow for every photographer.

There are, however, some established best practices you can use to simplify your workflow, get things done faster and easier, and maintain the best possible quality throughout the process. I encourage you to continually identify areas in which you already know (or suspect) your workflow is not as efficient as it can be and work on those areas. Over time you need to keep tightening and refining your photo workflow by finding areas of inefficiency and eliminating them. As a result, your work will improve, you'll have more fun, and most importantly, your photography will improve.

tip Get into the habit of thinking a little about your imaging workflow when you're out shooting. You'll make better decisions in the field if you previsualize the end result you plan to achieve with your computer processing.

Capture ⟶ Download ⟶ Sort ⟶ Process ⟶ Output

9-1

ABOUT THIS FIGURE *These are the steps in a simplified digital photography workflow.*

ASSET MANAGEMENT

Asset management is all about how you name, organize, store, and back up your image files. Asset management plays a crucial role in your ability to find, work with, and share your photos. For most photographers this is certainly not the most fun or exciting part of the process, but it's not optional — if nothing else, the sheer volume of digital photographs you make requires you to develop and implement a comprehensive system for managing your images.

FILE STORAGE SYSTEMS

The first thing to consider is where your digital photos will be stored. Today this almost always means using hard drives, but there are myriad configurations to consider. I strongly recommend that you set up a storage system where all your photos are on one (or a very few) hard drive units *with nothing but your photos on them*.

If at all possible, don't store your entire photo library in your Pictures folder on your internal system hard drive. Instead, I recommend you use external hard drives — either single drives or

RAID (Redundant Array of Independent Disks) — systems to store your pictures. Using external drives allows you to easily change or upgrade equipment and move drives between computer systems if necessary.

> **note** I keep my entire image library on a single external hard drive (my "master working drive"); I'm currently using a 1TB drive for this. Besides my image library, nothing else is on this drive.

You need to back up your files regularly — stop and consider how you would feel if you lost all your photos in an instant and were unable to recover them. You need *at least two identical copies* of your master working files; three is better (see 9-2). One backup is updated regularly: after every significant work session at minimum. The other drive unit(s) can be updated less frequently and should be stored off-site. With this system you need not worry about any single hard drive failing, and it's extremely unlikely that they would all fail at the same time. If a drive fails, get a replacement and copy everything from another

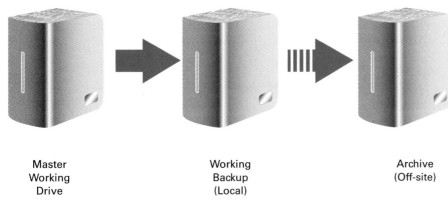

Master
Working
Drive

Working
Backup
(Local)

Archive
(Off-site)

9-2

ABOUT THIS FIGURE *This is a simple photo storage system using external hard drives.*

backup drive onto the new device. The key to making this system work easily is that your backup drives are *exact copies* of the master working drive.

There are two basic choices in hard drive storage: single drive units or RAID storage systems. RAID uses multiple drives that appear to your system as a single volume. A RAID system can be configured to automatically copy files between the disks in the system to provide transparent backup capability.

When considering the purchase of new hard drives, choose a system that will serve you for at least the next 18-24 months; you can estimate your storage needs based on your historical usage and your plans for future photography.

> **tip** If you use single drives, you should use specialized backup utility software to synchronize your backups. Using sync software makes backups faster and more reliable. For Mac, I recommend ChronoSync and Carbon Copy Cloner. For Windows, I recommend SyncToy.

ORGANIZING AND NAMING YOUR IMAGE FILES

At one point or another one of the most daunting challenges all photographers face is deciding how to arrange their image files into folders and what to name files and folders. The most important thing is to create a standardized system and use it consistently.

> **tip** What's most important about standardizing your asset management system is that you create a good plan that you can start using now. You can later decide whether you need to go back and rework your old image archives to conform to the new system.

There are lots of opinions about how image files should be named and organized; this is an area where your personal preferences play a significant role in your decisions. In the end, the system has to make sense and work for you. It doesn't make sense to adopt someone else's strategy if it only causes you confusion and the risk of misplacing or losing files.

That said, there are some widely accepted best practices for how to organize and name your files and folders:

- Every file and folder in your image library must have a unique name.

- Give files and folders meaningful names. The filenames assigned by your camera are useless in a structured storage system.

- In your names, include a formatted date, such as YYMMDD.

- Also include some kind of identifier as to what the folder/file contains. For the nature photographer, using the names of locations and/or subject matter makes sense.

- Use sequence numbers (or "serial" numbers) to differentiate files from a single shooting session.

- Name and group folders and subfolders according to their date or content.

- When possible, give your folders and the files they contain the same base filename.

- The system must be able to scale (grow exponentially) over time.

See 9-3 for an example of a simple folder and file system.

> **note** Many nature photographers organize their top-level folders based on the date the photos were taken.

ABOUT THIS FIGURE
This is a structured folder and file system using years and locations as folder names. Regardless of how you choose to group files together into subfolders, your work will be easier if you keep everything under one top-level folder and use as few nested subfolder levels as you can.

KEYWORDS AND OTHER METADATA

Metadata literally means "data about data." A digital photo can contain an enormous amount of metadata in addition to the pixel data used to render the image.

Image metadata is plain text information stored in a special part of the image file. It can describe information about the capture, such as the date and time it was made, and the camera settings such as aperture, shutter speed, and focal length. This metadata is called EXIF metadata and is embedded into the image files by the camera at the time of capture.

Metadata is also used for keywords (also called "tags") that describe the contents of the photo. For example, you could add the keywords "South America, Patagonia, Chile, Mountains, Summer, Alpine, Rugged," and so on to photos from that trip. Keywords have one purpose: to make it easier to find the pictures.

> **tip**
>
> Apply keywords to your photos early in the workflow. Add and enhance the keywords for your favorite photos to make them easier to find.

Many modern photo-management programs allow you to apply keywords and use them to find and sort photos. Programs such as Adobe Lightroom and Apple Aperture work very well with metadata — especially keywords. As your photo library grows, keywording becomes increasingly important because it can help you quickly find a photo even if you have no idea where it's stored on your hard drive. The procedure for adding keywords and searching with them varies depending on the software used.

> **note**
>
> Using metadata to organize and edit photos is a key advantage of using a database-driven imaging software such as Adobe Lightroom.

Keywords are also how people find photos on Web sites like Flickr; search engines also use keywords. Do a Google search for "Patagonia" and you get all kinds of photos in the results.

Conversely, a photo *without* any keywords becomes much harder (if not impossible) to find, whether on your own computer or the Internet.

When using keywords to describe the content of a photo, anything goes. Subject matter, themes, moods/emotions, time of year or time of day, colors, numbers, and descriptions of shapes all make good keywords. Look at 9-4 and make a list of all

the keywords you can think of to describe the picture. When you think you've come up with all the possible keywords, take a short break and come back to add more — you may be surprised at all the ways you can use words to describe the contents of a picture.

COLOR MANAGEMENT

Where asset management allows you to efficiently work with all your files, *color management* ensures that the color of your photos remains as

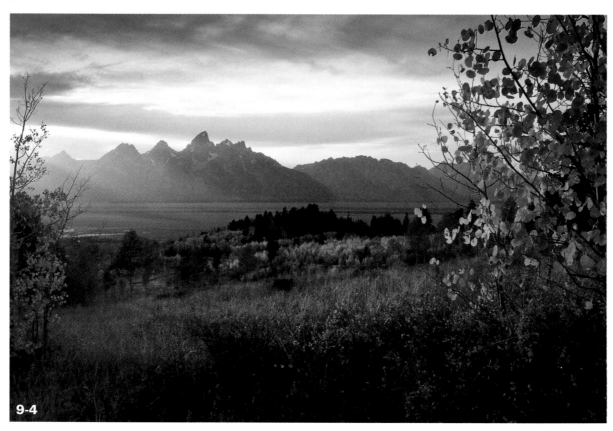

ABOUT THIS PHOTO *Image of the Grand Teton range in Jackson Hole, Wyoming (ISO 100, f/22, 1/13 sec. taken with a Tamron 18-200mm XR Di II lens). Some of the keywords I used for this image are Alpine, America, Aspen, Aspens, Autumn, Clouds, Cloudy, Colorado, Fall, Forest, Grass, Grasses, Jackson Hole, Landform, Landscape, Mountain, Mountains, Nature, North America, Plants, Shadow Mountain, Skies, Sky, Tree, Trees, U.S., U.S.A., United States, United States of America, Valley, Vegetation, and Wyoming.*

accurate as possible throughout the workflow. Adopting good color management policies is absolutely essential to the nature photographer.

Electronic devices differ in how they deal with color reproduction. Your computer monitor handles color differently than your printer; a projected image will be rendered differently than a print from a photo lab, and so on.

A *color management system (CMS)* handles color translations between devices. With good color management systems in place you can reasonably expect that what you see on the screen will look similar on a print. Your computer has a CMS built in; on Mac it's called ColorSync and on Windows it's either Image Color Management (ICM) or Windows Color Management (WCM).

COLOR SPACES AND PROFILES

Computer systems describe color numerically. The range of colors available in an image file or on a device is called its *color space*. Color spaces vary widely; for example, some monitors can display many more colors than others can.

Color spaces are based on a three-dimensional model that describes the numeric values of the colors available in the space. In this 3-D model (see 9-5), some color spaces are larger than others, which means they contain more possible colors. The size of the color space is called its *gamut*. A large gamut contains many colors; a color space with a small gamut has fewer colors.

A *color profile* describes the gamut of an image file or device to the CMS.

For example, if you save a photo with the sRGB color profile, the CMS will determine how to accurately translate the colors in the photo to your monitor and printer using the embedded profile.

9-5

ABOUT THIS FIGURE *3-D plot of the AdobeRGB (1998) color space.*

> **tip** When saving or exporting files from your imaging software, always be sure to enable the option to embed the profile for the color space used for the image. The procedure for doing this depends on your software.

DISPLAY CALIBRATION

By far, the most important step to managing your color is to calibrate and profile your computer display (monitor). This must be done using a combination of hardware and software — the calibration utilities that come with your operating system or other software are not sufficient.

A display calibration kit uses a device to measure the color on your screen as the software presents known color values, as shown in 9-6. At the end of the measurement process, a profile is created for your monitor. The CMS then uses that profile to display the colors on the screen.

> **note** I use and highly recommend the color management solutions from X-Rite. In particular, the Eye-One Display 2 and ColorMunki systems are my recommended solutions for photographers to calibrate and profile their displays.

CHOOSING A MONITOR Not all computer displays are appropriate for photo editing. Some monitors are difficult to calibrate and don't retain their accuracy very long. Some monitors are also far too bright to provide accurate color — an overly bright display is the main culprit in the vast majority of color matching problems for photographers. Whatever kind of computer you have, as a nature photographer you owe it to yourself to get the best monitor you can afford. The current crop of LCD displays is best for photo editing. The most important features for photographers' displays are manual brightness adjustment and separate white point controls to adjust the RGB channels independently. NEC Display Solutions, LaCie, and EIZO are leading makers of displays that can be optimized for photo editing.

9-6

ABOUT THIS FIGURE *The X-Rite Eye-One Display 2 measures color values of the display and creates a color profile for more accurate viewing. ©X-Rite*

See the appendix for resources on color management.

EDITING A SHOOT

After you make your photographs and transfer them to your hard drives, the next thing to do is go through them, pick your favorites, and organize them into logical groups.

This process has traditionally been called *photo editing*. For example, a magazine photo editor's job is to select the photos that will be used in an issue and eliminate those that don't make the cut. (A photo editor rarely does any actual processing of the photos.)

> **note** "Editing a photo" has also been used to describe the process of adjusting tone and color, retouching, and so on. In the sections that follow you edit photos based on the first definition.

EVALUATING PHOTOGRAPHS

You can use some common criteria to help decide whether a shot is worth processing and sharing. Use the following checklist to evaluate your photos as objectively as you can. (Refer to Chapter 4 if you need to review the fundamentals of composition and design.) Keep in mind that many flaws in these areas can be corrected with processing. What's important at this point in the workflow is that you get a clear idea of the strengths and weaknesses of each photo to determine if it's worth further attention. Evaluate your photos on both technical and artistic merits by asking the following questions:

■ What's the immediate impact of the photo? Is it strong or subtle? Wow or ho-hum?

- What's the subject? Or, "What is this a picture of?"

- What and where are the main focal point(s) and center(s) of interest?

- How does the eye travel around the frame?

- Are there objects in the frame that compete for attention with the main subject matter?

- What are the design elements within the composition?

- Is the exposure correct, or is the photo over- or underexposed?

- Does the color balance seem to be correct? Is there an undesirable colorcast or tint present?

- Is the photo sharp and in focus? (if applicable)

- Is there noise or other digital artifacts in the image?

- Are there elements that should be retouched or removed?

Use a checklist like this to help evaluate every photo, and you'll learn to critique photos more quickly and accurately and make better decisions about the ideal processing for each photo.

RATING AND SORTING

Methodically go through each batch of photos and determine the ones that have the most potential. It's easiest to do this in several rounds of editing — it's hard to make your best decisions with the information overload that occurs when looking at dozens or hundreds of photos.

As you review your photos during each round of editing, use the rating and/or labeling systems in your software to mark the ones that you like. I use

star ratings, starting with one star for the first pass and then adding more stars during each consecutive round of editing. The photos with the most stars become my final selections from the shoot.

Some photographers prefer color labels, for example: green for select, red for reject, blue for review later, and so on.

Regardless of the method you choose to rate your photos, be your own toughest critic. Edit tightly to ensure that only your best work remains. You have too many *good* photos to produce; don't worry too much about those that didn't make the grade.

tip Take some time to evaluate your rejected photos to figure out what went wrong. You can learn a lot more from your failures than from your successes!

Next, separate the selects from the rejects. Depending on your editing software, the methods for doing this may differ but the basic idea is to be able to view only your final selects when you're done editing. If your rated photos are mixed in with rejects it's hard to efficiently move forward with processing and enhancing the selects.

See 9-7 and 9-8 for a batch of photos from a shoot before and after editing.

caution Resist the urge to delete photos during your editing process. You might make a mistake, or you might change your mind later. If you're tempted to throw something away, instead, just hide it from view for now. It's good to be able to come back later to review old work and reevaluate your photos with fresh eyes.

ABOUT THESE FIGURES *9-7 shows the Lightroom window containing all the image thumbnails from a photo shoot prior to editing for selects. 9-8 shows the selected images after the edit, with star ratings visible on the thumbnails.*

9-7

9-8

ENHANCING YOUR PHOTOS

Sometimes your photos will look great straight out of the camera. Other times they will need serious work. But generally speaking, all photographs (especially if captured in RAW format) can use some processing to help them look their absolute best.

You should decide for yourself how little or how much "enhancement" you want to do to your photos. Some nature photographers (me included) prefer a minimal level of processing so each photo remains as faithful to the original creative vision at the time of capture. Other photographers favor a more heavy-handed approach that may allow for processing that could most accurately be referred to as "special effects."

Of course, in most cases how much is too much is entirely up to the photographer who made the picture. With photojournalism, truth in reporting is essential and photos should undergo as little manipulations as possible. However, with fine art, especially nature photography, there is much wider latitude of artistic license in the final image.

Unless you're making images to meet a client's requirement, I encourage you to make your pictures the way *you* want them to look and don't worry too much about other people's opinions about the style of your processing.

See 9-9 for before and after versions of an example image. I cropped the photo, applied tone adjustments to increase contrast and clarity,

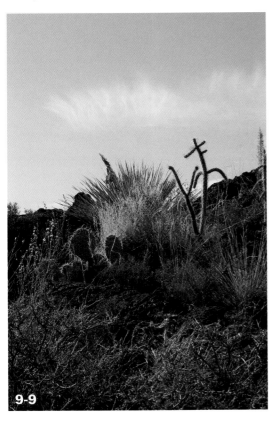
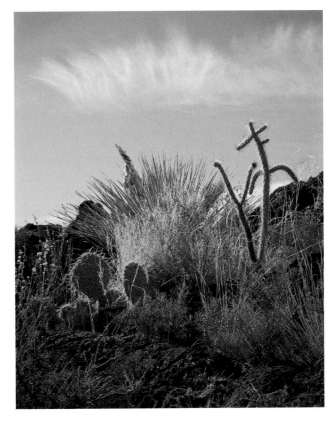

9-9

ABOUT THIS PHOTO *I photographed solidified lava flows and cacti at Valley of Fires Recreation Area in New Mexico (ISO 400, f/13, 1/100 sec. taken with a Canon EF 28-135mm IS lens). On the left is the original capture prior to processing; on the right is the final processed version.*

adjusted white balance, and slightly boosted the color saturation in the sky. I also applied sharpening and noise reduction.

DEVELOPING A PHOTO IN LIGHTROOM

Regardless of the software you use, you should follow a consistent workflow to finish your photos. Always start by making the largest adjustments first, then work your way down to the fine details.

In Adobe Photoshop Lightroom, processing a photo is done in the Develop module. Following are the essential steps to developing a photo in Lightroom:

1. **Crop.** Cropping a photo is the biggest change you can make because it changes the composition. Consider cropping as your first step; you can come back and refine your crop later if necessary (see 9-10 and 9-11).

2. **Adjust tones.** In the Basic panel, adjust highlight and shadow values using the Exposure and Blacks settings. Exposure adjusts the tones from the white point (highlights) and the Blacks slider adjusts the black point

(shadows). Using just Exposure and Blacks you can dramatically change the brightness and contrast of the photo. After getting these settings where you want them, adjust the midtones using the Brightness slider, and then adjust the Contrast slider to increase or decrease contrast around the midtones. In the example shown in 9-12 and 9-13, the Exposure increase of +0.36 is an approximately 1/3-stop increase in brightness levels, with the greatest changes concentrated around the highlights. A Blacks level of +16 significantly boosts the shadows and is unusual — this image was captured with brightness levels leaning well to the right of the histogram. Optimal Blacks values of +5 or +6 are more common. To lighten the image, especially in the midtones, I adjusted Brightness to +61 from its default of +50. I almost always end up setting my Contrast to somewhere around +35.

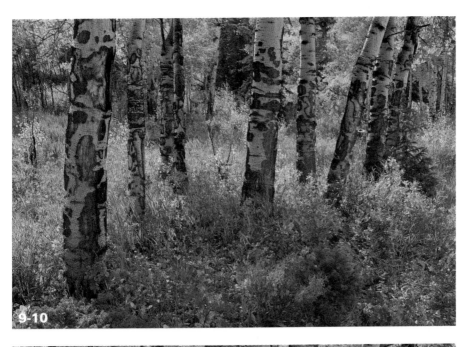

9-10

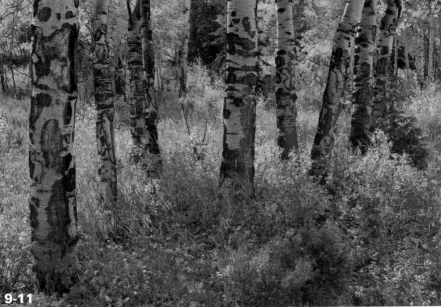

9-11

ABOUT THESE PHOTOS *9-10 and 9-11 show an image before and after cropping. I cropped the photo to create a more balanced composition and eliminate distracting elements from the edges of the frame.*

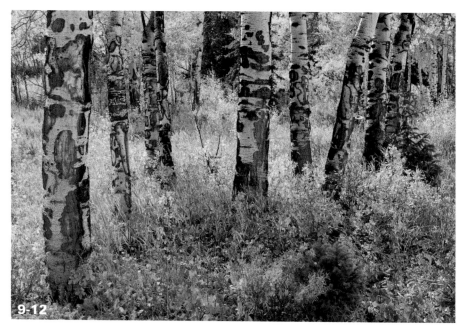

9-12

9-13

3. **Adjust color.** After adjusting tone, adjust color as necessary. First, consider refining the White Balance settings to correct any color-cast present in the photo. Temp and Tint can have a profound effect on the look of an image. In the example shown in 9-14 and 9-15, I used my calibrated screen preview as my guide and lowered the Temp to 4659, cooling the photo slightly by adding blue and removing yellow. It then looked a bit pink, so I tweaked Tint to –2, removing magenta and adding green. I adjusted Saturation to +7 and Vibrance to +6 to slightly boost the colors.

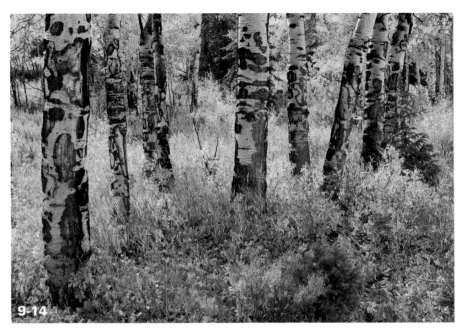

ABOUT THIS PHOTO
Image after adjusting White Balance and Saturation.

9-14

9-15

ABOUT THIS FIGURE *The Basic panel settings adjustments I made for White Balance and Saturation.*

4. **Sharpen.** After doing global tone and color adjustments, go to the Detail panel to apply sharpening. Different types of images benefit from different sharpening settings. If your photo has a lot of fine detail, use a higher Amount and a lower Radius. Photos with large areas of solid color and relatively little detail can use a lower Amount and a higher Radius.

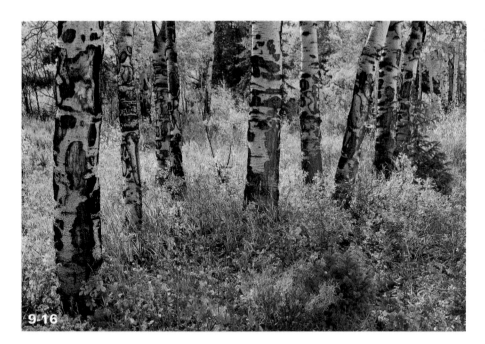

9-16

9-17

ABOUT THIS FIGURE *The Detail panel settings after I applied
Sharpening.*

In the example shown in 9-16 and 9-17, I zoomed in close to the photo, and while viewing the large preview, dragged the Amount slider to 45. This is a high resolution capture with lots of tiny details; using a Radius setting of 0.9 concentrates the effect of the sharpening along fine edges. Dragging the Detail slider to the right increases the sharpening on the fine details; I often end up somewhere between +15 and +30 for this adjustment. Masking set to 0 is appropriate for a photo like this; if you have a photo that contains the sky or other solid field of color, add higher amounts of Masking keep those areas smooth.

MAINTAINING THE HIGHEST POSSIBLE QUALITY In earlier chapters, I touched on the reasons why it's important for the nature photographer to capture in RAW mode whenever possible. Working in the digital darkroom is where the differences in file formats become more evident and can become your ally or a hindrance. If you capture RAW, you preserve all the original data from the sensor. This provides enormous flexibility when working on your photos in the computer, and you can attain and maintain the highest quality all the way through the process.

It's also important that you don't do any resizing of photos until the very end of the process, and only resize derivative files used for specific purposes. Always keep your original "master" files at their native resolution.

5. **Dodge and burn.** Most nature photographs really shine after some dodging and burning. Named after traditional darkroom techniques, in the digital darkroom dodging is lightening and burning is darkening specific areas of the photo. Dodging and/or burning can be used to help keep the viewer's eye in the frame, direct eye travel, and reduce distractions (see 9-18).

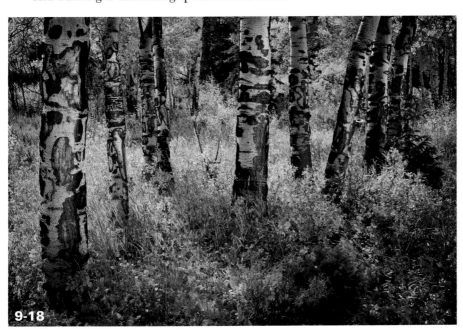

9-18

ABOUT THIS PHOTO *Final image after dodging and burning. I darkened the corners of the photo, lightened the trees, and darkened their shadows.*

Though the tools may have different names depending on your software, you can use these same basic steps to enhance all your photos. Some images are helped by additional processing such as retouching and spot removal, noise reduction, and fixing chromatic aberration and other artifacts.

STITCHING PANORAMAS IN PHOTOSHOP

If you have Adobe Photoshop (or Photoshop Elements) you can use the built-in Photomerge feature to combine multiple captures into one panoramic image. Following is an example of the stitching process in Photoshop CS5:

1. **Process the original, separate captures all the same way.** If you need to make changes to white balance, sharpening, exposure, and so on, you need to apply the same adjustments to all the photos. Do not process each image using its individual settings or the stitching won't work!

2. **Open Photoshop and from the File menu choose Automate ⇨ Photomerge.**

3. **In the Photomerge window click Browse, and in the next window navigate to the folder containing your photos to be stitched.** Shift+click to select them and click OK.

4. **Back in the Photomerge window, your photos should be listed in the center, as shown in 9-19.** For most nature panos, you can usually leave the Layout setting at the left side of the window on Auto. At the bottom of the window are check boxes to enable options for Vignette Removal and Geometric Distortion Correction; in some cases these will produce optimal results. Try stitching your pano without these enabled first. Make sure the Blend Images Together check box is selected.

5. **Click OK.** Photoshop creates a new document window and stitches together the original images using separate layers.

6. **When the process is complete, you will likely need to crop the photo edges to get rid of empty space resulting from the Photomerge process.**

7. **Flatten the image and use the Content Aware Fill, Clone Stamp, and/or Healing Brush to clean up any remaining artifacts.**

8. **Finish processing the image by doing any necessary tone and color corrections, and dodge and burn the final composite.**

See 9-20 for an example composite image.

9-20

ABOUT THIS PHOTO *Example of a final stitched pano image after running Photomerge in Photoshop.*

9-19

ABOUT THIS FIGURE
*The Photoshop Photomerge
window with a sequence of
images selected for stitching.*

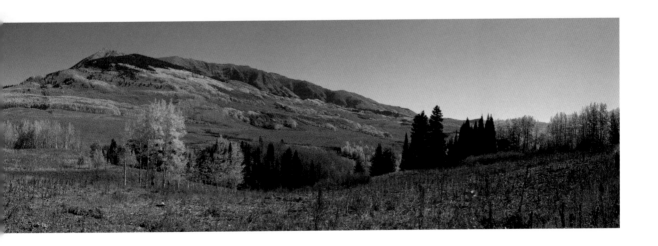

PRINTING YOUR PHOTOS

A fine nature photograph is never truly finished until it's printed. Making prints of your photos makes them tangible, meaningful, and significant. You learn a lot about your work and the technical process of digital photography by having your work printed. You can have your prints made by a service provider or learn to make them yourself.

> **tip** For your best work, consider having the prints professionally framed and hanging them on your walls. When you look at a photo day in and day out, you learn new things about it.

WORKING WITH A PHOTO LAB

Most photographers start out having their prints made by a service bureau. You can work with a local lab where you drop off your files on removable media, or you can use a national lab that accepts files submitted online.

> **note** Traditionally, photo labs processed film to make prints. Though they're still called labs, the process is now digital.

Although most labs use similar equipment to print your photos, the quality of printing from various labs varies widely. Order some small test prints before you have any large, expensive prints made.

The most important aspect of working with a lab is to find out about its color management policies and procedures. Many labs can provide a custom color profile to attach to your image files when saving them for printing; this simple step can often eliminate the majority of color problems. Most labs also offer color-correction services for an additional fee; however, if you and the lab both follow good color-management procedures this should not be necessary.

See the appendix for recommendations on labs.

MAKING YOUR OWN PRINTS

Many photographers enjoy making their own prints. The cost of equipment has dropped significantly over the years, and making high-quality prints at home is now affordable for most people. If you're interested in learning to make your own prints, here are some tips:

■ **Choosing a printer.** For the nature photographer, inkjet is the only kind of printer worth consideration; other types (such as laser and dye-sublimation) can't match the quality of inkjet for photo printing. The main considerations for choosing an inkjet printer are the maximum size it can print and the ink it uses. Most current printers use between eight and 12 ink colors. More inks allow you to reproduce a wider color gamut. Some inks are designed to last longer than others before the color starts to fade; check the specifications for permanence. See 9-21 for an example of a great entry- to midlevel printer.

9-21

ABOUT THIS PHOTO *The Epson Stylus Pro 3880 is an excellent, reasonably priced 17-inch printer that will satisfy photographers just starting to print their own work as well as experienced printing professionals. ©Epson.*

- **Choosing paper.** There is an enormous range of printing substrates available for inkjet photo printers. From glossy or semigloss photo paper, to canvas, to handmade Japanese papers, the list goes on and on. The best way to start is by getting some sample packs from online inkjet suppliers. Find paper that's approved for your type of printer. It's a good idea to start by using the papers sold by the printer manufacturer, but don't stop there. In general, the highest quality papers are not sold by printer companies. With time, you'll identify the kinds of paper you prefer; the appendix lists my recommendations.

- **Color management.** Paper manufacturers usually provide printer profiles for all their papers. In most cases, these "canned" profiles give very good results. However, if you become serious about your printing you should consider custom profiles made specifically for your own printer with each kind of paper you use.

- **Handling and storage.** When making your own prints it's critical to keep a clean, tidy workspace. Paper is best stored in a cool, dry place out of direct sunlight and this is especially true for prints. With most papers, if you stack prints on top of one another the surface will scratch — use interleaving sheets or poly bags to separate your finished prints. There are a variety of coatings you can apply to your prints to make them more durable and help the color last longer.

tip Wear cotton or silk gloves when handling prints and unprinted paper.

See the appendix for recommendations on inkjet printers and paper.

BUILDING A PORTFOLIO

As you develop your photographic body of work it's likely that you'll want to put together a printed portfolio of your nature photography. You can assemble your portfolio using prints from a lab or prints you make yourself. The primary purpose of the portfolio is to showcase your best photography.

Printed nature photography portfolios can be grouped into three general categories: (1) portfolios with removable pages, (2) portfolio books with a permanent binding, and (3) loose prints in a case or box.

In the first category, you have the choice of using plastic sleeves to insert your prints or simply inserting the prints without any covering. Plastic sleeves allow you to slip prints into them so you can easily change your portfolio pages whenever you like. Plastic sleeves are very durable and can withstand frequent use.

However, the aesthetic appeal of plastic sleeves is not as great as that of plain paper pages. Inserting your prints directly into the portfolio binder requires punching holes in precise locations.

One drawback of using straight prints without sleeves is that they are easily damaged. Even with just a few uses, fingerprints, bent page corners, and rips and tears can destroy the pages, requiring constant upkeep and replacement.

With permanently bound portfolio books you cannot replace the pages. However, these kinds of books certainly provide the most appeal and professional impression. The types of bindings vary, from stitching to "perfect-binding" that uses glue and sometimes also stitching.

EXHIBITING YOUR WORK One of the best ways to get feedback on your photography, see what other photographers are doing, and learn from other people is to show your work in exhibits. Start out modestly at local galleries; many hold group exhibits that are relatively easy to enter. As you gain experience exhibiting your work, you can enter larger shows and maybe even host your own solo exhibitions.

Portfolios using loose prints in a case often present the most professional appearance. At minimum, these prints should be mounted to boards — don't just stack the paper prints in the box. Ideally you should also mat the prints. A case of nicely matted prints (without plastic sleeves) really creates great impact. However, this type of portfolio also requires the most upkeep as the mat and mounting boards quickly become dirty and marred.

Your decisions about portfolio style should be based on your expectations of who will be viewing it, how often you expect to change out photos, and your available budget.

Regardless of the type of portfolio book you choose, there are some practical guidelines for putting together your photos into the strongest presentation:

- **Use only your best work.** Don't pad your portfolio with images of lesser quality just to make it longer. It's better to have a smaller portfolio with just a few very strong images than it is to have a larger portfolio featuring mediocre work.

- **Place all the photos on the pages in the same orientation.** In other words, whether each individual photo is portrait (vertical) or landscape (horizontal), all the photos should be placed on the pages in the same orientation so the viewer doesn't have to turn the book sideways, back and forth to view the images.

Unfortunately, regardless of which overall format you choose for the book, this means that one or the other orientation of images will not appear as large as it could on the page. For example, if you use a vertical orientation for the book, your horizontal photos will be constrained to the short width of the vertical pages and there will be lots of blank space at the top and bottom. With a portfolio using a landscape orientation the reverse would be true for vertical images. (You could use photos of only one orientation in your portfolio, but I don't recommend this.)

- **Each portfolio should contain no more than 24 photos.** Sixteen to 18 is ideal for most portfolios; you want to allow the viewer to seriously engage with each photograph without becoming overwhelmed by a lengthy commitment of time. Even with very strong images, a portfolio can become uninteresting when there's just too much to take in. Separating your photography into smaller groups helps the work appear stronger, more cohesive, and more professional. (Collections of more than 24 images are well suited for photo books, which is discussed in the next section.)

- **Each portfolio should be focused on a specific subject or theme.** It's better to make several smaller portfolios with a unified theme than to make a larger one with multiple kinds of photos.

- **Don't combine color and black-and-white photos in the same portfolio, unless you can group all those pages together in one section of the book.** Switching back and forth between color and black-and-white is distracting for the viewer; the change itself detracts from the true impact of each photo.

- **When possible, show a range of images using different focal lengths.** A portfolio of only wide-angle landscape photos quickly becomes boring. It's good to take the viewer through a series of viewpoints to keep things interesting. An exception to this rule is very specialized genres of images such as abstracts or macros that can stand on their own as a body of work. If you choose to make a portfolio showing only one type of subject matter, every image must be extremely strong in its own right.

- **The sequencing of photos is crucial to the effect of the portfolio.** Arrange the order of the pages very carefully to create smooth transitions between the photos and to tell the story of your work. Think in terms of mood and drama, and bring the viewer into the collection of images in a deliberate manner. Start strong and finish strong, but don't bunch up your lesser work in the middle, either. You can use slide-show software to make this easier before assembling the actual pages of the book.

- **Don't make the portfolio too big or too small.** 11×14 and 16×20 are the best sizes for the outer dimensions of a photography portfolio.

When planning the production of your portfolio, look at lots of example books from other photographers. Go to your local art supply store and see all the styles of portfolio books and cases

available. Search online for portfolios to learn about your options and ask the advice of other professionals.

A list of portfolio suppliers is in the appendix.

CUSTOM PHOTO BOOKS

Personalized photo books have become extremely affordable and very popular with nature photographers in recent years. Though the printed pages may not be as high quality as what you can produce with a fine-art portfolio, the quality of these products continues to improve significantly and rapidly. Once you've assembled a strong collection of work, consider having your own photo book made.

Unlike a portfolio, a photo book need not only include your most stellar imagery; rather, a photo book is intended to tell a story in pictures or simply share a collection of your favorite images. A printed photo book can reasonably contain dozens or hundreds of photos.

To make a photo book, you upload your files to an online service provider (such as Blurb, shown in 9-22) that then prints the book and ships it to you. You can set up your photo book using desktop software on your own computer, such as Adobe InDesign, or use the layout utilities provided by the vendor.

See the appendix for vendors of photo books.

> **tip** If you want to offer your photo book for sale, you can often do this through the print vendor's Web site. Online book retailers such as Amazon.com also are increasingly making these types of services available to independent publishers.

ABOUT THIS FIGURE *On the Blurb Web site you can create your own custom photo books. You can order just one book or many, and you can list your book for sale on the Blurb site.*

9-22

CREATING PHOTOGRAPHY WEB SITES

These days it seems everyone has a Web site, and for photographers — especially nature photographers — having an online presence is absolutely the most effective way to share your work with others. Today's Internet is vastly more powerful than even a few years ago, and sharing photography is one of the main interests across the Web. Fortunately, building and maintaining an effective Web presence has become much easier than before.

GETTING STARTED

Just a few years ago it was difficult and potentially very costly to have your own Web site. In recent years, online service providers have made the process of developing and maintaining your Web site much easier and cheaper — and in many cases, free!

When you develop your Web site from scratch, you have a straightforward choice: do it yourself or hire someone to do it for you. I recommend that you carefully consider both options.

In the easiest scenario, all you need to do is create an account with a service provider and upload your images. These types of Web sites use a database system (often called the "back end") to manage the site content. The pages that viewers see (the "front end") are generated by templates and style sheets that make designing and updating a Web site much easier than ever before. All the customization is done through a control panel interface — you can build and maintain these kinds of Web sites using only your Web browser — and no programming is required of you.

tip Blog software, in particular, has become very popular with photographers. You can use a free blog service like WordPress, TypePad, or Blogger to create a full-fledged Web site, including photo galleries.

If you prefer to hire a professional to build your Web site, I strongly recommend you do just that: hire an experienced professional. Generally speaking, if you get your best friend's neighbor's kid to build your site for practice or for a school project, you're virtually guaranteed to be disappointed with the results. Unfortunately, the majority of so-called Web designers you encounter are not far removed from this level of competence — anyone can call himself a professional. Be wary; do your homework. Ask for referrals from your colleagues and get client references from prospective designers. And always, *always* get the terms of engagement in writing before any work begins. A Web design contract should clearly and precisely state the scope of work to be performed and the associated fees. If the scope of work changes, it's natural that the fees will change, and again, this needs to be in writing.

tip If you hire a developer to build your site, make sure it's set up so you can maintain it yourself.

WEB SERVICES FOR PHOTOGRAPHERS

All modern Web services, including those made especially for photographers, are designed using the database method previously described. With an account set up, you simply choose a design, upload your photos, and type any text you need. The Web service does the rest.

Many photographers, from rank beginners to established pros, use these types of services to host their Web sites and present their work. Photo hosting sites range from free and open communities like Flickr and Photobucket to more expensive and full-featured services like PhotoShelter (see 9-23), SmugMug, and Zenfolio. Most paid

9-23

ABOUT THIS FIGURE *PhotoShelter lets you make your own custom Web site without any programming, and the photos you upload can also be searchable on the PhotoShelter stock photo index.*

services allow extensive customization of features and look-and-feel; a list of Web services is in the appendix.

At some point you may want further customization beyond the default templates offered by your service provider. Desktop application software for building Web sites (such as Adobe Dreamweaver) has also become much easier to use — you can use Dreamweaver to create customized code for your site hosted by a service provider. Many photo-editing programs like Lightroom and Aperture can generate Web galleries and upload them straight from your computer. Apple's iPhoto, iWeb, and MobileMe provide comprehensive solutions for easily creating online photo galleries.

If you've resisted building a Web site because you expect it to be a lot of work or that you'll have to learn all kinds of new technical skills, forget that. Now you have no excuse for not showing your work online.

Here are a few tips for getting your first Web site started:

- **Consider registering your own domain name.** The domain name is the address people use to find your site, such as NatCoalson.com. You're not required to have your own domain name — most of the online services provide a default address for your Web space — but having your own domain name makes your site easier to find and appears more legitimate than a random, generic domain name.

- **Look at lots of other photography sites to get some ideas of what you like.** Layout, fonts, colors, and the organizational strategies of your galleries are all customizable and with infinite options available you'll do well to envision the kind of site you want before you select a provider.

- **There's often a big difference between what you can get for free versus what paying even a small fee allows you to do.** As you research Web photo hosting services find out the differences between free and paid options.

- **Carefully review the recommended technical specifications provided by the vendor for the preparation of your image files.** You want your photos to be viewed at the highest possible quality on the Web site; resolution and color space are the most important factors.

- **If you want people to find your photos using search engines, be sure to add keyword tags to them before or after uploading.**

- **If you're using a shared Web hosting service like Flickr or Facebook be sure to carefully read the terms and conditions of the Web site prior to uploading your photos.** Some Web sites, most notably Facebook, claim certain rights to the use of your photos that you may not be comfortable with.

tip

Photos saved for sharing on the Web should always be saved as JPEG files using the sRGB color profile.

Assignment

Produce a Finished Photo

For this assignment, use your choice of photo software to post-process and enhance a single photograph to its best potential. Find an image that you haven't done any work to yet. Process your photo using this sequence of steps:

1. Crop if it helps improve the composition and/or fulfill your vision for the image.

2. As necessary, fine-tune the tonal range of the image by adjusting white point, black point, and midpoint.

3. Also as necessary, increase or decrease the overall contrast in the photo.

4. Evaluate the color in the image and adjust white balance and saturation as appropriate.

5. Zoom in close and check for sharpness. Try applying a moderate amount of sharpening to the entire image. Even a simple Sharpen filter in Photoshop can make a big difference.

6. While zoomed in close, pan around the photo and look for elements that should be removed or otherwise retouched. Use a clone stamp or healing brush tool to clean up the image.

My example for this assignment required more processing than usual. The sunrise at Kaiteriteri Beach in New Zealand was so bright that both the camera and my software had a hard time with this photo. With extreme dynamic range, off-the-charts color saturation, and a white balance that defies explanation, I'm still not sure this looks quite like what it was to be there. In particular, the glow on the horizon was a hue of fluorescent orange like I've never seen and that's incredibly difficult to reproduce. Image taken at ISO 100, f/20, 15.0 sec. with a Canon EF 24-105mm L lens.

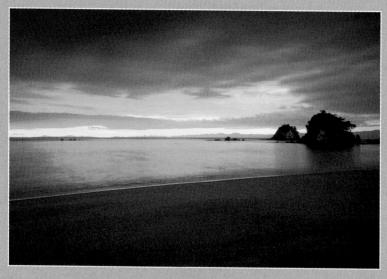

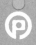 Remember to visit www.pwassignments.com after you complete the assignment and share your favorite photo! It's a community of enthusiastic photographers and a great place to view what other readers have created. You can also post comments, read encouraging suggestions, and get feedback.

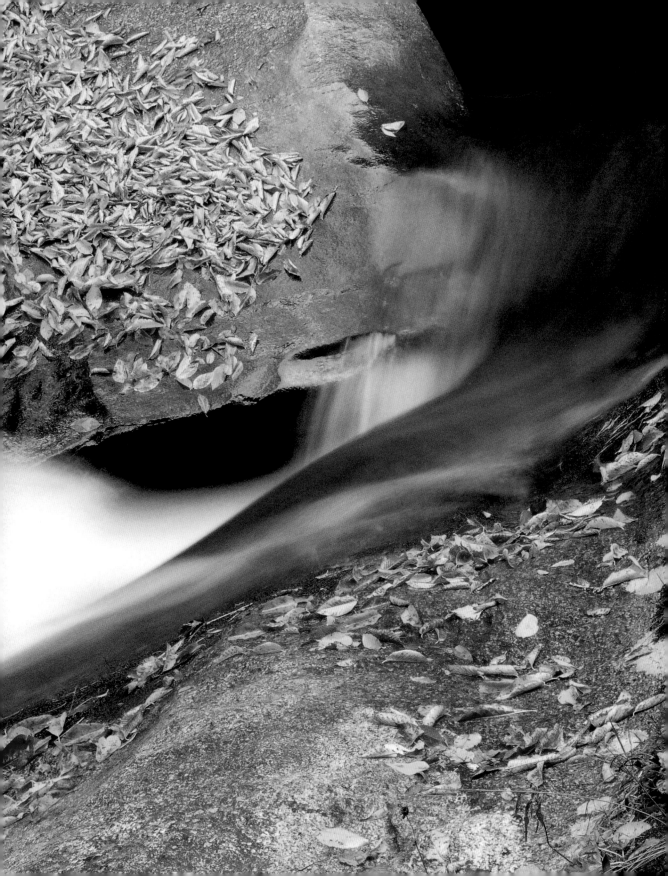

Nurturing Your Creativity

Honing Your Technical Skills

Developing Your Style

Taking Your Next Steps

Like all art, producing good nature photography requires a continual balance between advancing your technical skills and refining your artistic vision. At times you work on the creative process; at other times you brush up on the technical aspects of photography. Neither should be neglected and neither should dominate.

Take a structured approach to practicing your photography. Like practicing technical skills, developing your creativity in a methodical way provides the best possible results.

As you've seen throughout this book, making good nature photographs doesn't come easy. And no matter where you are in your photography there is always room for improvement. This is the challenge and reward of nature photography — no matter how good you become, you can always be better.

See more. Shoot more. Keep pushing onward and upward. If you don't, your work becomes stagnant and predictable — and no photographers want to have their work considered boring!

Many people who don't practice nature photography will look at a well-made photo and say "I wish I had a better camera." As you know by now, great pictures are not made by the camera. Though a photograph can be *captured* by a camera, it's truly created in the mind of the photographer who made it. The most important equipment you have is between your ears.

In this chapter, you learn techniques for nurturing your creativity, honing your technical skills, and developing your style.

NURTURING YOUR CREATIVITY

While some people are naturally inclined to think more creatively than others, you'll be glad to know that creative skills *can* be learned and developed. Creativity in and of itself is not useful — you need to deliberately apply your creativity to produce better pictures. If you pay careful attention to what you're doing, you can make interesting and engaging photographs that express your unique vision, as illustrated in 10-1.

KEYS TO CREATIVE DEVELOPMENT

The secret to unleashing your creative potential is deceptively simple: (1) know the rules, and (2) break them. Simple as this is, implementing this idea involves a series of many complex steps that can't be accomplished overnight.

> **tip**
> On the Web, you can find an infinite number of exercises to enhance and develop your creativity. These shouldn't be only about photography — look for techniques related to creative problem solving of any kind.

You can eliminate mental barriers by focusing on what's possible instead of what is not possible. The difference is subtle but powerful — concentrate on the *potential*, not the limitations, and you'll produce more high-quality results. Learn to turn problems around and look at them from many angles. Ask the question in as many ways as

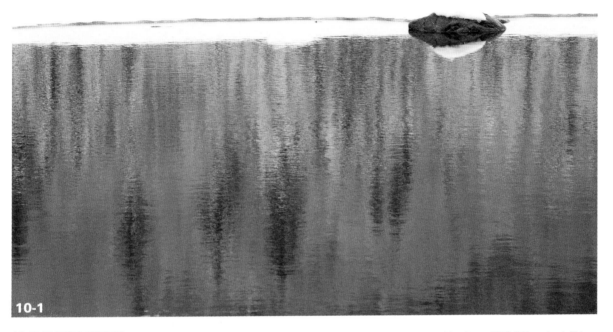

10-1

ABOUT THIS PHOTO *Image of Lost Lake Slough near Kebler Pass, Colorado (ISO 100, f/10, 1/80 sec. with a Canon EF 70-200mm lens). This image is a good example of my creative vision and photographic style.*

possible. To create 10-2, I made many photographs of this beach, looking in all directions. As I worked, I began noticing how the water and sand combined to resemble the appearance of the clouds above. This relationship became my main focus — I wanted to create a photo in which the distinction between sky and earth was minimized. Surrounded by this atmospheric effect, my feeling of being grounded disappeared and I worked to convey the feeling of floating in the sky.

> **tip** The best way to expand your creative horizons is to use your artistic license to do things that might be unfamiliar or even uncomfortable at times.

IDENTIFYING YOUR PERSONAL VISION

In nature photography, your ability to see is different than having personal vision. *Seeing* is being able to accurately assess and evaluate what's in

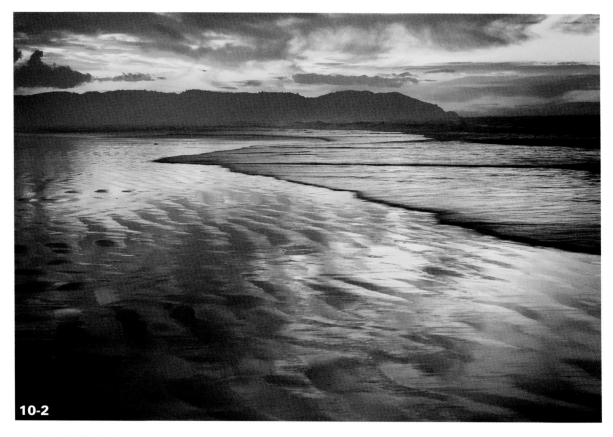

10-2

ABOUT THIS PHOTO *Image of the Bay of Plenty, Ohope, New Zealand (ISO 640, f/10, 1/5 sec. with a Canon EF 24-105mm L lens). I kept asking myself, "What if the wet sand looked like clouds?"*

front of you. *Vision* is your ability to creatively express your personality and intention through your photographs. Seeing is understanding and vision is responding. Your photographic vision conveys how you see the world and translate your experiences to others via the images you create.

Like seeing, your vision develops over time. And as you can learn to see, you can learn to define and refine your vision.

Controlling your creative process through conscious intention, clear objectives, and consistent methods is the fastest, most direct way to understand and refine your personal creative vision (see 10-3). I spent hours photographing this location prior to making this picture, discovering new compositions all around me. When I found this part of the scene, with the water glowing from under the rocks, I knew that I had the subject matter and graphic elements I'd been looking for. I then worked this one small area, refining the composition over many frames, which culminated in the final representation of my creative response to the place.

ABOUT THIS PHOTO
Image of Lincoln Creek, Independence Pass, Colorado (ISO 100, f/32, 8.0 sec. with a Canon EF 70-200mm f/4 L IS lens).

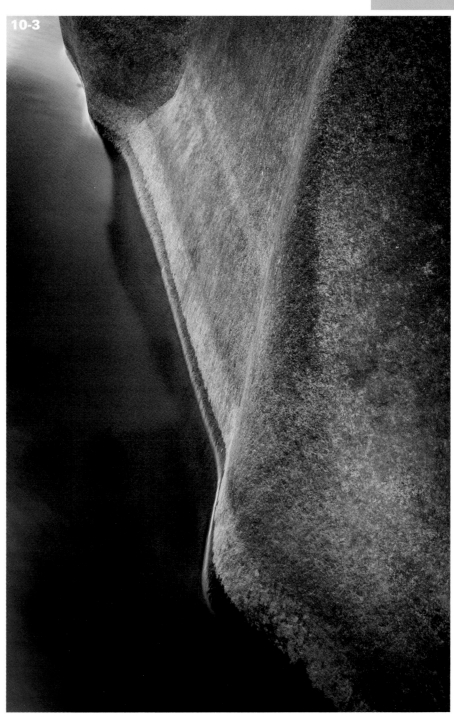

10-3

FINDING YOUR CREATIVE GROOVE WHILE ON LOCATION

When you go out to shoot, allow some time to immerse yourself in the environment and clear your head of all the other stuff that can get in the way of successful photography. Don't expect to find your groove right away — allow it to happen over time, especially in an unfamiliar location. Here are some tips:

- **Travel with other photographers.** The time you spend traveling between locations with other people interested in similar photography opens your mind to new possibilities.

- **Travel alone.** The time you spend in isolation in nature allows you to resolve your creative process into tangible results while getting in touch with nature on a personal level.

- **Actively seek out new situations.** The surest way to stagnate your creative process is to spend all your time in very similar places. Find a variety of environments in which to work.

- **Find opportunities to make pictures in different light and in different weather — even if it's sometimes uncomfortable.**

- **Shoot more, shoot longer, and work harder toward ever more specific goals.** Learn to react quickly and fluidly to find the essence of each of the places you explore. Find ways to connect both with the subject and the future viewer of each photograph.

- **Return to the same places repeatedly.**

- **Learn to ignore and eliminate distractions.** When you're out shooting and when you're at home editing, work with conscious intention and present-moment awareness.

- **Allow yourself to respond honestly to the subject and the environment.**

- **Keep an open mind.** Although previsualizing the shots you want to make is an important skill, it's often more important to be able to respond to what you find on location and not to remain locked into a single concept.

- **Learn the technical aspects of photography.** The technical process becomes intuitive, freeing you to focus on your creative vision and artistic goals.

- **Carry on an internal dialogue in which you ask questions and answer them.** Narrate your own activities while you work.

> **note** It's hard to combine objectives on trips: you might not do your best work on days that you've scheduled time with the family, business meetings, or long periods of travel.

WRITING

One of the most significant ways you can improve your nature photography is to write and talk about pictures. If a picture is really worth a thousand words, taking the time to come up with those words will naturally develop your work. In doing so, you engage multiple parts of your brain in the creative process. Practice putting words to your pictures by talking to people about your and others' work and writing things on paper. Keep finding new ways to put words together with images.

Some people resist the idea of writing about their photography. After all, it's about the pictures, right? Who wants to take time out to write during the creative process of making photographs? Try it, and you'll find it well worth the effort. And you can do it in a way that fits you.

Writing can take many forms. You can jot down ideas, questions, concepts to develop, people to contact, and so on. When you have an idea, just

getting it out of your mind and onto paper (or into the computer) helps you refine the idea and develop it more fully. Many photographers maintain blogs featuring their pictures and writing, which allows others to respond and provide different perspectives through constructive dialogue about their images and creative process.

The real benefit to writing, or any kind of note-taking, is having an outlet for your thoughts. Getting ideas out of your head and into words helps you choose the ideas you want to pursue and allows you to let other ideas rest or be dropped completely.

If you really don't like to write, just scribble. This is a case where the action matters more than the outcome. If you like to draw or sketch, you can use your writing materials to sketch ideas for compositions, camera angles, and so on. As with other kinds of visual art, sketching offers great benefits for the nature photographer.

Carry a notebook and/or index cards and pens or pencils in your camera bag. Also carry in your camera bag printed notes, cheat sheets, and reference materials to spur your creativity and remind you of your goals and the techniques you want to practice.

THE ARTIST STATEMENT

The artist statement is an important tool for artists in all mediums, and photography is no exception. The statement serves two meaningful purposes: (1) similar to the way a mission statement helps guide the operations of a company, the artist statement helps define meaning and purpose for your work, and (2) it helps others better understand your artistic motivation and goals.

An artist statement explains the work from your perspective, including descriptions of what you're trying to communicate with the pictures. When

putting together your artist statement, think like a journalist and answer the "who, what, where, when, why, and how" with regard to the work and the process you used to create it. An artist statement should generally not be biographical — stick to writing about the work itself.

Write an artist statement and keep updating, improving, and refining it continually. Following is an excerpt from my most recent artist statement:

> "...The subjects of my photographs range from pristine natural landscapes to abstract close-ups of refuse. I make the photographs into straight prints and mixed media installations.
>
> My images exploit the tension between chaos and order. In the complex real world, visual chaos is everywhere. Within the photographic frame, order can be attained. Many of my photographs are a result of my seeking the calm amid the storm — peace, calm, and stability are common themes in my work...
>
> I'm generally not as interested in capturing a slice of time in my pictures as that I want to reveal a glimpse of eternity...of universal truths and undeniable constants. I am looking for answers. I want to understand the relationships that form my distinct place in this world and the nature of my role in the past, present, and future. Through my art, I have a stronger connection to things greater than I.
>
> I'm very interested in photographic impressionism, minimalism, and surrealism. My work has been influenced by classic photographers like Man Ray, yet more so by contemporaries including Tony Sweet, William Neill, John Paul Caponigro, and Bryan F. Peterson. The philosophies of Galen Rowell and Freeman Patterson have had a profound impact on the way I view my art. Through study of the work

of these visionaries, seeing through my eyes and seeing with my mind's eye have become distinctly different experiences for me."

Your statement doesn't need to discuss the same topics. The whole point is to make it personal. If one sentence describes your work and your philosophy as an artist, fine. But it's important that your artist statement speaks for the work, even when someone's not looking at that work.

HONING YOUR TECHNICAL SKILLS

There's no substitute for experience. You can think about photography all day, but unless you're out there making pictures, processing them, and evaluating the results you won't see as much progress as you could. Get out into the landscape and do it!

Honing your technical skills gives you more creative freedom. You can practice your craft by following a consistent set of procedures when shooting, taking some classes and workshops, and learning to properly critique photographs made both by yourself and others.

PRACTICING YOUR CRAFT

When you go out into the natural world, whether or not you're making photographs, you should immerse yourself into the experience. Keep practicing previsualizing the images you want to make, and learn what it takes to make those images.

For every successful image you make, there will be many more that fail. A ratio of 100:1 is common — for every hundred pictures you make there may be one that survives a tough edit. In producing a strong body of work, you make many images that other people will never see. After some time you will become more productive, but you simply can't expect every photo you make to be a winner.

GETTING FORMAL EDUCATION AND TRAINING

For most nature photographers some formal study is beneficial. Though it's certainly possible to figure out everything yourself, you'll do well to learn from other photographers who have trod a similar path. If nothing else, learning from other people's mistakes can save you enormous amounts of time. Here are some ways to get started:

- **Find classes and workshops that are nearby and affordable.** If you can do a destination photo workshop once per year you'll have fun and learn a lot. Many photographers enjoy the camaraderie of a group workshop; you not only learn from the instructors; you learn from the other students.

- **Learn the vocabulary of photography and the principles of visual language.** Study photographic history, especially the work of masters and classic photographs to understand the solutions other people came up with. Books and magazines are great for this.

- **Build and maintain a support system where you can find answers.** When you get stuck, ask for help.

- **Engage and interact with the photographic community. Don't work in a bubble.** Although nature photography is largely a solitary pursuit, you'll find that some of your greatest breakthroughs can be spurred on by the work of others.

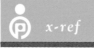 *x-ref*

A list of helpful Web sites, publications, and workshops is included in the appendix.

LEARNING TO EVALUATE PHOTOS

It's critical that you learn to effectively critique photographs. Start by practicing critique with other photographers' work; you can see it more objectively. Then practice critiquing your own work. It's vital that you learn to evaluate your work as if it's not your own. You must be able to see the work for what it really is, not for your memory of it or how you feel about it. All that matters are the elements within the frame and how they engage the viewer.

If something doesn't seem to work in a photo, figure out what it is, and determine how it could be corrected next time.

tip I strongly recommend that you resist the urge to throw out or even ignore your failed pictures. You can learn much more from your failures than from your successes. You should periodically review old work to examine what didn't work.

GETTING AND GIVING CRITIQUES

You can find many Web sites where people trade critiques; these are a good place to start. At first you can simply read what others are saying in order to get an idea of what goes into a critique. Then find resources that actually teach and provide suggestions on how to critique. Like all other aspects of photography, some fundamental principles guide the process of critique, and there is a right and wrong way to do it. Keep this in mind when you're getting critiques — some will be much more useful than others.

Find out about local camera clubs in your area. Most welcome guests at no charge to check out meetings and then require only very modest membership fees; some are free. Camera clubs are great places to get feedback and critique about your work. Many have monthly image competitions; don't let this frighten you. In most camera clubs, the competitions are friendly, good natured, and nonthreatening.

REFINING YOUR PROCESS

Over time, you should work hard to develop and refine your internal thought process and your external workflow, a cycle illustrated in 10-4. The more methodical you can be when creating, the more predictably high quality the results will be. Workflow really does matter. Maybe it seems counterintuitive, but following a routine allows you to be more creatively flexible at key opportunities. Your thought process should be directed and controlled rather than random. Keep tightening your workflow and color management; find

EXCHANGING IDEAS WITH OTHER PEOPLE At every opportunity you should talk with other photographers and with artists who work in other mediums. Also talk with photo buyers, from art collectors to art directors and publishers. Social media Web sites are a great way to interact with other artists and buyers alike. Facebook, Twitter, and Flickr are great options for sharing your work (be sure to read the terms of use for these sites before posting your photos). Try to share your nature photography with other people in a wide range of venues and always ask for comments, but understand that general feedback and commentary can be very different than true critique. Your family members making comments on their favorite photos is not the same as getting a professional evaluation of your portfolio. Most importantly, learn to accept comments and critiques without letting it ruffle your feathers!

areas of inefficiency and eliminate them. (See Chapter 9 for more on workflow and processing.) The more manual control you apply toward working your equipment, the most control you have over the outcomes.

10-4

ABOUT THIS FIGURE *Diagram illustrates the creative cycle.*

WORKING WITH BETTER EQUIPMENT

It's important to get the most and best use from whatever gear you can afford, and it's good to have at least a basic setup of your own equipment. But don't let your ability to afford equipment limit your work — buy, borrow, or rent whatever newer and better gear you can as you develop your work. Do lots of research so you know about the available options and try out different gear to find equipment that truly fits your needs.

tip Keep practicing so you can learn to use your gear until you can use it with your eyes closed — or at least, not looking directly at every control when you're changing it.

ENTERING COMPETITIONS

Entering your photos in competition can be an encouraging or disheartening experience depending on how you take it. Although sometimes brutal, photo competitions serve some practical purposes:

■ They give you a chance to see the work of other photographers in a similar context as your own.

■ They give you some ideas as to how judges might view certain images.

■ If you win, there can be good money and prizes involved.

■ Some competitions provide a mechanism for getting critique, or at the very least some feedback from the public.

■ They can help you develop a thick skin.

Entering your best work into competitions is a good part of the overall development process. However, like everything else, don't take it too seriously. Some people become very emotionally invested in competitions and are crushed when their favorite photo doesn't get the accolades they think it deserves. Though you can learn a lot by participating in competitions, don't get too caught up in the process or the results. A photo that takes the highest honors in one competition might not get any recognition whatsoever in another (see 10-5).

caution Always be sure to carefully read and understand the rules and terms for each competition you enter. In many cases you are explicitly granting unlimited usage rights for your images!

ABOUT THIS PHOTO
*Image of Palisade, Colorado
(ISO 100, f/22, 1/10 sec. with a
Canon EF 17-40mm L lens). Due
to the content of the picture,
this image has done very well
in some venues and not in oth-
ers. It has received high honors
and extensive licensed use in
agriculturally-related contests
and publications, but because it
shows a grape farm (not truly
"nature") it's not a good fit for
nature photography-related
competitions.*

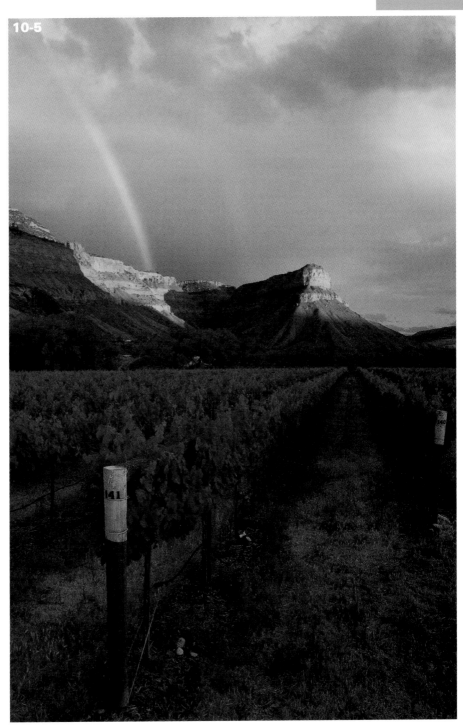

x-ref

Chapter 9 has information about evaluating a photograph and the elements of a merit photo.

DEVELOPING YOUR STYLE

As you work on your nature photography you can and should conscientiously work toward developing your own style. Whether it's entirely unique is not the point; what matters is that you create a body of work that represents your experiences and interaction with nature.

Just starting out, it helps to work toward simple, obtainable goals. Uncontrolled creativity results in random, scattered results; self-assignments and personal projects help you develop your creative thinking skills. For example, you could spend a summer building a portfolio of wildflower photos or create a series featuring the most dramatic landforms of America's national parks. In either case, if you have a specific goal in mind it sets up the framework for you to channel your creativity into pictures that are uniquely your own. In the end, your photographs should show your own personal, creative vision.

Start by thinking about the kinds of pictures you like the most. Find representative examples of other photographers' work. Evaluate the compositions, the light, and the conditions in which those pictures were taken and write down your thoughts about your own style.

PRODUCING A BODY OF WORK

An artistic *body of work* is a collection that represents your complete vision and in which the individual pieces work together in a cohesive way. In many cases the whole is more than the sum of the parts. Some photographers have many distinct bodies of work. They can be based on photographic style, subject matter, and theme.

To start producing a body of work, find subjects and subject matter that resonate with you and work consciously to develop pictures that tell the complete story. This kind of self-assignment serves two purposes: (1) it gives you concrete, identifiable goals to work toward, and (2) it naturally refines your creative process and personal artistic vision, allowing your unique personality and preferences to show through.

ESTABLISHING YOUR PERSONAL PHILOSOPHY

For all artists at some point personal philosophy enters the picture. You need to know where you're headed and where you want to go. Identify your personal preferences and trust them. Develop your personal compass; it will help you make decisions.

Where does photography fit in your life? What do you see? What do you want the viewer to see? What do you care about? What are you trying to say? To use your power of seeing to translate into creative photographs, you must keep asking questions — as clearly as you can phrase them — and find good answers to those questions. It's not enough to simply ask "Why?" or "What if?" — it's the answers to those questions that propel your work forward.

Be willing to ask a lot of questions and do your best to not assume anything. Try to avoid labels and stay open to all possibilities. Think and plan ahead — but always come back to the present moment to concentrate on your photography.

tip Get involved in protecting nature. As a nature photographer one of your primary objectives is to protect the places you work. Find a cause you believe in and align yourself with one or more groups that shares your eco-philosophy.

TAKING YOUR NEXT STEPS

For many nature photographers, photography is a lifelong passion. Often, progress is slow and even frustrating. It takes years to develop solid technical skills; the artistic process continues throughout a lifetime. It's important to be patient and allow the process to unfold naturally while actively nourishing and encouraging your creative development. Don't expect immediate results; you need to find your own ways to maintain your dedication and commitment to your craft.

> **tip**
> Give back to the photographic community. Never forget where you came from; many photographers follow a similar path to development and there is always someone you can help along the way. Contribute whatever, wherever, and whenever you can.

Working toward specific goals is a very important part of developing your photography. When setting goals, be as specific as possible; you need to know when you've reached key milestones. In some cases, a set timeline makes sense. Periodically review your progress and alter your game plan as appropriate. Most importantly, when you evaluate your own progress, never compare your progress to that of other people.

Be willing to experiment fearlessly and fail along the way. There's a way of thinking called "beginner's mind." This is what you experience when you are fully immersed in the creative process and not distracted by anything else. You're not in a hurry to finish or to get anywhere; you're fully engaged in what you're doing. Time seems to pass quickly. Beginner's mind is what happens when you look at the clock and find hours have passed while you were working, and you find you've produced a lot of work. Allow yourself to find and renew your beginner's mind as a nature

photographer. Don't give up, but also know when it's time to take a break. Some of your greatest creative breakthroughs will come after a period of photographic rest and inactivity.

Now that you know all that's involved in making beautiful nature photographs, here's a distilled cheat sheet that summarizes the key points of the process:

- Be prepared to forego comfort and convenience to encounter the best light.

- Know your camera before you are pressured to get a shot.

- Take the gear that you need to get the shots you want.

- Slow down and pay attention to what you're doing and what's happening around you.

- Change your point of view; don't just stand in one place the whole time you're shooting.

- Make your compositions as clean as you can.

- Check your exposure and focus as you're shooting.

- Enjoy the process of nature photography!

Believe your success is possible. Learn to listen to and respect your inner voice. Find what's right for you and pursue it.

Work to become well rounded in your thinking and knowledge, but also find photographic niches that you prefer and find ways to make your work as personal as possible.

Practicing nature photography is not a linear process; it's been said that in the end photographers reinvent themselves many times.

I wish you much success in your photographic endeavors!

Assignment

Write, Photograph, Write Again

Envision a series of photographs you want to make — a sequence of images that collectively tell a complete story. Write it down, either in bullet-point notes or long-form paragraphs; whatever is most comfortable.

Then go make the pictures. Allow your writing and previsualization to guide your process, but don't be restrained by outmoded ideas if something better comes to mind. If photographing the series takes days or weeks, that's okay. When you have enough material to assemble the body of work, edit tightly to get to only the best images. When you've put together the entire series, write a statement that describes the body of work.

My example for this assignment is the last of a workshop spanning several days and shooting at many locations. I decided to make a series that illustrated the eternal cycles of the changing seasons. I previsualized photographs that included many colors, swirling together around a central axis, to show change, progression, and the passage of time. I wrote lots of notes and made sketches about what I intended to do. Then, on location, I made many dozens of photographs. This image is the one that best captured my intentions for the series.

To make this picture, I set up my tripod so I could spin the camera around the focal point during long exposures. I made many test shots, trying different angles and shutter speeds, until I found the combination that accomplished what I envisioned. This image was taken at ISO 100, f/32, 1.0 sec. with a Tamron 18-200mm XR Di II lens.

Remember to visit www.pwassignments.com after you complete the assignment and share your favorite photo! It's a community of enthusiastic photographers and a great place to view what other readers have created. You can also post comments, read encouraging suggestions, and get feedback.

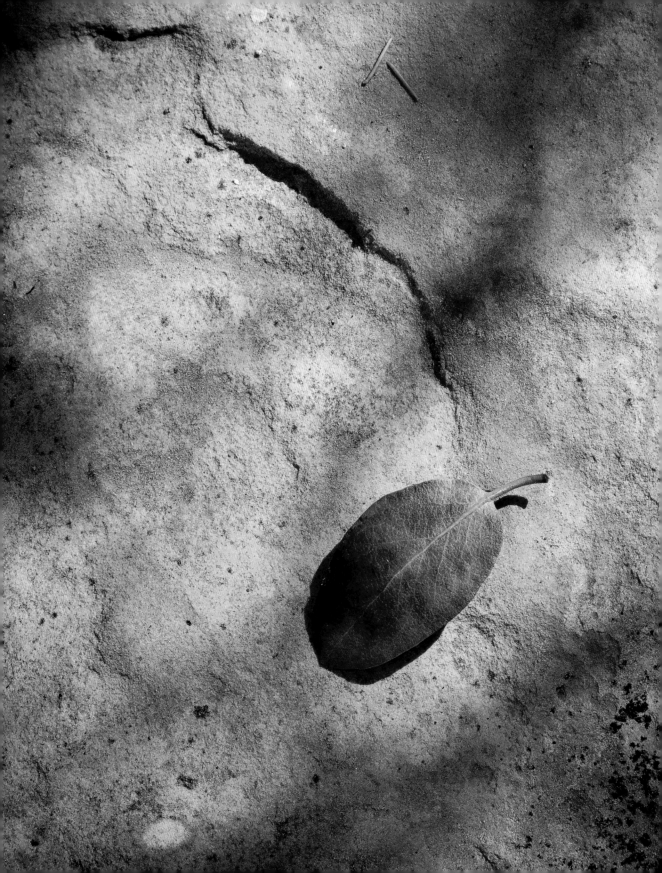

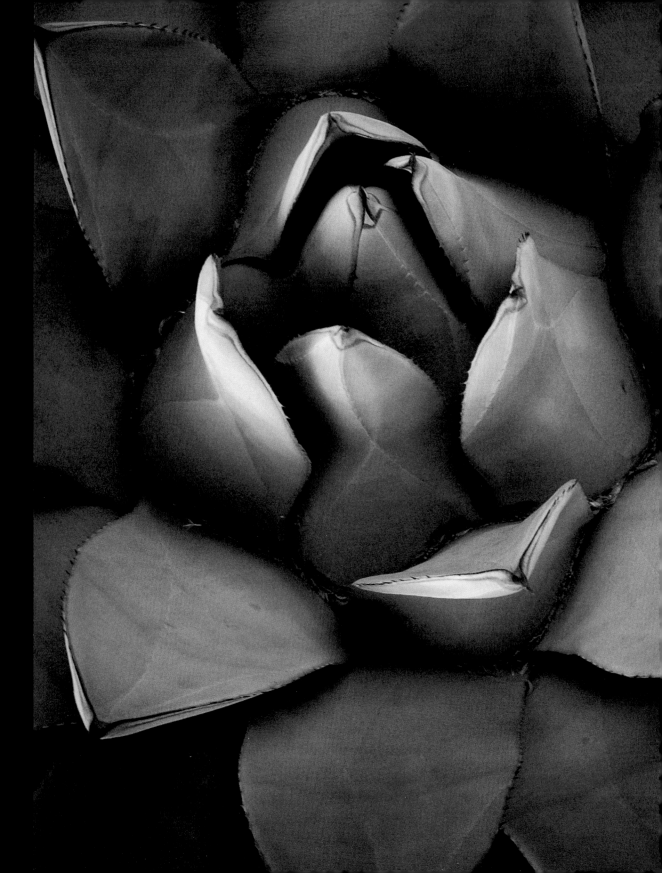

Magazines

Organizations

Online Communities

Workshops and Classes

Nature Photographers

Inkjet Photo Printers and Paper

Photo Labs

Photo Book Printers

Photo Hosting Services

Blog Services

Color Management and Workflow

Portfolio Supplies

Panoramic Photography

Camera Equipment Manufacturers and
Retailers

Camera Equipment Rental

Camera Insurance

Camera Cleaning Supplies

Software for Photographers

 note Links on the Web change frequently, and the links listed here may become unusable. For an updated list of links to these and more online resources visit www.NatCoalson.com/links.

MAGAZINES

- Digital Photo Pro: www.digitalphotopro.com
- Nature's Best Photography: www.naturesbestphotography.com
- Nature Photographer: www.naturephotographermag.com
- National Geographic: www.natgeo.com
- Outdoor Photographer: www.outdoorphotographer.com

ORGANIZATIONS

- North American Nature Photography Association (NANPA): www.nanpa.org
- Sierra Club: www.sierraclub.org

ONLINE COMMUNITIES

- Fred Miranda: www.fredmiranda.com
- The Luminous Landscape: www.luminous-landscape.com/forum
- Nature Photographers Online Magazine: www.naturephotographers.net
- NatureScapes.net
- Photo.net
- Photography Corner: www.photographycorner.com

WORKSHOPS AND CLASSES

- Anderson Ranch Arts Center: www.andersonranch.org
- Aspen Photo Workshops: www.aspenphotoworkshops.com
- Better Photo: www.betterphoto.com
- Focus on Nature: www.focusonnature.is
- FisheyeConnect: www.fisheyeconnect.com
- Gordon-Tal Photographic Workshops: www.gtworkshops.com
- Jackson Hole Photo Workshops: www.jacksonholephotoworkshops.com
- Illuminate Workshops: www.illuminateworkshops.com
- Maine Media Workshops: www.mainemedia.edu
- Moab Photography Symposium: www.moabphotosym.com
- Moab Photo Workshops: www.moabphotoworkshops.com
- The New Mexico Photography Field School: www.photofieldschool.com
- Photography at the Summit: www.photographyatthesummit.com
- Rocky Mountain School of Photography: www.rmsp.com
- Santa Fe Photographic Workshops: www.santafeworkshops.com
- Shaw Guides: www.photoworkshops.shawguides.com
- Workshops for Photographers: www.workshopsforphotographers.com

NATURE PHOTOGRAPHERS

- Ansel Adams: www.anseladams.com
- Marc Adamus: www.marcadamus.com
- Scott Bacon: www.baconphoto.com
- Andy Biggs: www.andybiggs.com
- Craig Blacklock: www.blacklockgallery.com
- Jim Brandenburg: www.jimbrandenburg.com
- John Paul Caponigro: www.johnpaul caponigro.com
- Elizabeth Carmel: www.elizabethcarmel.com
- Grant Collier: www.gcollier.com
- Jon Cornforth: www.cornforthimages.com
- Charles Cramer: www.charlescramer.com
- Jack Dykinga: www.dykinga.com
- Bret Edge: www.bretedge.com
- Michael Frye: www.michaelfrye.com
- Jim Goldstein: www.jmg-galleries.com
- Jay Goodrich: www.jaygoodrich.com
- Michael Gordon: www.michael-gordon.com
- Rod Hanna: www.rodhanna.com
- Stephen Johnson: www.sjphoto.com
- George Lepp: www.georgelepp.com
- G. Brad Lewis: www.volcanoman.com
- Peter Lik: www.peterlik.com
- Mike Moats: www.tinylandscapes.com
- Arthur Morris: www.birdsasart.com
- Marc Muench: www.marcmuench.com
- David Muench: www.muenchphotography.com

- Nature Photography Gallery: www.nature photographygallery.com
- William Neill: www.williamneill.com
- Moose Peterson: www.moosepeterson.com
- Ian Plant: www.ianplant.com
- Galen Rowell: www.mountainlight.com
- Adam Schallau: www.adamschallau.com
- John Shaw: www.johnshawphoto.com
- Jesse Speer: www.jessespeer.com
- Erik Stensland: www.imagesofrmnp.com
- Tony Sweet: www.tonysweet.com
- Guy Tal: www.guytal.com
- Jim Talaric: www.talaric.com
- Brenda Tharp: www.brendatharp.com
- Tom Till: www.tomtill.com
- Monte Trumbull: www.montetrumbull.com
- Art Wolfe: www.artwolfe.com
- Kah Kit Yoong: www.magichourtravelscapes.com

INKJET PHOTO PRINTERS AND PAPER

- Canon: www.usa.canon.com
- Epson: www.epson.com
- Hahnemühle: www.hahnemuhle.com
- Harman: www.harman-inkjet.com
- Ilford: www.ilford.com
- Premier Imaging Products: www.premier imagingproducts.com

PHOTO LABS

- Bay Photo: www.bayphoto.com
- Mpix: www.mpix.com
- Nichols Photo Lab: www.nicholsphotolab.com
- West Coast Imaging: www.westcoast imaging.com
- White House Custom Colour: www.whcc.com

PHOTO BOOK PRINTERS

- www.Blurb.com
- www.KodakGallery.com
- www.Lulu.com
- www.MyPublisher.com
- www.Shutterfly.com
- www.SmileBooks.com
- www.Snapfish.com

 note

Apple offers integrated book printing services for users of iPhoto and Aperture.

PHOTO HOSTING SERVICES

- www.Deviantart.com
- www.Facebook.com
- www.Flickr.com
- www.Me.com
- www.Photobucket.com
- www.PhotoShelter.com
- www.Picasa.com

- www.Shutterfly.com
- www.SmugMug.com
- www.Snapfish.com
- www.PBase.com
- www.Zenfolio.com

BLOG SERVICES

- www.Blogger.com
- www.Quora.com
- www.TypePad.com
- www.WordPress.com

COLOR MANAGEMENT AND WORKFLOW

- American Society of Media Photographers (ASMP): www.dpBestflow.org
- Chromix: www.chromix.com
- Digital Dog: www.digitaldog.net
- Dry Creek Photo: www.drycreekphoto.com
- International Color Consortium: www.color.org
- X-Rite: www.x-rite.com

PORTFOLIO SUPPLIES

- AsukaBook: www.asukabook.com
- Dick Blick: www.dickblick.com
- Light Impressions: www.lightimpressions direct.com
- Pina Zangaro: www.pzdirect.com

PANORAMIC PHOTOGRAPHY

- GigaPan: www.gigapansystems.com
- International Association of Panoramic Photographers (IAPP): www.panphoto.com
- Panoguide: www.panoguide.com
- PanoTools: http://wiki.panotools.org/Heads

CAMERA EQUIPMENT MANUFACTURERS AND RETAILERS

- Acratech: www.acratech.net
- B&H Photo/Video: www.bhphoto.com
- Canon: www.usa.canon.com
- Hoodman Corporation: www.hoodmanusa.com
- Induro Tripods: www.indurogear.com
- Mac Group: www.macgroupus.com
- Nikon: www.nikonusa.com
- Photo-Imaging Consultants, LLC: www.digital2you.cc
- Tamron USA: www.tamron-usa.com

CAMERA EQUIPMENT RENTAL

- www.BorrowLenses.com
- www.GlassandGear.com
- www.LensRentals.com

CAMERA INSURANCE

- Hill & Usher: www.hillusher.com
- R.V. Nuccio & Associates Inc.: www.rvnuccio.com

CAMERA CLEANING SUPPLIES

- Copper Hill Images: www.copperhillimages.com
- DUST-AID: www.dust-aid.com
- VisibleDust: www.visibledust.com

SOFTWARE FOR PHOTOGRAPHERS

- Apple Aperture: www.apple.com/aperture
- Adobe Photoshop: www.adobe.com/photoshop
- Adobe Photoshop Elements: www.adobe.com/elements
- Adobe Photoshop Lightroom: www.adobe.com/lightroom
- CaptureOne: www.captureone.com
- Depth of Field Calculator by Allen Zhong (Android app): www.appbrain.com
- DOFMaster (iPhone, iPod touch, iPad, and Android app): www.dofmaster.com
- DxO Optics Pro: www.dxo.com
- Hasselblad Phocus: www.hasselbladusa.com
- Nik Software: www.niksoftware.com
- Nikon Capture NX: www.capturenx.com
- onOne Software: www.ononesoftware.com
- PhotoCalc (iPhone, iPod touch, and iPad app): www.adairsystems.com/photocalc

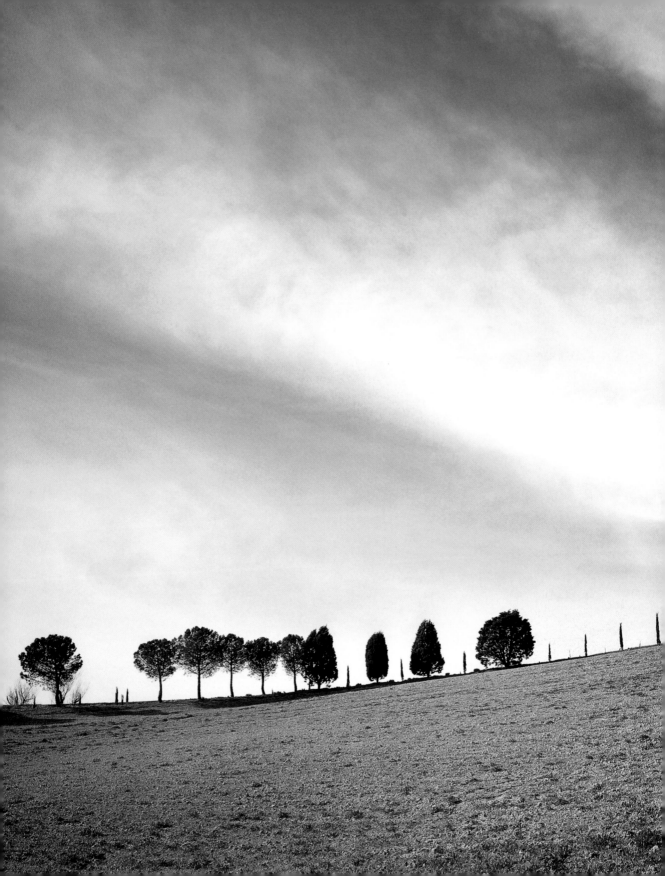

GLOSSARY

35mm Common film size format for cameras; first used with film and now used as the basis for full-frame digital cameras.

absorption When light waves penetrate the surface of an object and do not reflect.

aerial perspective The appearance of distance due to atmospheric haze.

analogous Colors that are close to one another in hue.

aperture The opening in a camera lens that lets light through.

Aperture Priority Exposure mode where the photographer sets the aperture value and the camera determines the shutter speed for the exposure.

APS Advanced Photo System; a class of digital camera sensor sizes smaller than full frame.

asset management The hardware, software, and organizational systems used to store digital files.

backlight When the main source of light is behind the subject.

background The part of the picture farthest from the camera.

ball head A type of tripod head that connects the camera to the tripod with a large rotating ball secured by clamps.

body of work A collection of imagery representing the artist's unique vision.

bokeh The way a particular lens blurs objects when they are completely out of focus.

bracketing Making a series of images with slight changes in settings.

build quality The standards of materials and construction used to manufacture camera equipment.

camera body The main part of a camera system that houses the recording media and exposure controls.

camera shake Blur in a photograph caused by movement of the camera during exposure.

center of interest The part of the photograph that provokes the greatest intellectual stimulation.

chiaroscuro The appearance of depth and dimension caused by variation in light and shadow.

chromatic aberration Color fringes along object edges in a photograph caused by light waves striking the image sensor at differing angles.

clipping Lack of detail in the brightest or darkest parts of the photograph. Highlight clipping is pure white; shadow clipping is pure black.

colorcast An undesirable tint affecting the overall color of a photo, most often caused by incorrect white balance settings.

color management Systems of computer hardware and software designed to translate color values between electronic devices. The CMS is the built-in color management system on your computer.

color profile A small piece of computer code that describes to the CMS the colors of an image file or an imaging device.

color space The numeric model of color used for an image file or device.

color wheel A visual representation of the relationships of color.

CompactFlash (CF) card A memory card on which most dSLR cameras can store captured images. See also *Secure Digital (SD) card.*

complementary Colors opposite each other on the color wheel.

composite An image made by combining multiple original images. Panoramic and HDR photos are composites.

Continuous mode A camera drive mode where multiple captures are made when the photographer holds down the shutter button.

contrast Difference and variation in the visual qualities of a photograph. Contrast is most often used to describe variation in tone.

cool light Light with a blue tint; high color values on the Kelvin scale.

cross-processing A style of developing photos that warms and cools the shadows and highlights separately.

deep focus A long distance of sharpness in a photo.

depth of field The area of sharp focus within a scene.

Depth of Field Preview A button on the camera body that stops down the lens to the selected aperture showing how much of the picture will be in sharp focus.

diaphragm In a camera lens, overlapping leaves made of metal or plastic that open and close to create the aperture.

diffraction When light waves bend and scatter as they pass through an object.

diffused light Light that appears soft because the waves are coming from many directions. The opposite of direct light.

diffuser A light modifier photographers use to soften direct light.

direct light Light that strongly appears to come from one direction, often creating strong shadows.

dominance When an element takes the leading role in a photographic composition, based mainly on size within the frame.

dust spots Undesirable artifacts that appear in a photograph caused by dust on the image sensor.

dynamic range The range of light values in a scene, or the range of light that a camera can capture.

equivalent exposures/equivalence Photos showing the same balance of tone and color but made using different camera settings.

establishing shot A wide-angle photo showing the larger environment or scene in which subsequent closer images are made.

exposure A combination of camera settings and lighting that produces the captured image. Exposure is affected by many variables including ISO, aperture, and shutter speed.

exposure compensation In Auto-exposure shooting modes, manually overriding the camera's metered exposure to either increase or decrease the exposure value. In Aperture Priority mode, applying exposure compensation affects the shutter speed. In Shutter Priority, exposure compensation affects the aperture setting.

exposure mode Sets how the camera will determine the correct exposure values based on available light and other factors.

figure/ground reversal Eye motion within a composition caused by the proximity of foreground and background objects and their competing dominance.

fill light Adding a small amount of light to reveal more detail in shaded areas.

filling the frame Allowing the main subject matter to extend beyond the edges of the frame.

filter factor The amount of exposure lost as light passes through a lens filter.

focal length The distance between the main focusing element and the image sensor.

focal point The part of the picture where the eye is first attracted.

foreground The part of the picture closest to the camera.

frame The box created by the edges of a picture.

frame in a frame When an object creates an additional frame around another part of the picture.

front light Light striking the front of the object as seen from the camera position.

f-stop The size of the aperture.

full frame A digital camera sensor size approximately the same size as a 35mm film frame.

gamut The range of available colors.

global adjustments Changes applied to all parts of a picture during post-processing.

golden hour The time of warm light after sunrise and before sunset. See also *magic hour*.

harmony Visually pleasing color relationships.

HDR (High Dynamic Range) Scenes that contain a wider range of light values than the camera can capture in a single exposure.

high key A photo that is primarily light in tonal values.

histogram A bar graph showing the range of brightness values in a photo.

HSL Hue, saturation, luminance. A common model for describing and manipulating digital color values.

hue The named color of an object; red, orange, and purple are hues.

image stabilization Camera and lens technology that allows longer shutter speeds without blur by stabilizing the image as the exposure is made. See also *vibration reduction*.

intersection Where lines in a composition converge.

JPEG A common image file format for the display and transfer of photos on the Internet and for printing.

Kelvin scale A scale by which the color of light is measured.

lens One or more glass or plastic discs that gather and focus light onto a specific point inside the camera.

Live View A real-time preview of the framed shot displayed on the camera's rear LCD panel.

local adjustments Changes made only to localized areas in a photo during post-processing.

low key A photo that is primarily dark in tone.

macro photography/macro Traditionally, photos made at 1:1 or greater magnification. Currently used to describe extreme close-up photography at any magnification ratio.

magic hour See *golden hour*.

magnification factor The amount of apparent enlargement caused by using a 35mm focal-length measurement on an APS-sized camera.

Manual mode An exposure mode that requires the photographer to manually enter both aperture and shutter speed values.

medium format A class of cameras larger than 35mm but smaller than large format. Medium-format cameras come in several physical frame sizes.

merger In a composition, when elements appear to blend into one another due to sharing the same tone or color.

metadata Textual information embedded in a digital image file that describes the contents of the file.

mirror lockup A camera setting that reduces blur caused by mirror slap.

mirror slap Blur in a photo caused by the action of the mirror moving up as the shutter button is pressed.

neutral density (ND) filter A lens filter that reduces the amount of light coming into the lens without changing the color.

nodal point For panoramic photography, the point around which the lens can pivot to make photos without significant distortion.

noise Undesirable colored blobs or grainy speckles in a digital image. Most often caused by high ISO, low light, or underexposure.

normal focal length A lens that renders approximately the same appearance of perspective as the human eye.

overexposed A photo that appears brighter than the actual scene.

pan/tilt head A type of tripod head with separate controls for up/down, side-to-side, and rotation movements.

panning Moving the camera in a linear direction during the exposure.

panoramic A photograph showing a very wide angle of view, often created by combining multiple captures into a single image.

patterns Repeating, geometric graphics in a photo.

photo editing Selecting and separating the best photos from a shoot.

photography From Greek words meaning "writing with light."

plane of critical focus The distance at which the lens is precisely focused and the most sharp.

polarizing filter A lens filter that realigns the light waves coming into the camera so that they are parallel, reducing haze and glare.

post-processing Manipulating photographs after they are captured by the camera.

previsualization Imagining what a photograph will look like before making it.

prime lens A lens that only offers one focal length. Also called a "fixed" lens or fixed focal-length lens.

proportion The size relationships of objects in a composition.

quality of light A combination of direction, intensity, diffusion, and color.

RAW A capture format that preserves all the original data from the camera sensor.

resolution The amount of detail in a digital image.

saturation The purity of color, as opposed to neutral gray.

scale The size of objects within a composition.

Secure Digital (SD) card A memory card on which many dSLR cameras can store captured images. See also *CompactFlash (CF) card*.

selective focus Using a wide aperture and a specific focusing distance to make parts of the photo sharp and others blurry.

sharpening Increasing the contrast along edges of objects in the photograph.

shoot to the right A technique used to capture the most possible image data by slightly overexposing the digital capture. Refers to the appearance of tonal data concentrated to the right of the histogram.

shooting mode The main setting that determines how the camera will calculate exposure settings (or not). Common shooting modes are Aperture Priority (Av or A, for "aperture value" or "aperture"), Shutter Priority (Tv or S, for "time value" or "shutter"), Manual, and Program.

shutter curtain Panels of fabric or plastic that move across the recording surface to expose a picture when the shutter is released.

Shutter Priority A shooting mode where the photographer sets the shutter speed and the camera determines the aperture setting for the exposure.

shutter speed How long the camera's shutter is open and exposing the recording surface to light.

sidelight Light coming from the side of an object.

silhouette A featureless, dark shape created by backlighting.

specular light Direct light that is not significantly affected by anything in its path. The midday sun on a clear day is a specular light source.

split neutral density filter A lens filter with only part of the surface tinted, used to darken just a portion of the framed composition in order to provide a balanced exposure.

stitching Combining multiple photos to form a panoramic image.

stops Changes in exposure measured by doubling or halving the previous value.

subject The theme or message of a photo.

subject matter The objects in a photograph.

telephoto Lenses whose physical focal length is shorter than the apparent focal length suggested by the magnification.

tempo The pace at which the eye travels between objects in a composition.

texture Random, organic surfaces that elicit a tactile sensation when viewed.

tones The range of brightness in a photo, from darkest to lightest, without regard to color.

transmit Allowing light to pass through an object.

underexposed A photograph that appears darker than the actual scene.

UV filter A lens filter that limits the amount of ultraviolet light rays entering the lens. Used to reduce haze and protect the front lens element.

vibration reduction See *image stabilization*.

warm light Light with a yellow, orange, or golden color; low values on the Kelvin scale.

white balance The method by which cameras and software compensate for the color of light in a scene with the intention of producing a balanced, "neutral" color rendition.

workflow A sequence of steps taken to produce a specific outcome.

zoom lens A lens that offers varying focal length and magnification.

zooming Enlarging or reducing the scene as it appears in the camera.

continued